THE CANADIAN ROCKIES

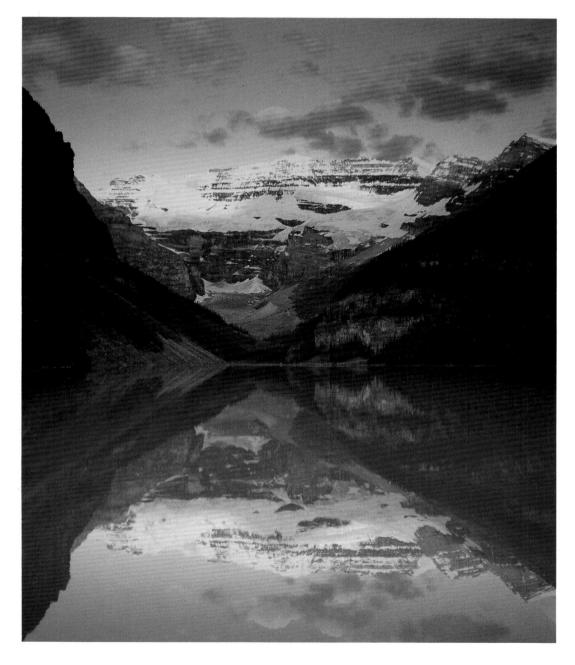

Sunrise at Lake Louise, Banff National Park

Overleaf: Moonrise over Athabasca River, Jasper National Park

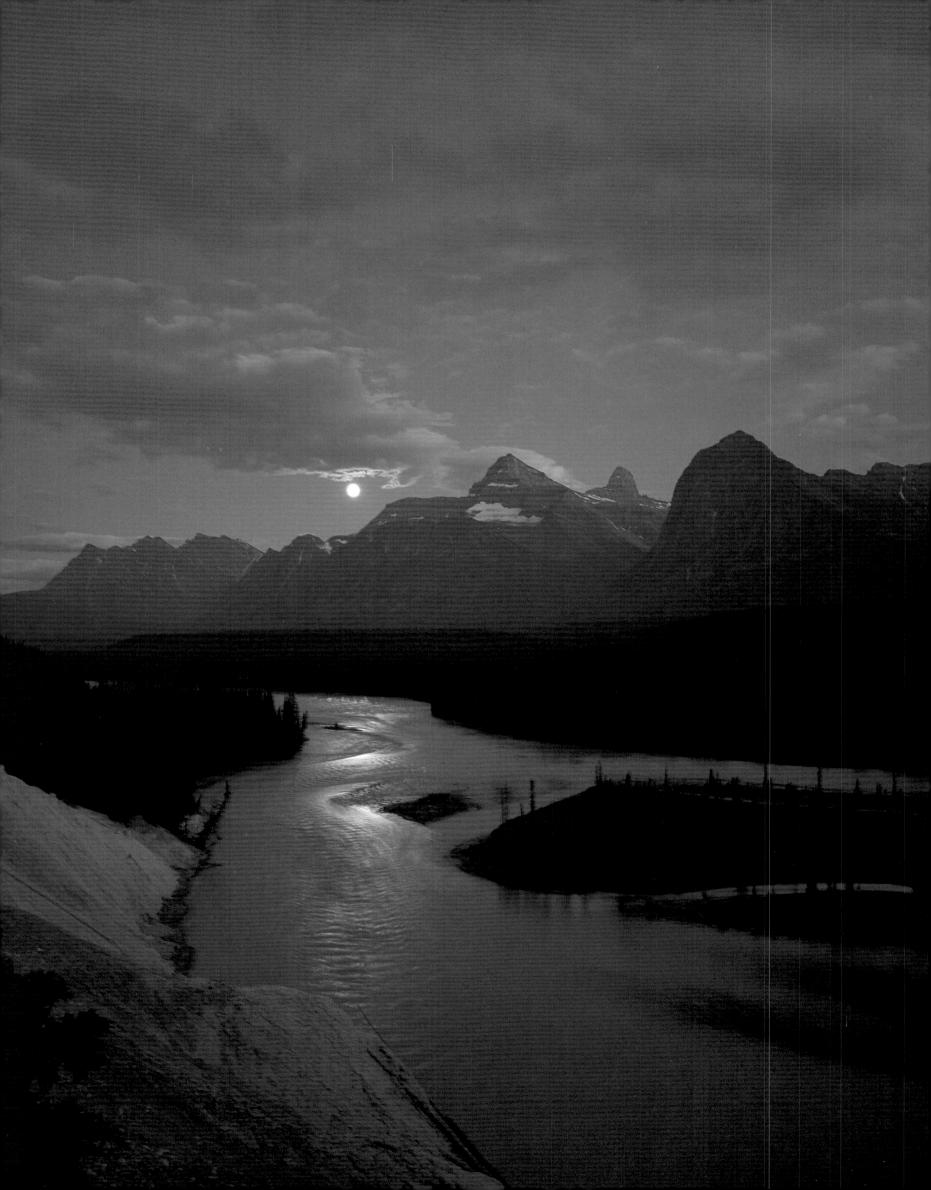

THE CANADIAN COLLEGE CONTROLL COLLEGE CANADIAN COLLEGE CA

ALTITUDE

PUBLISHING

Canadian Rockies/Vancouver

Copyright ©1993 Douglas Leighton

All rights reserved.

No part of this work may be reproduced or used in any form or by any means without the prior written permission of the publisher.

Canadian Cataloguing in Publication Data

Leighton, Douglas, 1953The Canadian Rockies Photo Album
ISBN 0-55153-010-4

1. Rocky Mountains, Canadian (BC and Alta.) – Pictorial works.*

I. Title.

FC219.L47 1993 971.1'0022'2

C93-091039-7 F1090.L44 1993

987654

Edited by Elizabeth Wilson Design: Robert MacDonald, MediaClones Inc.

Made in Western Canada

Printed and bound in Western Canada by Friesen Printers, Altona, Manitoba.

Altitude Publishing Canada Ltd. gratefully acknowledges the support of the Canada/Alberta Agreement on the cultural industries.

Altitude GreenTree Program

Altitude will plant in Western Canada twice as many trees as were used in the manufacturing of this book.

Altitude Publishing Canada Ltd.

Box 1410, Canmore Alberta Canada TOL 0M0

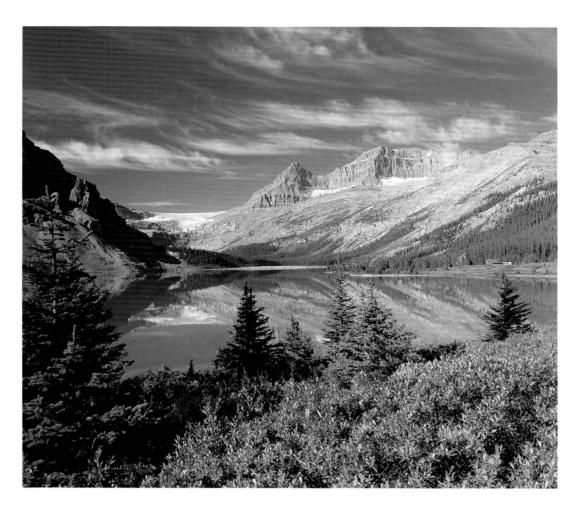

Num-Ti-Jah Lodge at Bow Lake, Banff National Park

CONTENTS

Banff National Park 11
Lake Louise 37
The Icefields Parkway 55
Jasper National Park 67
Yoho National Park 79
Kootenay National Park 91
Kananaskis Country 101
Waterton National Park 107

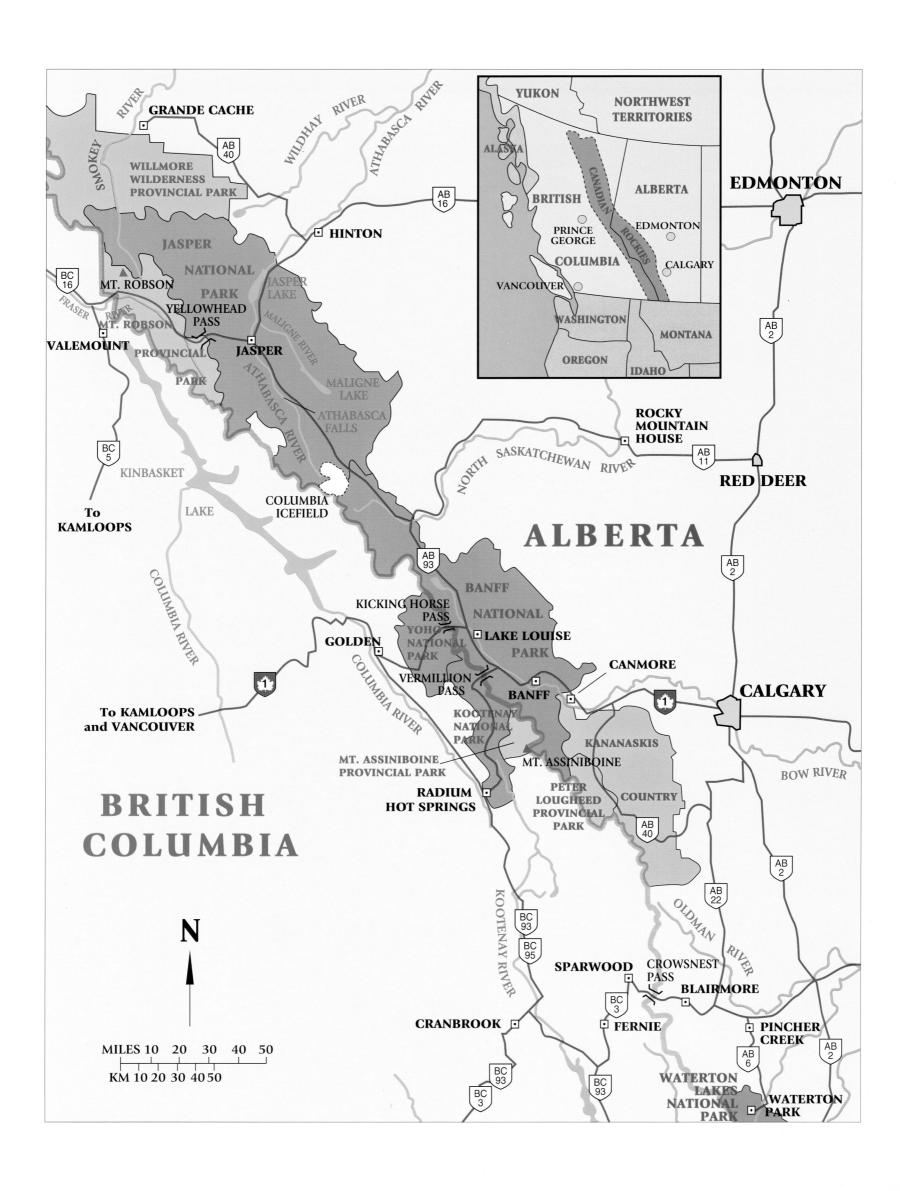

THE CANADIAN ROCKIES

he Canadian Rockies have been among the most famous mountain landscapes in the world for more than a century. In 1889 British travel writer Douglas Sladen came to see this "new Switzerland" on the newly inaugurated Canadian Pacific Railway passenger line. After a long ride across the empty plains, he reached Calgary, a dusty frontier "cow town" in the foothills. Rolling west he finally saw "... the Rocky Mountains, which you have been reading about and dreaming about since you were a child, filling the horizon ... you see that the wall was no mere illusion of distance, but that the whole range ... is a castellated formation of an extraordinary beauty ..."

Sladen was utterly awed by that powerful first impression – an experience shared by millions of travellers since. And though the prairies have been plowed and Calgary has become a high-tech city of 750,000, the mountains still stand wild and free. Protected in one of the world's largest blocks of mountain parks, the Canadian Rockies are an island of rare natural wilderness in a swelling sea of civilization – a last refuge for old-growth forests, for wilderness, and whole mountain ecosystems. Recognizing the ecological treasure preserved here, in 1984 the United Nations declared four contiguous National Parks – Banff, Jasper, Yoho and Kootenay – to be a 20,160 sq km/7782 sq mi World Heritage Site. Adjoining Mt. Assiniboine, Mt. Robson and Hamber provincial parks were added in 1990.

Yet paradoxically, one of the most famous landmarks in this natural preserve is a "castle," the Banff Springs Hotel, and there is a full range of tourist facilities to serve visitors. The first national parks were children of the railway, created to attract and serve tourists. Only much later were they seen as temples of nature.

Today this history bequeaths the Canadian Rockies with the best of both worlds. This is a place where you can watch alpenglow on wilderness peaks from a luxurious dining room, golf past grazing elk, ride a gondola or ski lift to a summit view, take a tour boat up a glacial lake or a snowcoach onto a glacier, explore easy walks and fabulous viewpoints. Or leave civilization far behind on a trail to the real wilderness.

To the Stoney Indians who live in their foothills, these "shining mountains" have always been sacred places. The young men went alone for vision quests in the peaks, fasting and waiting for days and nights for wisdom in the eagle's view of the white-capped stone ocean chopping to the sunset horizon. Among the spirits of these brooding giants, they could feel part of the infinite whole.

Many of today's visitors are on their own kind of vision quest. These mountains rejuvenate tired souls. You can still feel the peace, hear the quiet and watch clouds and bighorn sheep drift across wild valleys. Protected by our conviction to the national parks that shelter them, these primeval experiences may survive to inspire the future.

DOUGLAS LEIGHTON

Overleaf: Numa Pass, Kootenay National Park

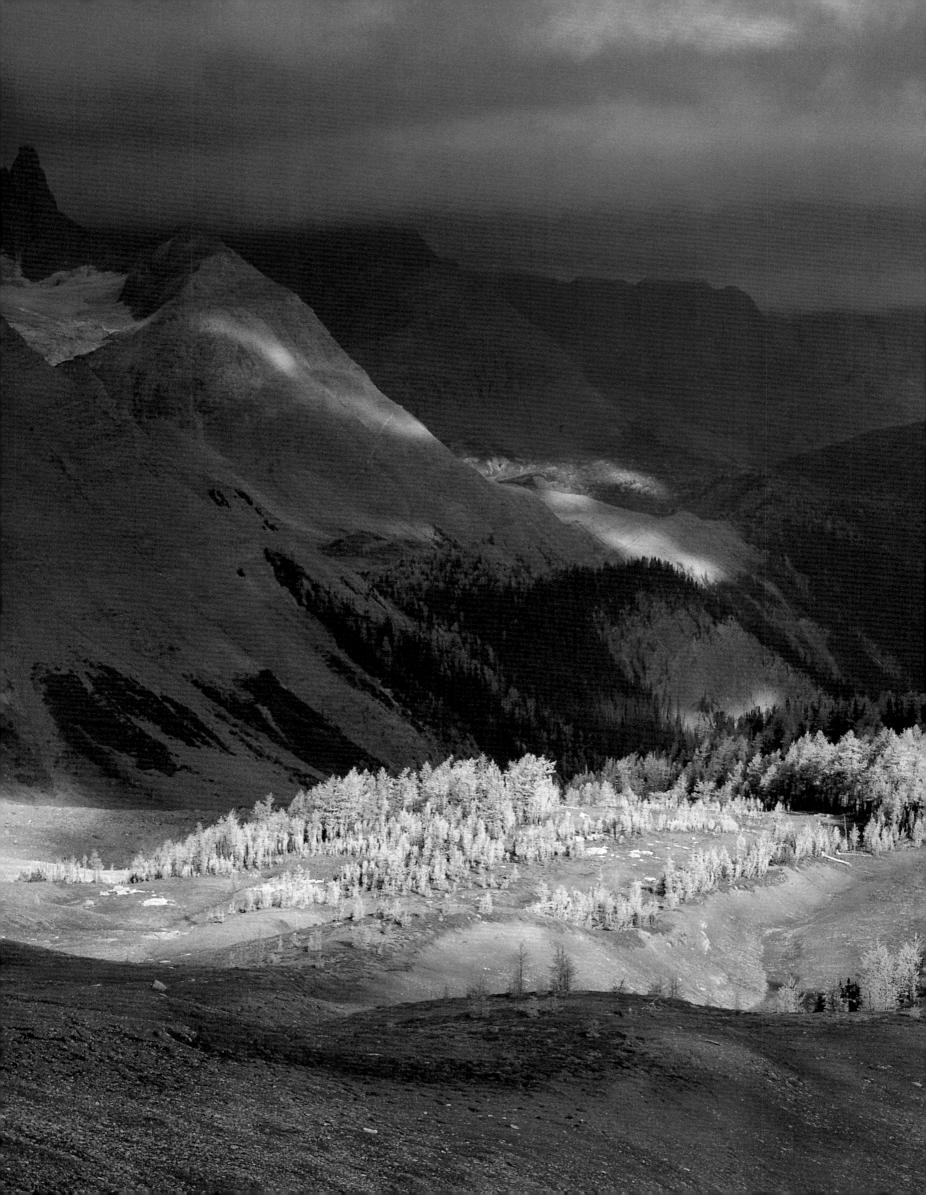

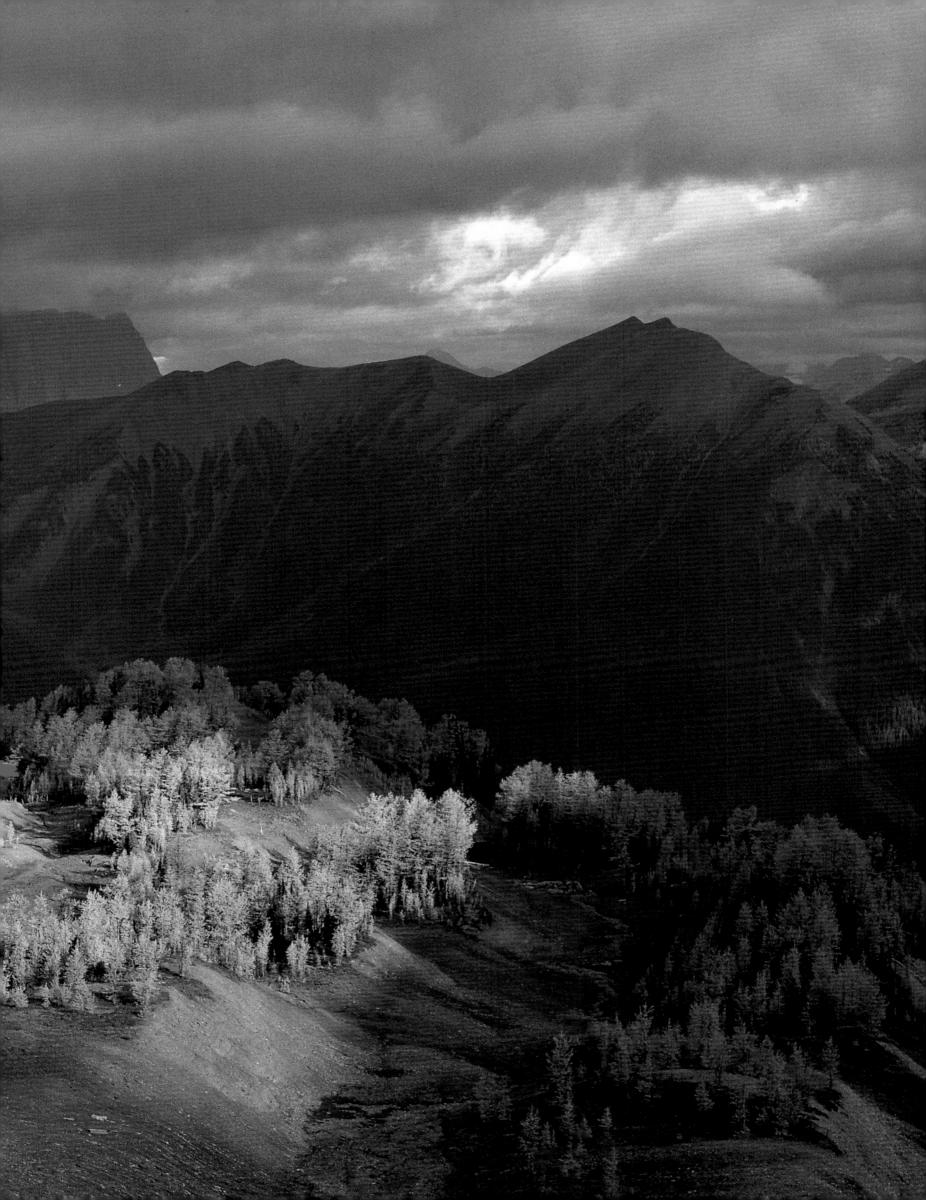

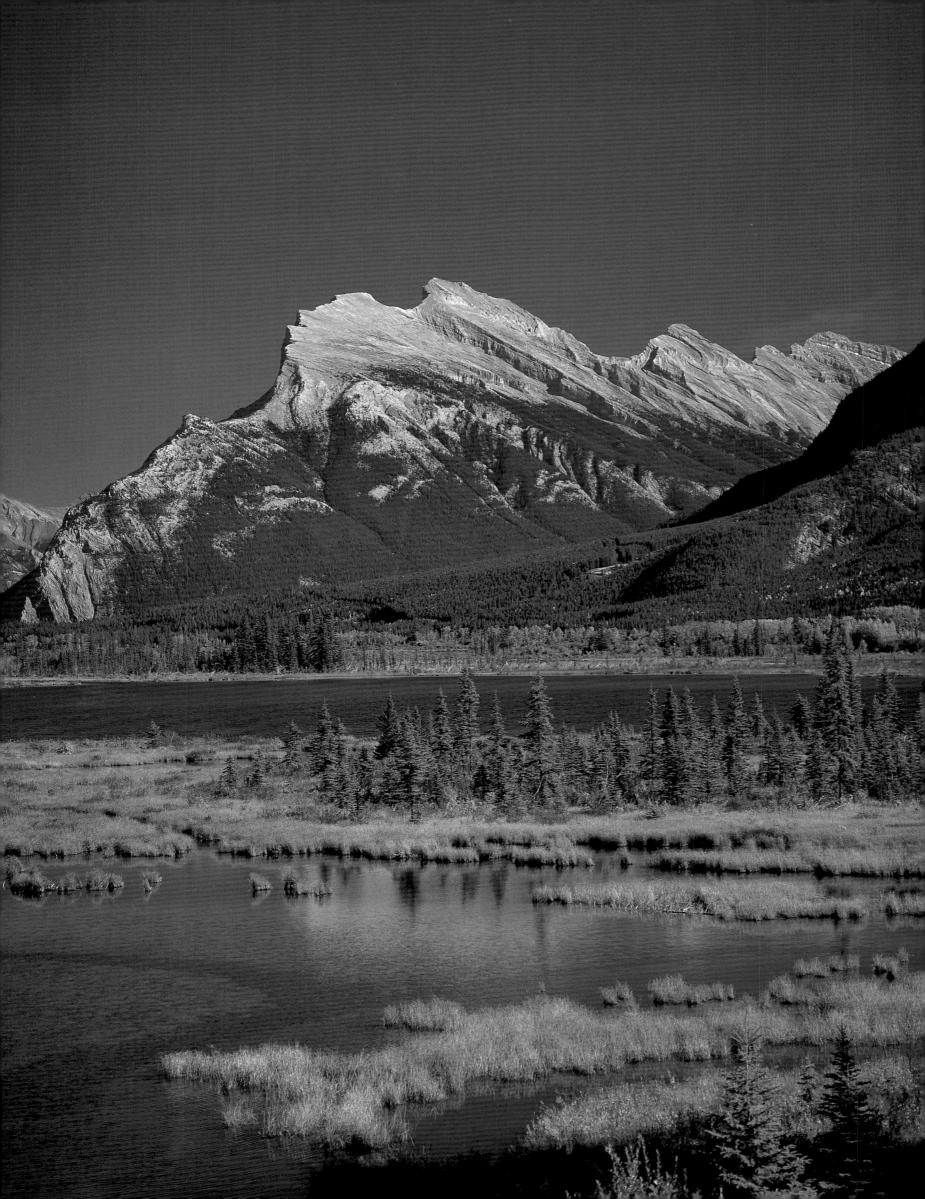

BANFF NATIONAL PARK

"If we can't export the scenery, we'll import the tourists."

William C. Van Horne

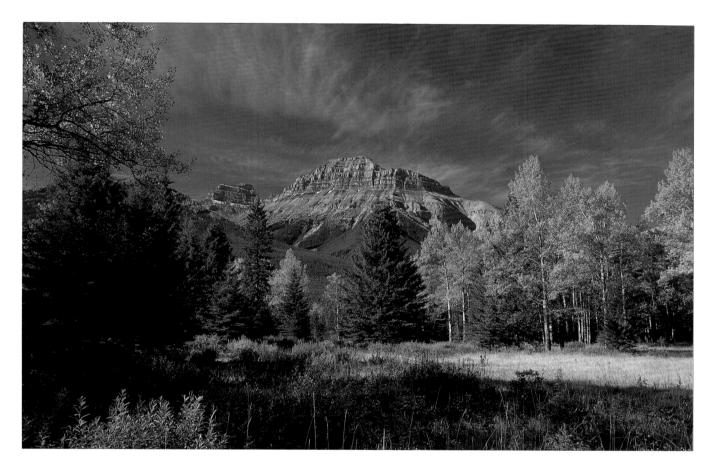

Pilot Mountain

The Bow Valley Parkway is always a beautiful drive, but in late September it really puts on a glorious show. The yellows of trembling aspen and crimsons of red-osier dogwood colour the valley; subalpine larches splash gold on the shoulders of 2954 m/9690 ft Pilot Mountain.

Left: Mt. Rundle from Vermilion Lakes

his panorama just west of Banff is one of the most famous views of the Canadian Rockies. Named for Reverend Robert Rundle, a Wesleyan missionary who met the Stoney Indians here in 1847, the knife-edged 2949 m/9675 ft high peak is the top corner of a massive, tilted block of layered limestone and shale 15 km/10 m long. There's a hiking trail to the summit on this side, sheer cliffs on the other.

A Tale of Two Banffs

ne Banff is a wild 6641 sq km/2563 sq mi national park; the other is an urban island within the park, a lively, cosmopolitan town with 7000 residents that hosts millions of visitors every year. Understandably, the different needs of preservation and recreation create unique conflicts and opportunities here in Canada's first national park.

Banff's odd character is the product of changing expectations. Today national parks are increasingly seen as protected areas dedicated to wilderness conservation, but when a 26 sq km/10 sq mi reserve was set aside in 1885 the whole west was a wilderness. This park was to be "built" and "improved" to make it a "creditable National Park." The Canadian Pacific Railway had just been completed and its visionary manager William C. Van Horne had seen the obvious tourism potential of this spectacular landscape. "If we can't export the scenery, we'll import the tourists" he proclaimed. When he heard of the hot springs discovered on Sulphur Mountain in 1883, just off the railway line, he knew that this spot could be a resort to rival the spas of the Alps. The Canadian government agreed and in 1887 the 676 sq km/261 sq mi Rocky Mountains National Park, as the park was first called, was officially established.

In 1888 the railway's first Banff Springs Hotel, complete with luxurious hot springs water piped in, hosted 1503 visitors during its inaugural summer season. On the way to the hotel from the railway station, visitors passed through the townsite (named for Banffshire, the birthplace of the CPR's president George Stephen), already surveyed and growing to serve them. They took carriage rides to the Cave and Basin and Upper Hot Springs for a soak or to Lake Minnewanka for sight-seeing, and went hiking, mountain climbing, trail riding and fishing. Three years later the guest list had doubled,

with most visitors arriving from the United States and Britain. With the railway's international "Fifty Switzerlands in One" promotions behind it, international tourism began booming in the "Canadian Pacific Rockies."

By the Roaring Twenties, a new Banff Springs castle had been built, there were mountain teahouses and lodges, and pioneer powder hounds were already eyeing the Sunshine ski area, which would make the park a year round resort a decade later. Concerned about this frenzy of development, Canadian officials took another look and in 1930 defined a new mission for the national parks: "to leave them unimpaired for the enjoyment of future generations." In 1978, this conservation mandate was further strengthened with a new policy declaring that the first and fundamental purpose of the parks is the protection of their ecological and historical integrity.

Today park managers are kept busy balancing the two sides of Banff's personality. The townsite and other satellite developments are confined within established boundaries and, although this creates some crowded spots in the busy summer season, it is a small price to pay for all the wonderful space left wild elsewhere in the park. You may have to go a little farther off the beaten track to find wilderness in Banff, but stunning scenery is everywhere. Banff Avenue, for instance, must be one of the most beautiful outdoor malls in the world. And while people browse in the shops, elk, bighorn sheep, mountain goats, deer, moose, caribou, black bears and grizzly bears browse in the park. In fact, you may notice that a number of Banff's elk are town-dwellers who happily avoid the wolves while feasting on some of the finest lawns and ornamental shrubbery civilization has to offer.

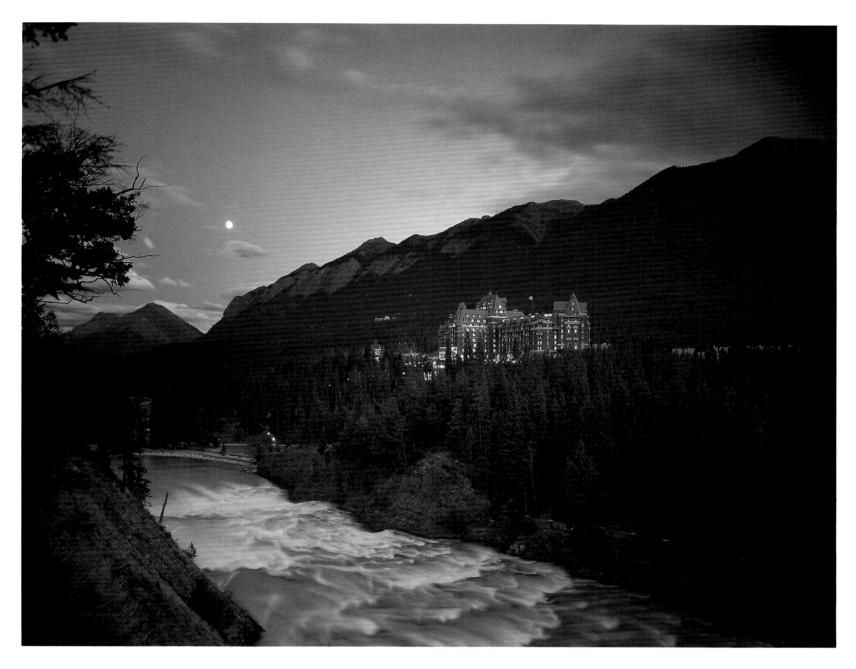

Banff Springs Hotel

As dusk falls and the moon rises over the Bow Valley, the Banff Springs Hotel seems as timeless as the Bow River flowing past below it.

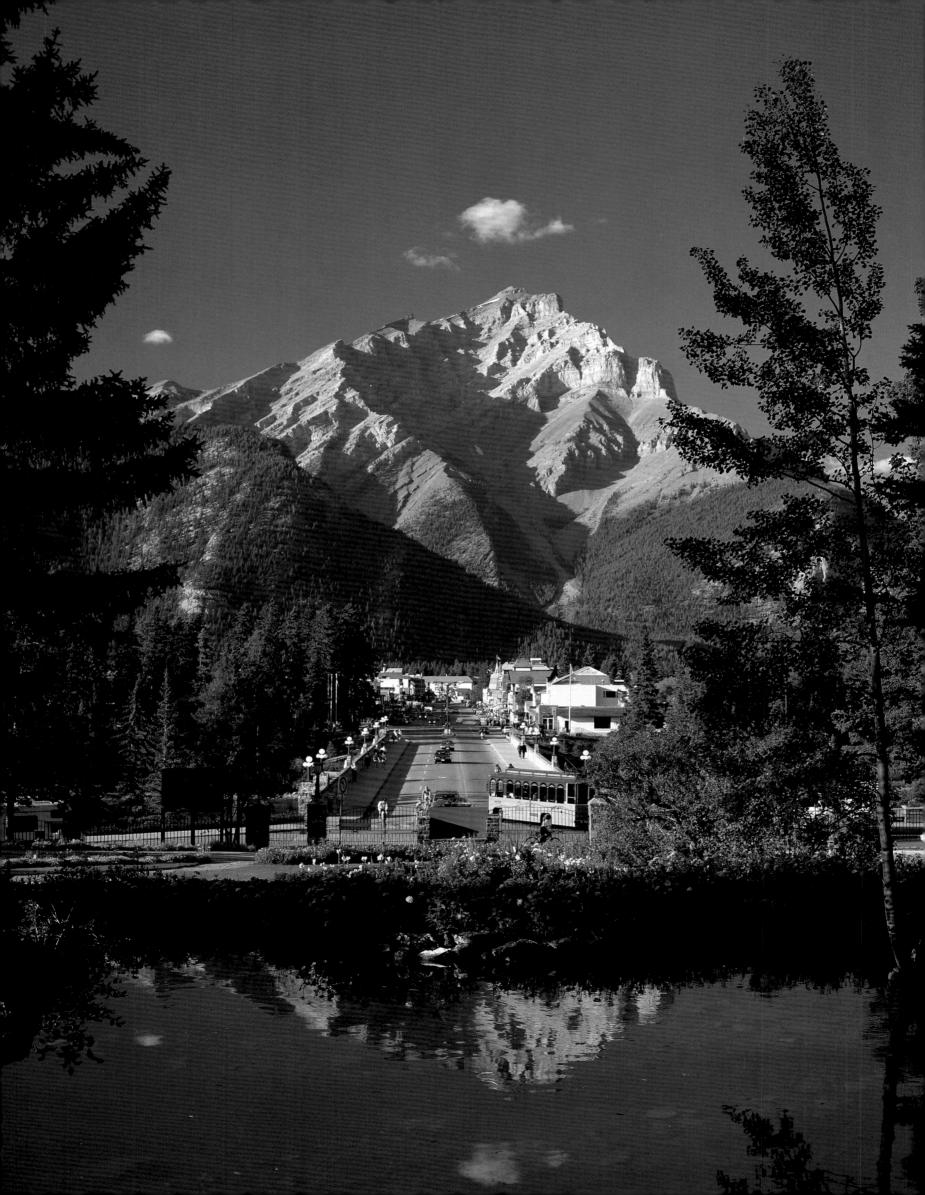

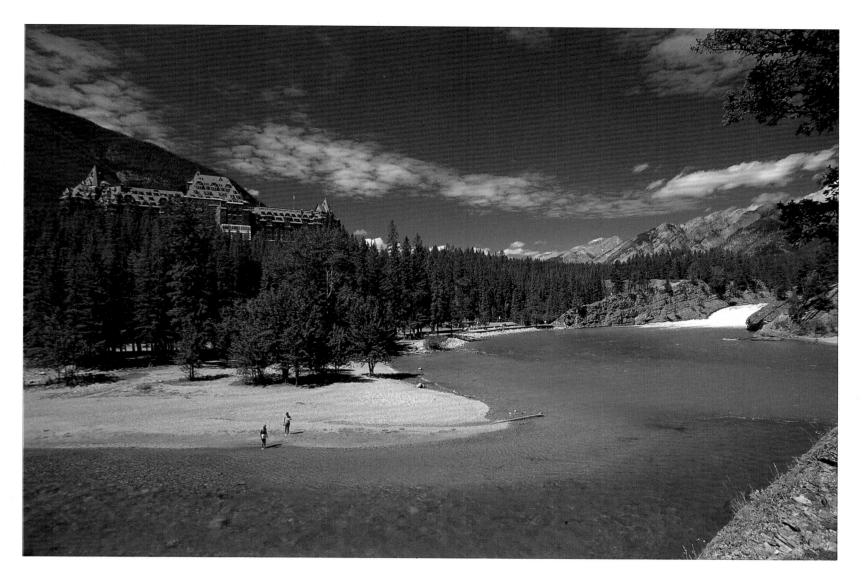

At Bow Falls in Banff

The Bow River roars by just below the Banff Springs Hotel. Shuttle buses pass here on their way to the Banff Springs Hotel Golf Course. Marilyn Monroe (or at least a blonde mannequin) went over these falls in the 1953 movie *River of No Return*.

Left: Banff Townsite

Banff was born and built to be a mountain resort, a historical fact clearly revealed here in the beautiful design of this classic view. From the Cascade Gardens, Banff Avenue stretches quite perfectly toward the base of 2998 m/9836 ft Cascade Mountain. Seven thousand residents now call Banff home.

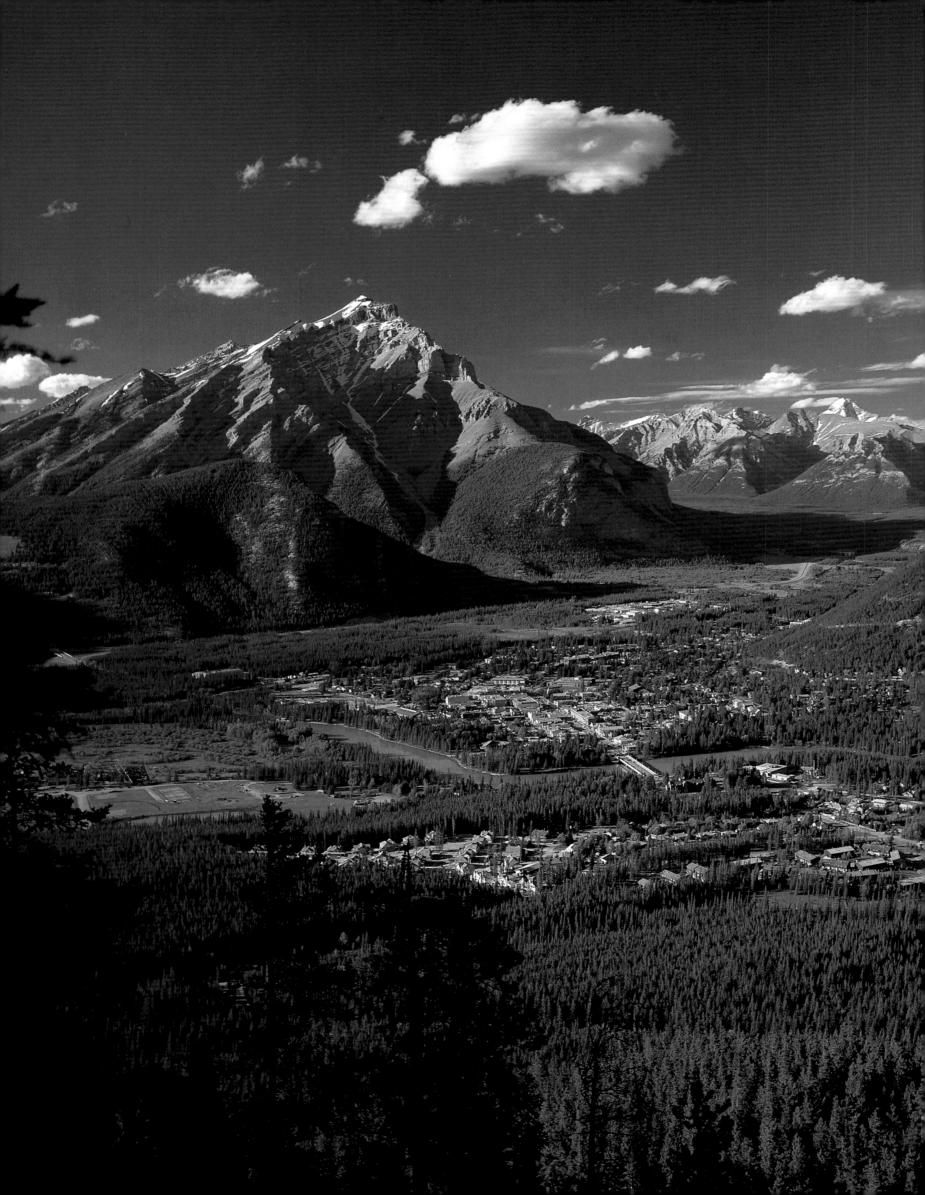

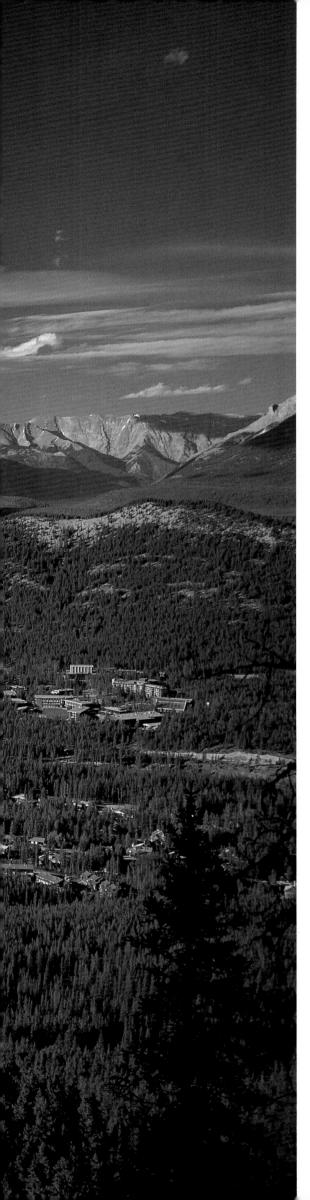

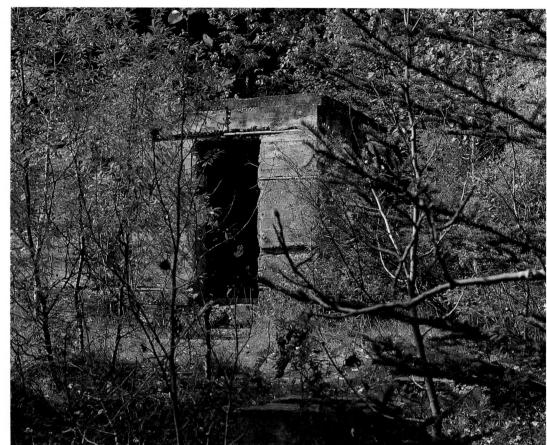

Ruins at Bankhead

Tradually returning to the forest, these concrete ruins were once part of the busy town of Bankhead, home to miners digging anthracite coal from the base of Cascade Mountain from 1904 to 1923. Today visitors can explore the abandoned townsite on a self-guiding interpretive trail.

Left: Banff and the Bow Valley

Ould there be a more beautiful setting for a mountain town? Banff sits on the banks of the Bow River, with 2998 m/9836 ft Cascade Mountain looming to the left and friendly 1692 m/5550 ft Tunnel Mountain, with the Banff Centre at its base, on the right. Beyond the distant Cascade Valley and Lake Minnewanka, 3164 m/10,375 ft Mt. Alymer is visible on the horizon, draped in snow.

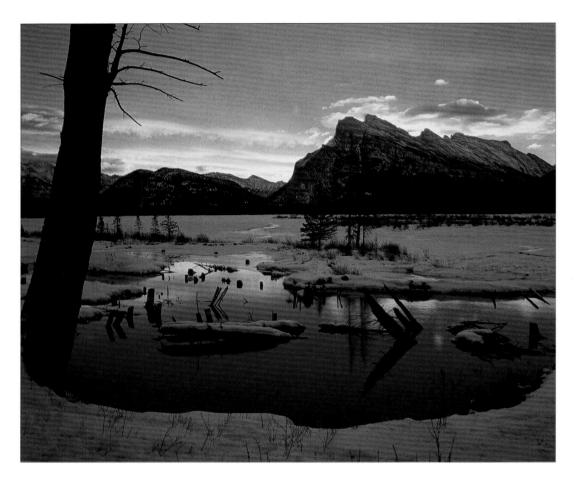

Winter Dawn, Second Vermilion Lake

The prairie sunrises that backlight Mt. Rundle sometimes paint the sky with rare colours. Stone Age people wintered here more than 10,000 years ago, attracted by game and the warm springs that keep this old beaver pond open today.

Right: Third Vermilion Lake

As the last light catches the peaks of Mt. Rundle, these wetlands come alive. Beavers stir from their lodges, elk emerge to graze on the meadows and coyotes and owls begin the hunt. Early summer evenings are filled with songbird songs, loon calls and the eerie winnowing of snipe. More than just another pretty place, the Vermilion Lakes are an oasis for wildlife.

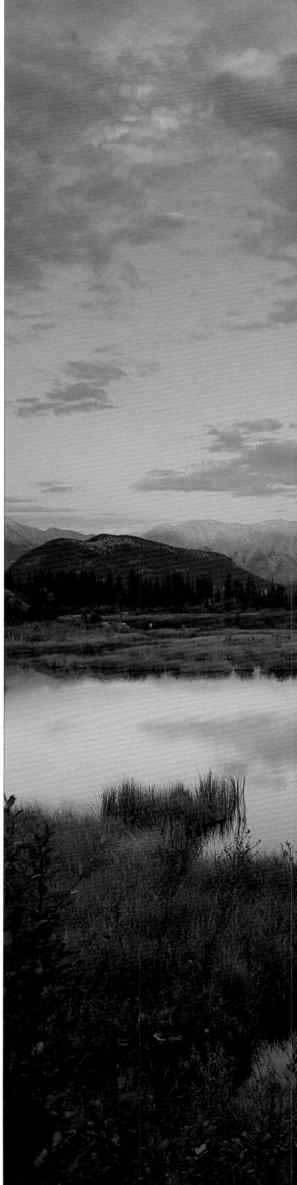

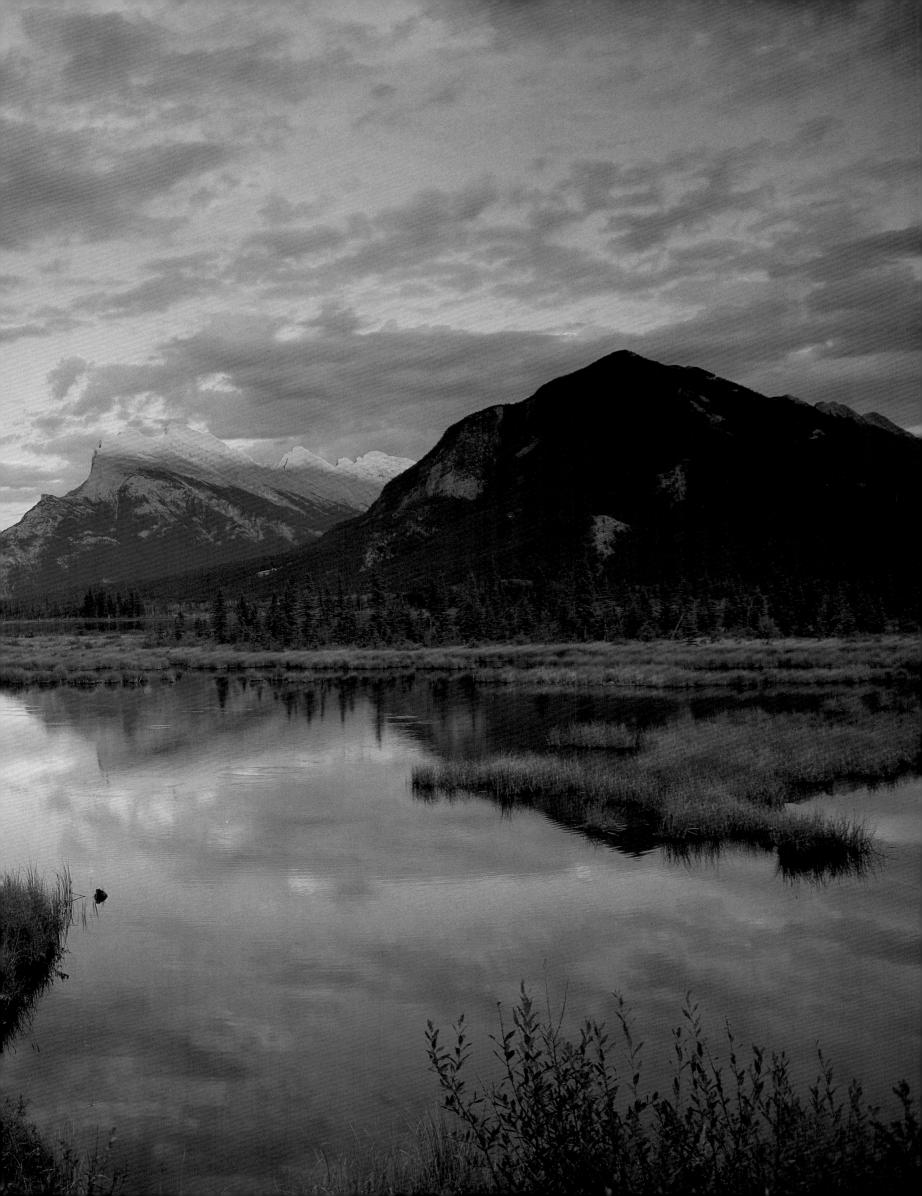

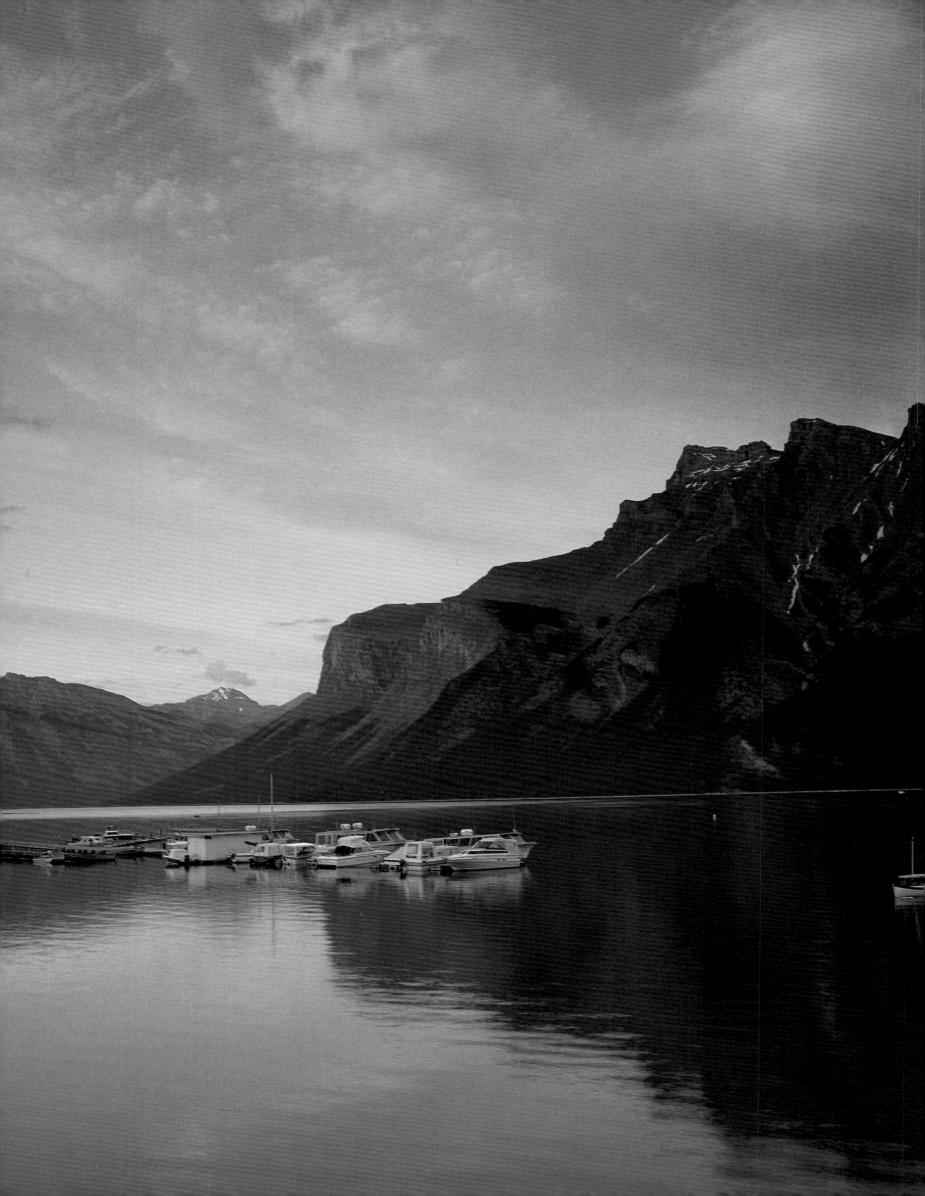

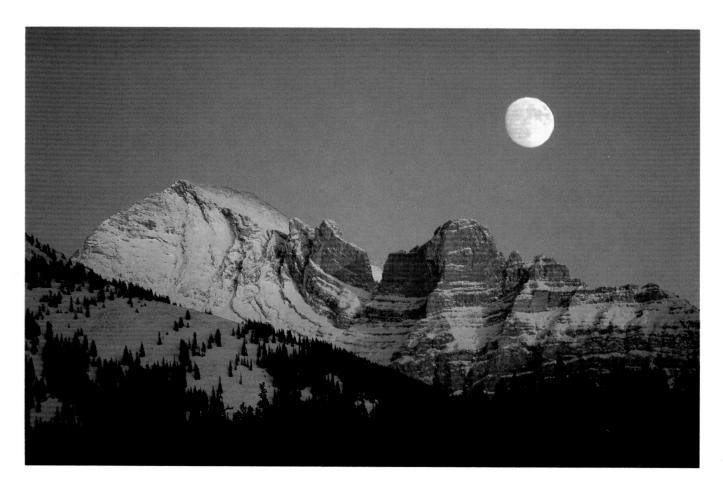

Mountain Moonrise over Mt. Girouard

In the early winter the full moon rise coincides with the alpenglow lighting the peaks, here over 2995 m/9827 ft Mt. Girouard in the Fairholme Range east of Banff.

Left: Lake Minnewanka

he largest lake in Banff National Park was made larger when a dam was built at its west end to supply power to the town of Banff. Tour and fishing boats find a sheltered port here when the big lake lives up to its stormy name, which means "lake of the water spirit." Mt. Inglismaldie towers 2964 m/9725 ft above the distant shore.

Overleaf: Banff Springs Hotel, Bow Valley

The Canadian Pacific Railway built Banff's castle here for the view down the Bow River between Tunnel Mountain (left) and Mt. Rundle, to the snow-capped Fairholme Range. The hotel's 27-hole golf course can be seen along the river. Tunnel Mountain was named for a tunnel that was never built; the railway went around (behind) it.

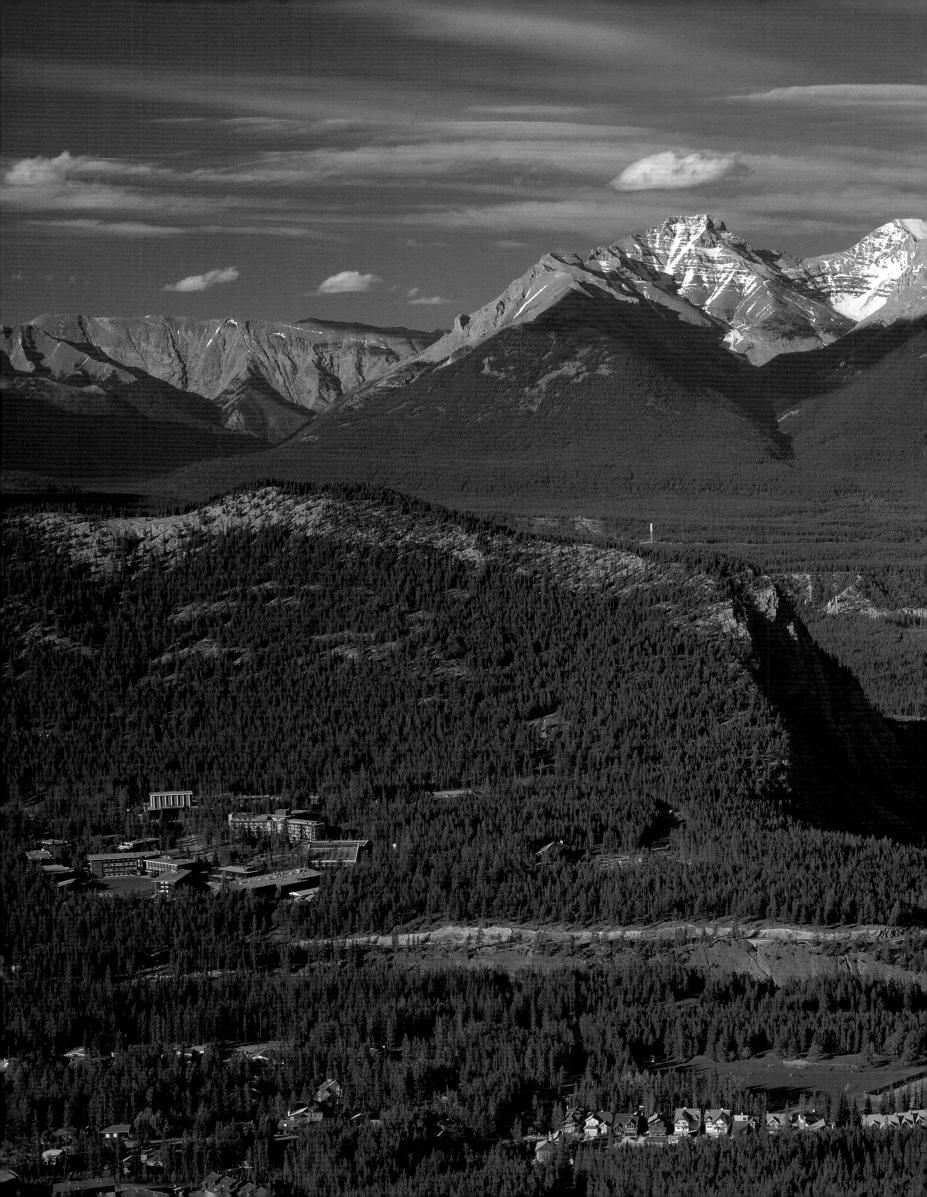

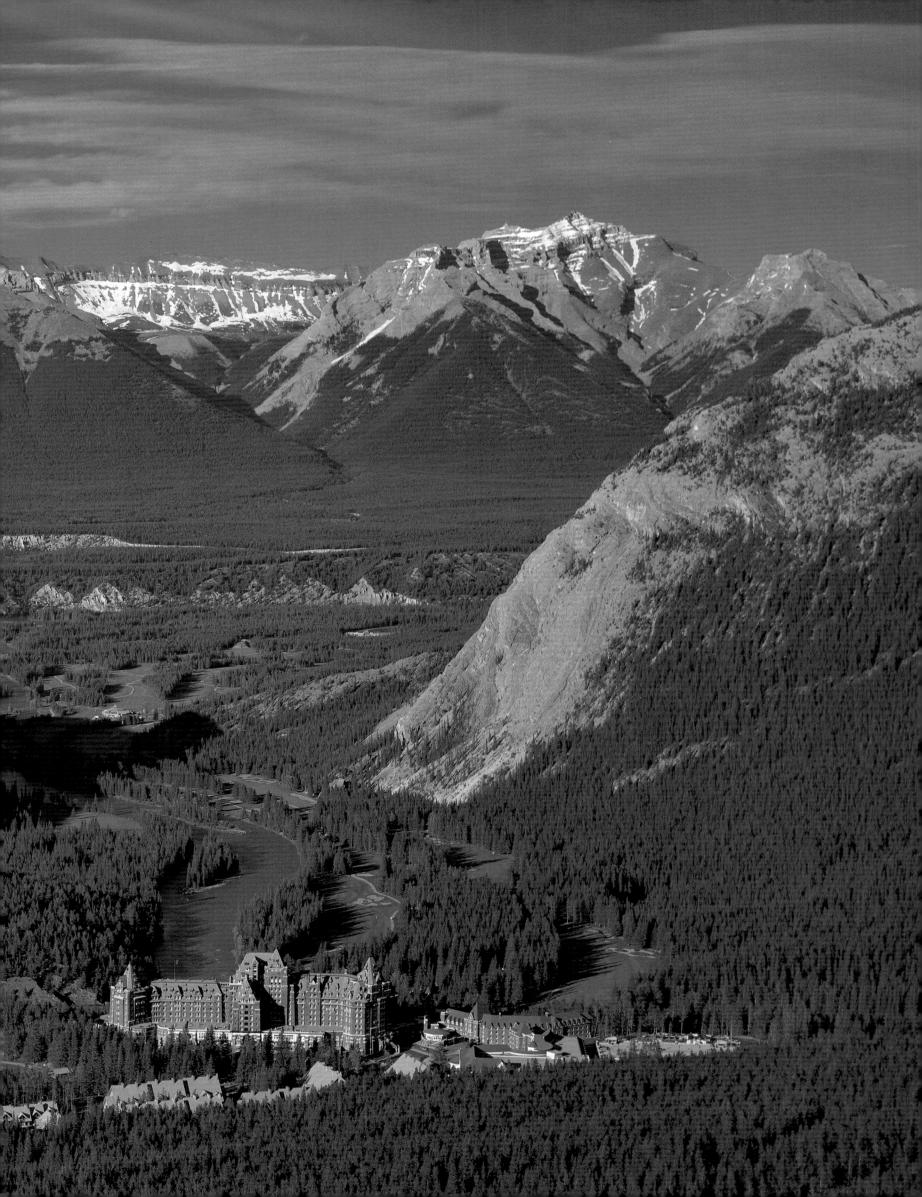

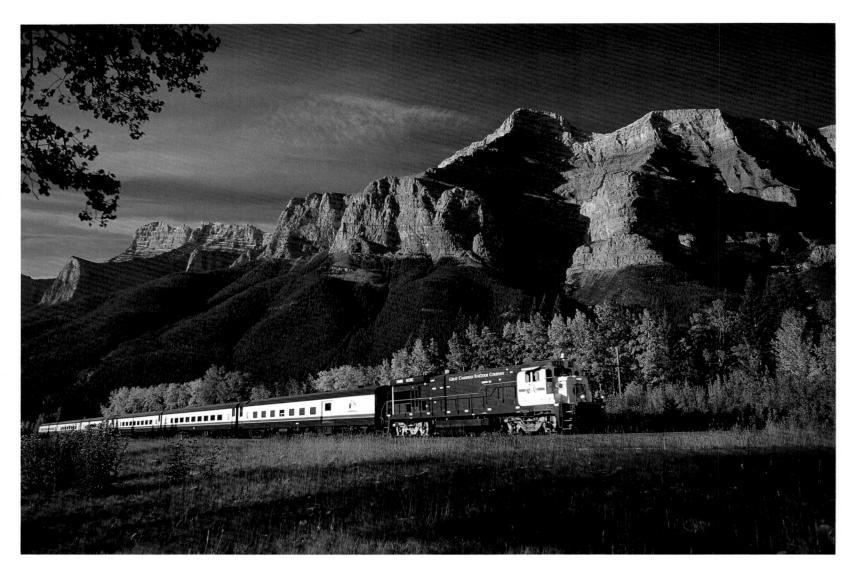

Rocky Mountaineer Passenger Train below Mt. Rundle

Banff National Park was created in 1885 to lure railway passengers to the mountains, and today visitors are still arriving by train. One of the Canadian Pacific Railway's first passengers, Susan A. MacDonald, the adventurous wife of Canada's first Prime Minister, chose to tour in a seat mounted on the front of the locomotive.

Right: Rocky Mountain Bighorn Ram

Bighorn sheep are creatures of habit who follow familiar routes to traditional ranges generation after generation. Looking down from the "Green Spot" meadow on Mt. Norquay one spring day, this ram may have been taking his last look at Banff before heading up to a highcountry meadow for the summer. Some sheep, mostly ewes and lambs, stay on lower ranges around Banff all year.

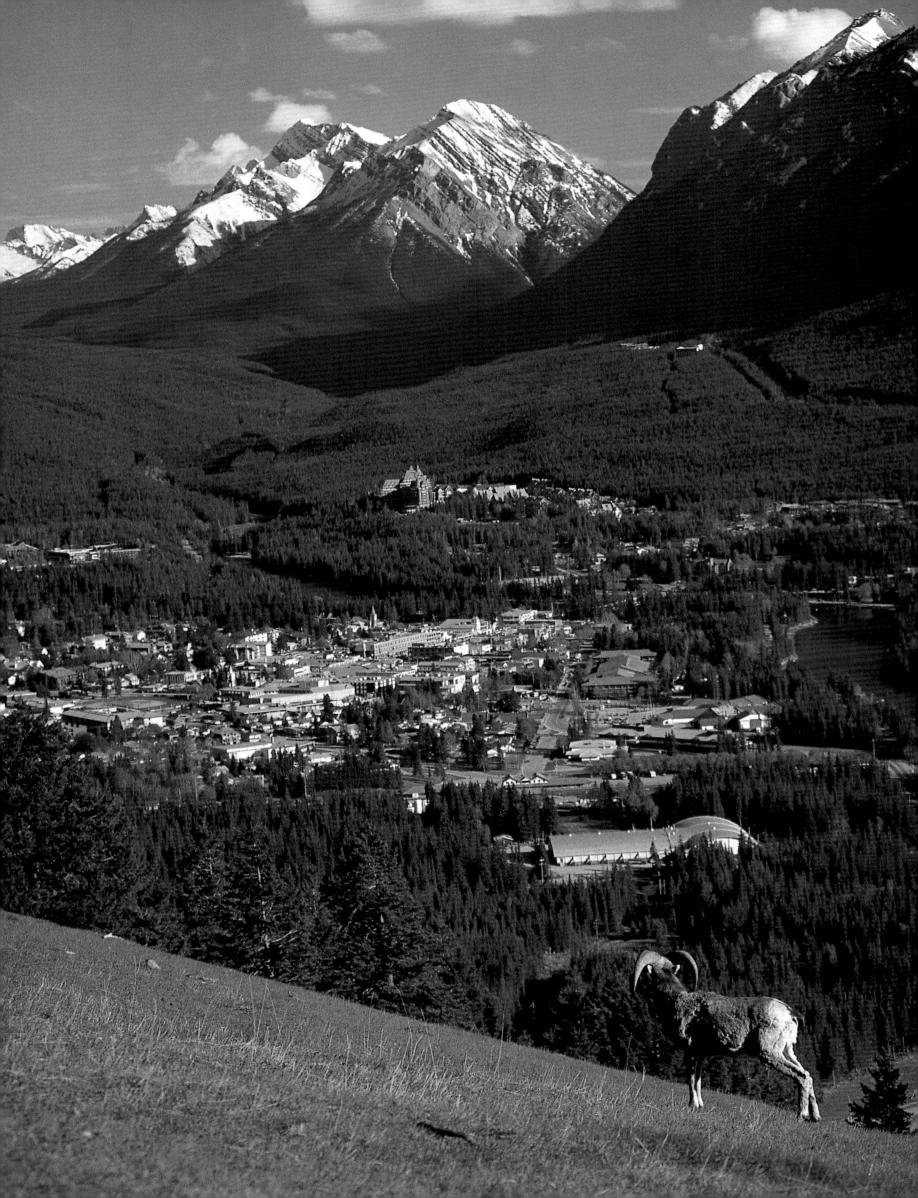

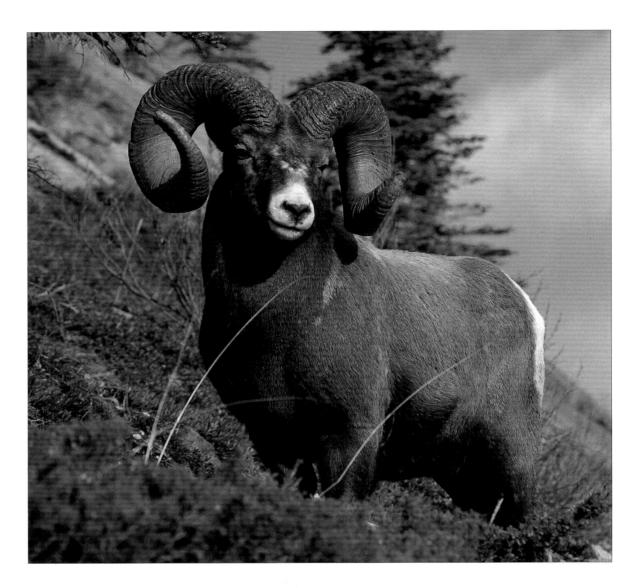

Bighorn Ram

Big horns are the status symbol of bighorn rams and this old king of the mountain has a Rolls Royce pair. In late autumn the bachelor herds of rams descend to traditional rutting grounds to compete for breeding rights. Horn displays determine the basic pecking order and head-butting battles settle final arguments between rivals with similar sized horns.

Right: Bull Elk

Elk, or "wapiti," are the most abundant large mammal in the Rockies. During the September rutting season, the challenging bugles of rival bulls echo through these mountain valleys. They run themselves ragged in this frenzied mating game. I found this bull one November morning, feeding on late green creekside salads, recuperating to face the coming wolves of winter.

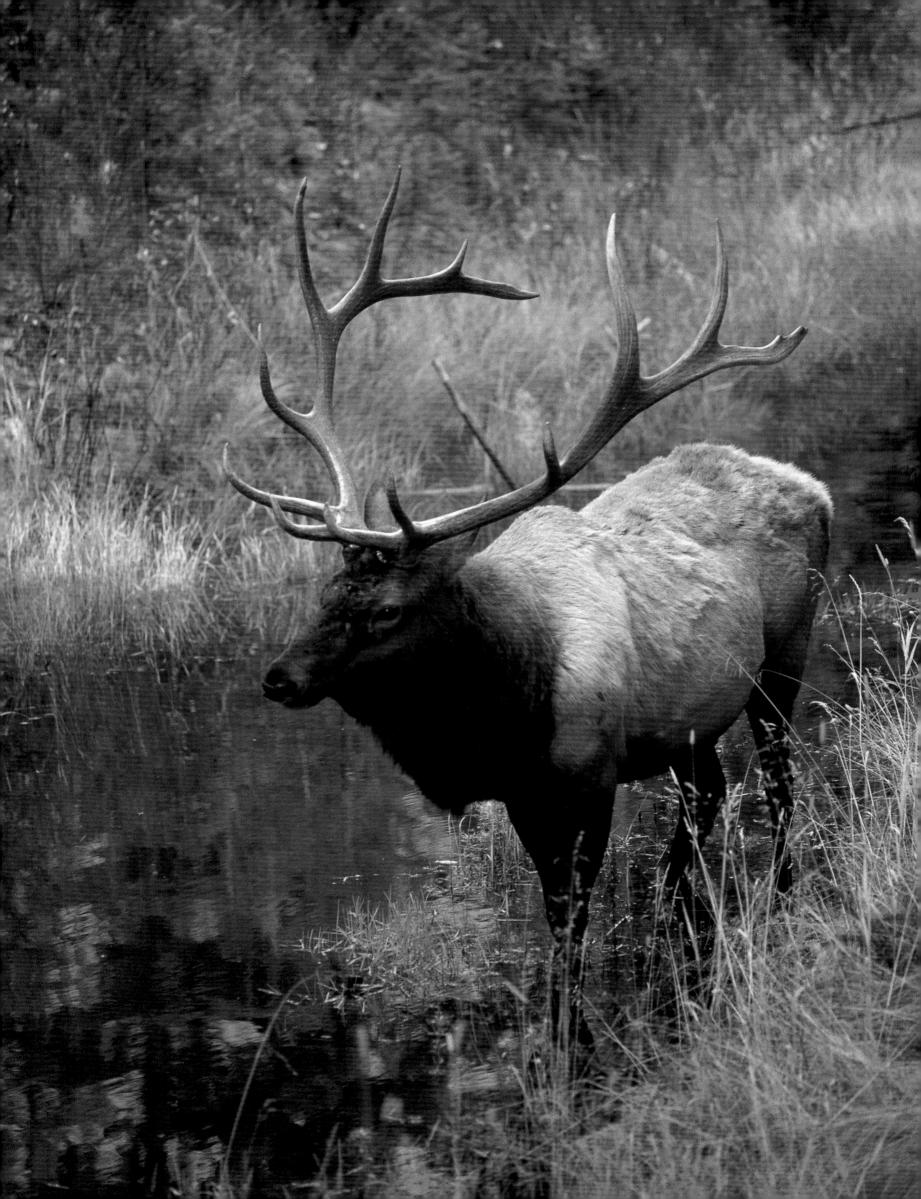

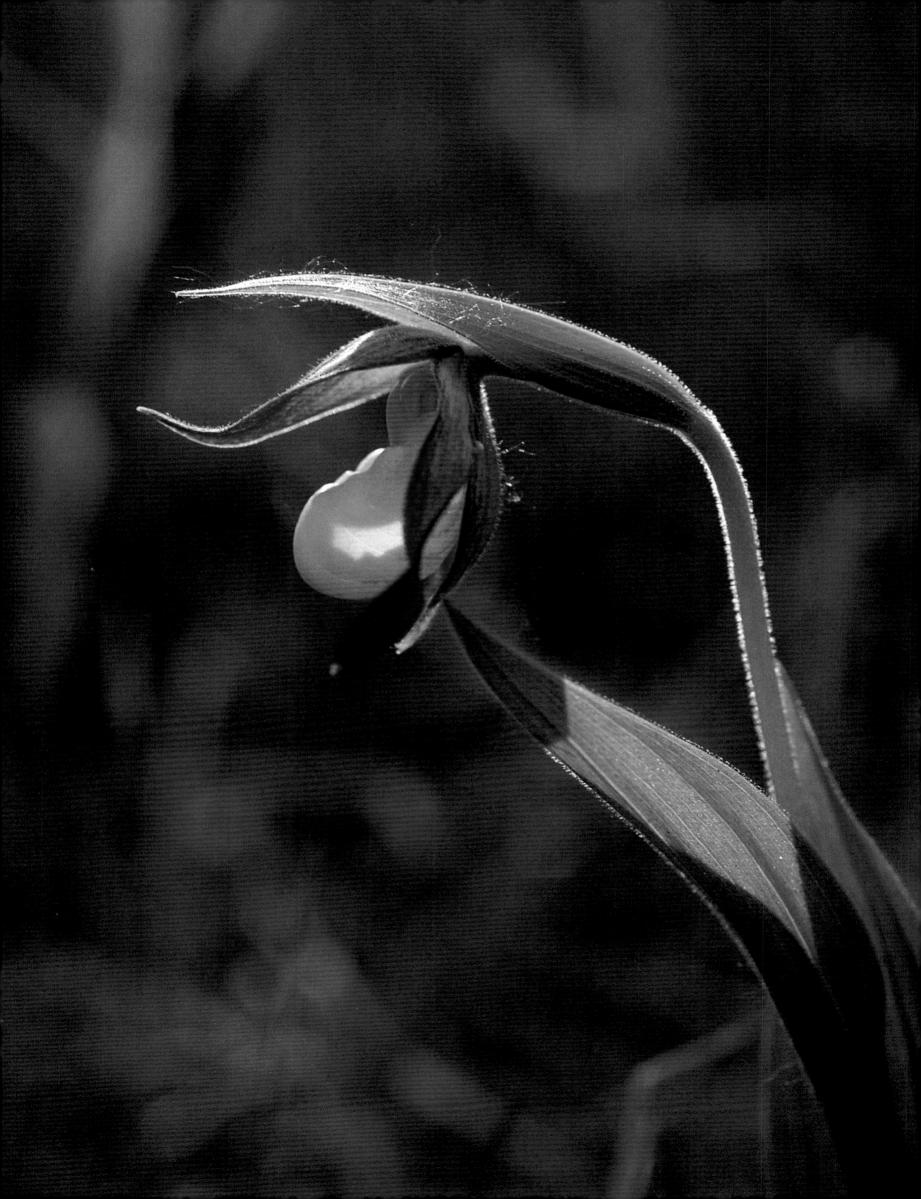

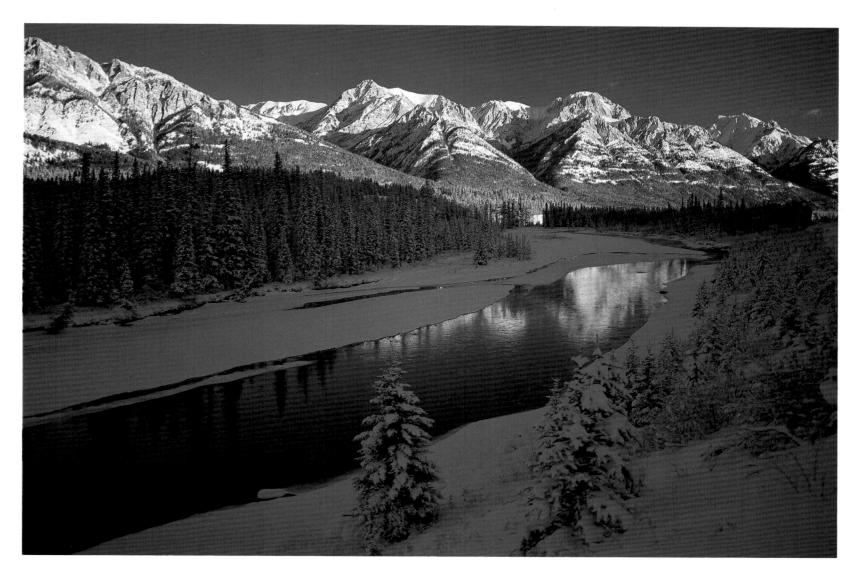

Bow River, Sawback Range

In the crackling crisp air of a chill winter day, the dogtooth peaks of the Sawback Range glow in the late afternoon light above the Bow River valley. Warm springs keep parts of the river open all year.

Left: Yellow Lady's Slipper

Lo both hikers and bees, this beautiful flower of moist forest and muskegs is always a surprise. Both are attracted by its colour and scent, but while the hiker just stops and sniffs the bee climbs in, then has a hard time getting out. Bumbling about inside the blossom, it is sure to pollinate it. Sadly, these orchids' rare beauty is becoming rarer as unknowing visitors pick them, even within the parks.

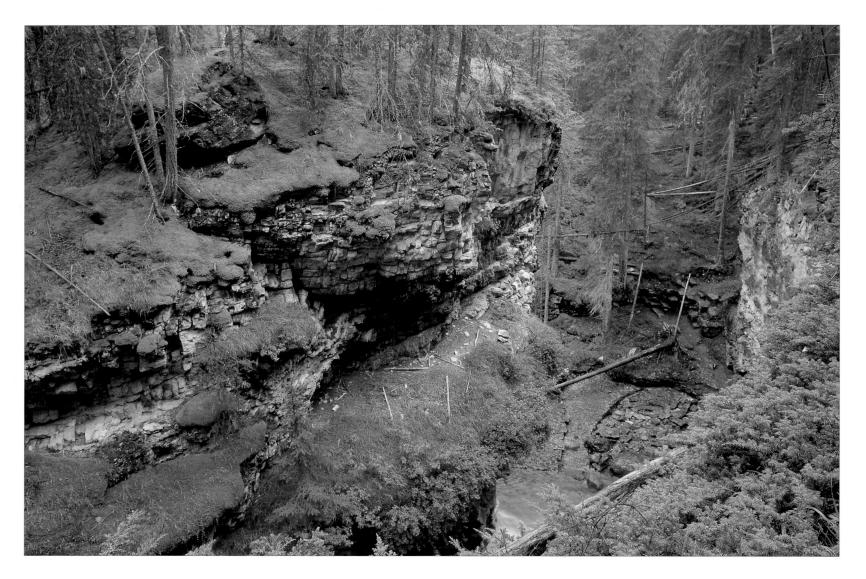

Johnston Canyon

Johnston Creek has sliced as much as 30 m/100 ft through the limestone bedrock to create Johnston Canyon, which is north of Banff on Hwy 1A. These moist, mossy cliffs offer niches for nesting black swifts – one of only three known sites in Alberta – as well as flycatchers and dippers.

Johnston Canyon Lower Falls

Only an easy 20 minute stroll up an elaborately built trail, these 15 m/50 ft falls are the smallest of two in this deeply sliced and sculpted canyon. The shade and cool spray make this a delightful retreat on a hot summer day.

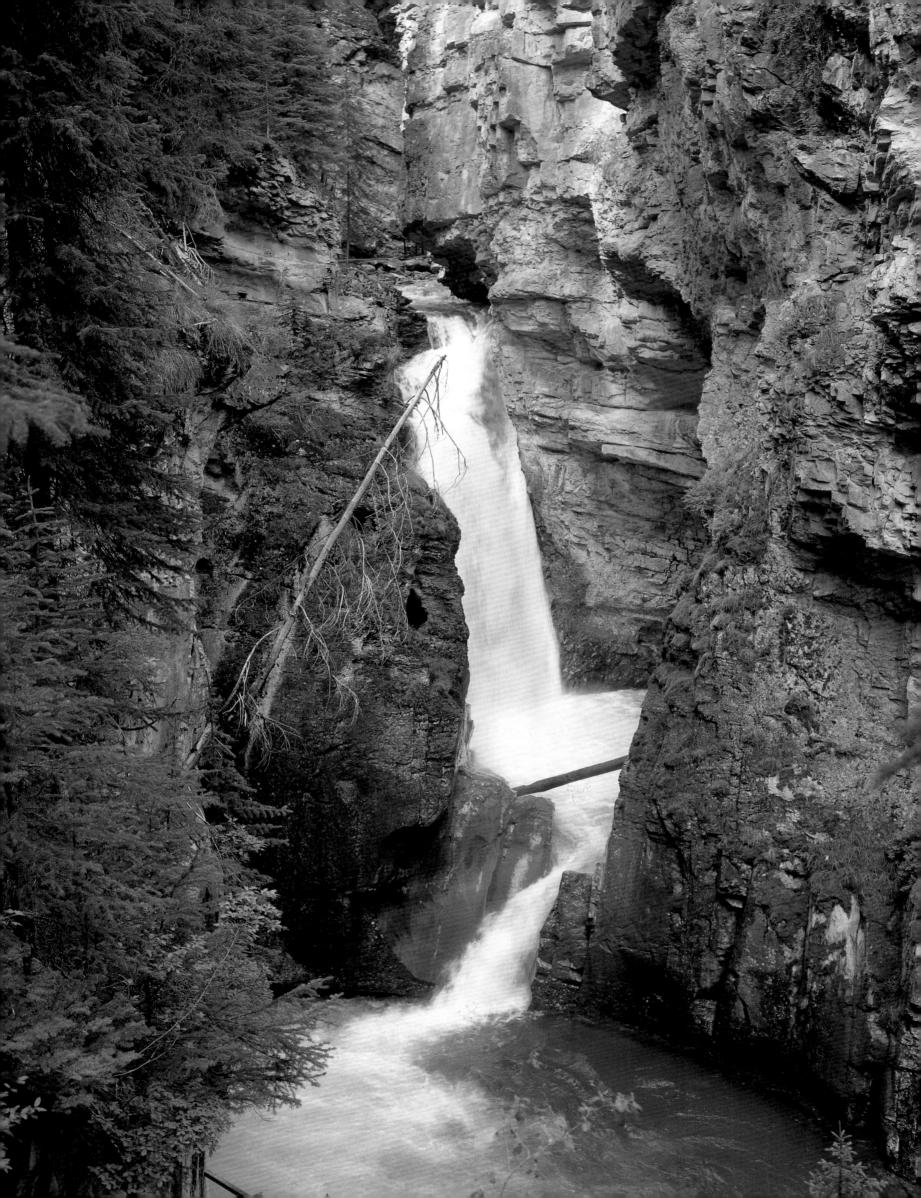

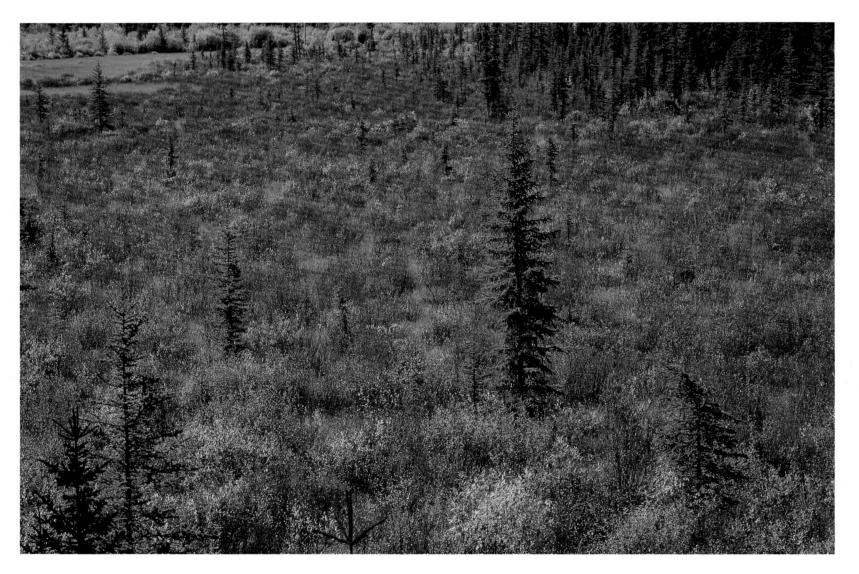

Autumn Muskeg at Muleshoe

Muskeg in summer sings with mosquitoes. Then these boggy lands along the Bow River hold little appeal, except for the birdwatchers who find a host of bug-eating birds here. But with the killing autumn frosts, the insects go to ground and these shrublands go van Gogh.

Right: Castle Mountain

his 2766 m/9076 ft landmark may be the best named peak in the Canadian Rockies. In 1858 Dr. James Hector of the Palliser Expedition named it as soon as he saw it, standing alone, guarding the upper Bow Valley. Geologists see it as a slice of limestone and quartzite layer cake, sheared thin by Ice Age glaciers on both sides.

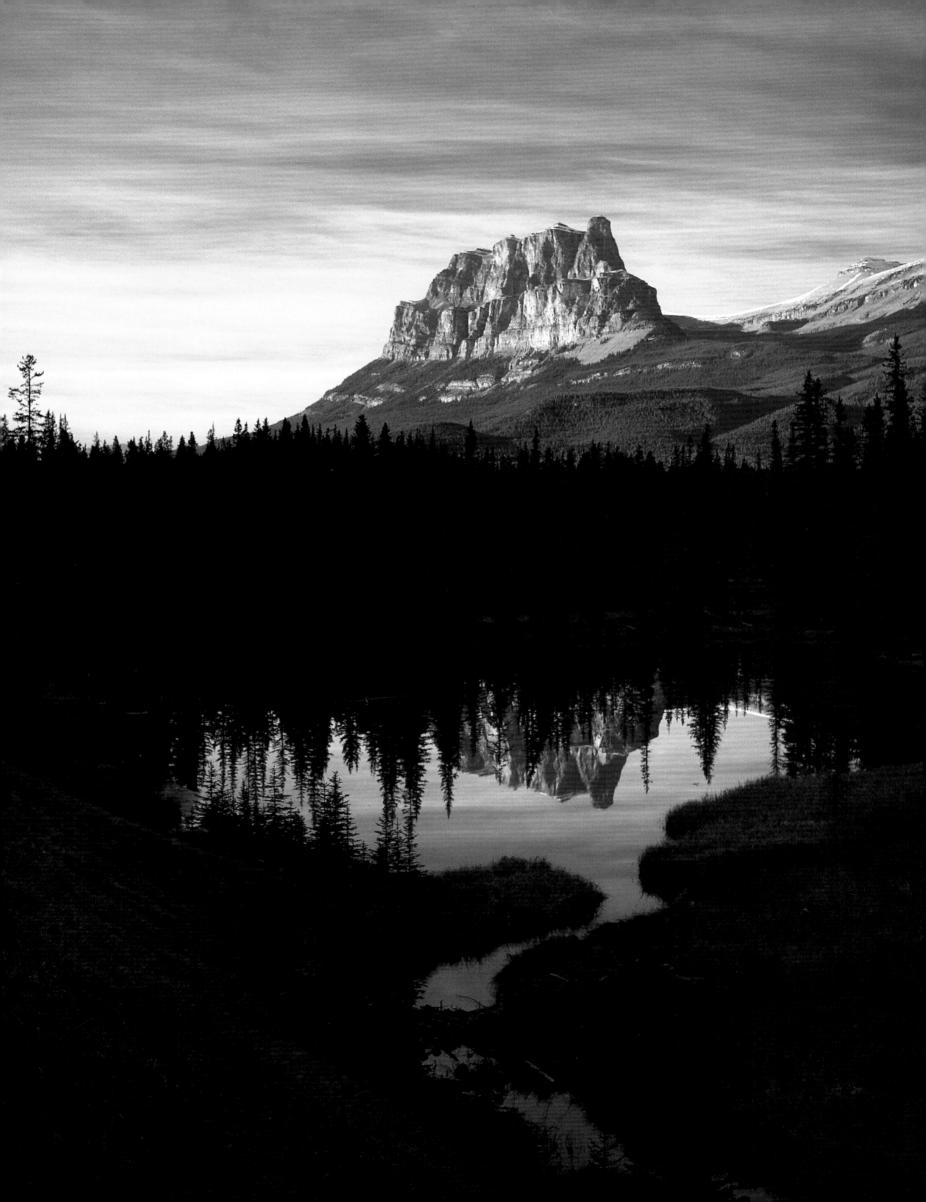

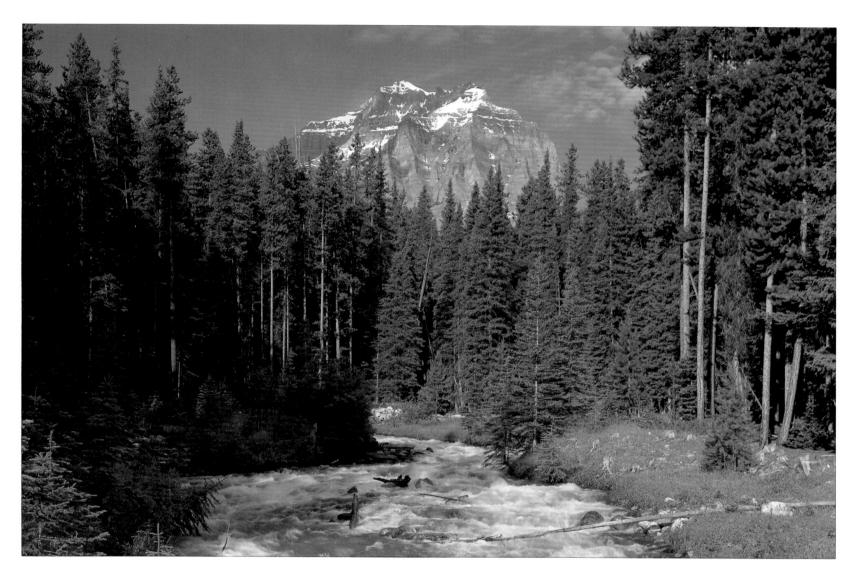

Mt. Temple, Moraine Creek

At 3543 m/11,621 ft, the highest peak in the Bow Range looks like a temple – but it was actually named for a British economist. The creek flows from Moraine Lake in the Valley of the Ten Peaks.

Left: Eisenhower Peak, Castle Mountain

In 1946 Castle Mountain was renamed Mt. Eisenhower in honour of the World War II commander of the Allied forces in Europe (and later the 34th President of the United States). It was obviously still a castle; in 1979 the original name was restored and this 2752 m/9007 ft east tower became Eisenhower Peak.

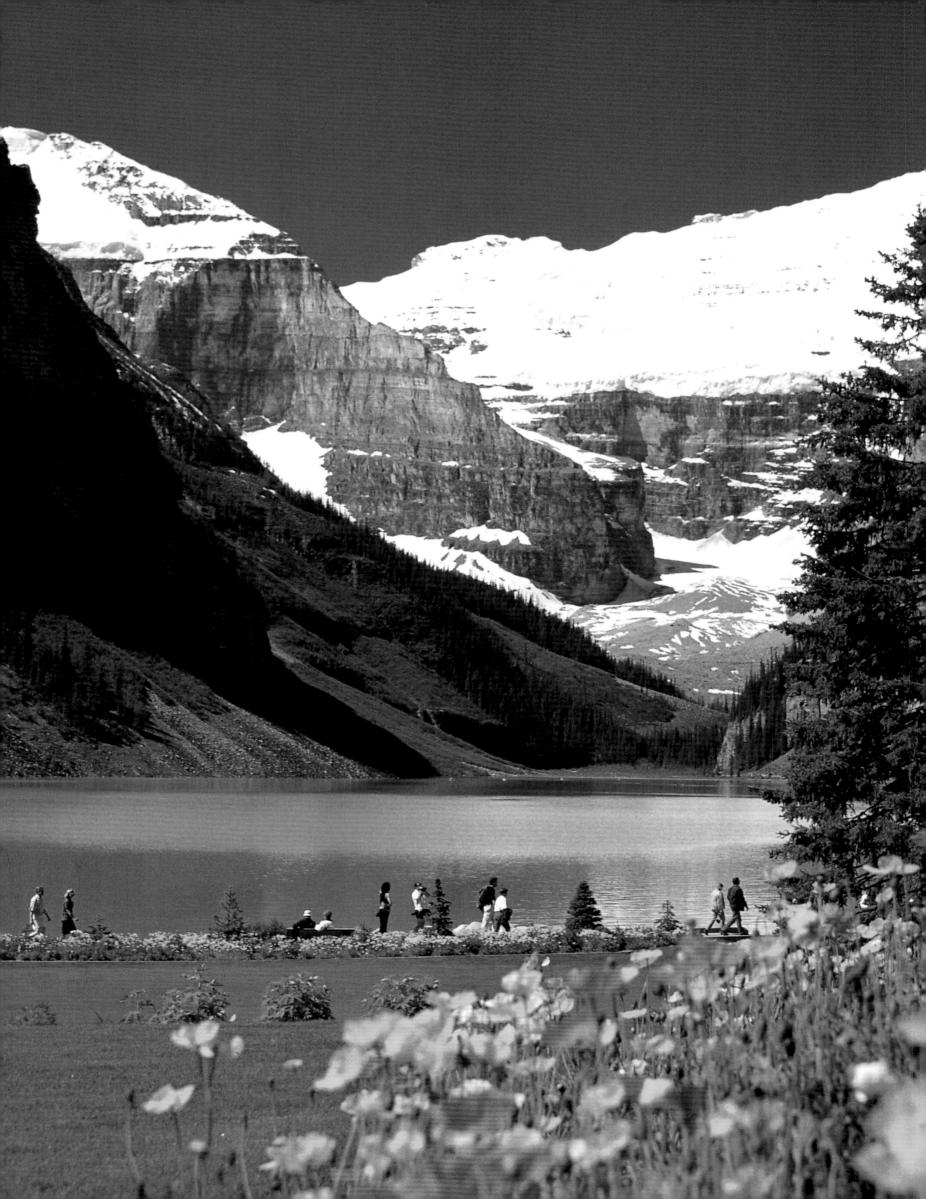

LAKE LOUISE

"No painting or photograph can prepare you for the real place."

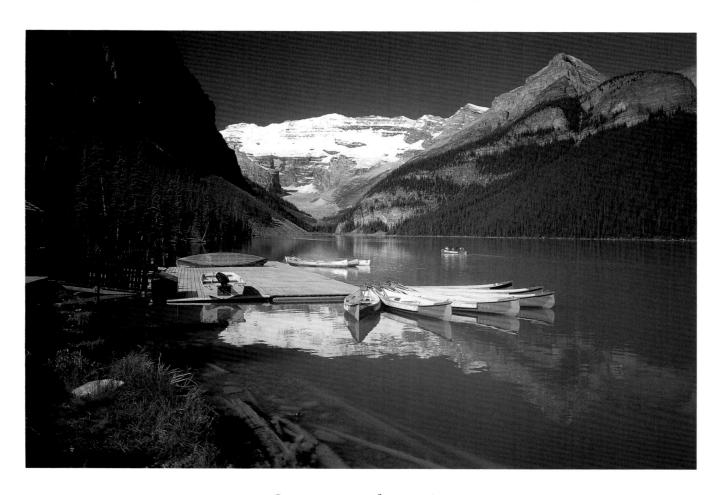

Canoes on Lake Louise

In the clear mountain air it may be hard to believe that 3464 m/11,365 ft Mt. Victoria is really 9 km/6 mi away from Lake Louise – until you hear the rumble of an avalanche *after* you see it falling from the Victoria Glacier.

Left: The Grounds at Chateau Lake Louise

Le Chateau Lake Louise has one of the world's great mountain views and its owners have always taken great pride in creating a fabulous floral foreground to accent it. Icelandic and Oriental poppies have been splashing colour on this scene since the turn of the century.

Jewel of the Mountains

here are two lakes that every visitor touring the Canadian Rockies really should see, pressing schedule or not: Lake Louise and Moraine Lake. Not visiting them is like going to the Grand Canyon and not looking over the edge. Fortunately, both of these world-famous lakes are accessible by road, and they're just 16 km/10 mi apart. Unfortunately, if you *are* in a hurry you'll probably be late – this is scenery to savour, complemented by trails that tempt you to explore.

Among the countless accolades given to Lake Louise, "the Mona Lisa of the Mountains" fits her best. This classic composition of ice, rock, forest, water and clouds is a natural masterpiece that has a stunning impact on every pilgrim who reaches its shores. No painting or photograph can prepare you for the real place. In the early days of tourism here, the Canadian Pacific Railway was even accused of colouring the water and erecting fake glaciers – the scene simply looked too good to be true. But Lake Louise is real and this Mona Lisa is alive, dynamic, and ever-changing with the season, the weather and each hour of the day.

This famous lake has attracted tens of millions of admirers over the years, and the shore below the Chateau Lake Louise is a very busy place on a summer afternoon. To experience Lake Louise at her glorious best, go at dawn. The shoreline is quiet but for the songs of spring birds resounding from this amphitheatre and the lake is almost always glass calm. Each dawn brings a unique transformation of colour and mood.

Guests at the Chateau Lake Louise have been enjoying this magical scene ever since the Canadian Pacific Railway built the first log hotel in 1890. While some are content to contemplate the lake's looming backdrop, others come to climb it. On August 3, 1896 Philip Abbot, a renowned American climber making an attempt on Mt. Lefroy (the 3423 m/11,227 ft peak to the left of Mt. Victoria), became the first climbing fatality in the Canadian Rockies. His death provoked an international debate about this new sport and brought a new era of mountaineering to the Rockies. These summits were clearly an irresistible challenge, so the railway imported professional Swiss guides to lead climbers safely to them.

Lake Louise sits in a hanging valley above the Bow Valley, one of several scooped out of the Bow Range by the huge glaciers that flowed down from the Great Divide in past ice ages. Lovely Moraine Lake lies in the Valley of the Ten Peaks to the south. This valley was first seen and named in 1893 by Samuel Allen, a young Yale University student, while he was looking for a route up 3543 m/11,621 ft Mt. Temple. Moraine Lake was named for the large pile of lichen-covered boulders which dams it. This looks like a moraine - that is, a pile of rubble bulldozed here by an advancing glacier - but it may actually be a huge rockfall from the 3101 m/10,171 ft Tower of Babel above. Either way, it provides a superb viewpoint and habitat for the golden mantled ground squirrels, chipmunks and pikas who entertain all who come here.

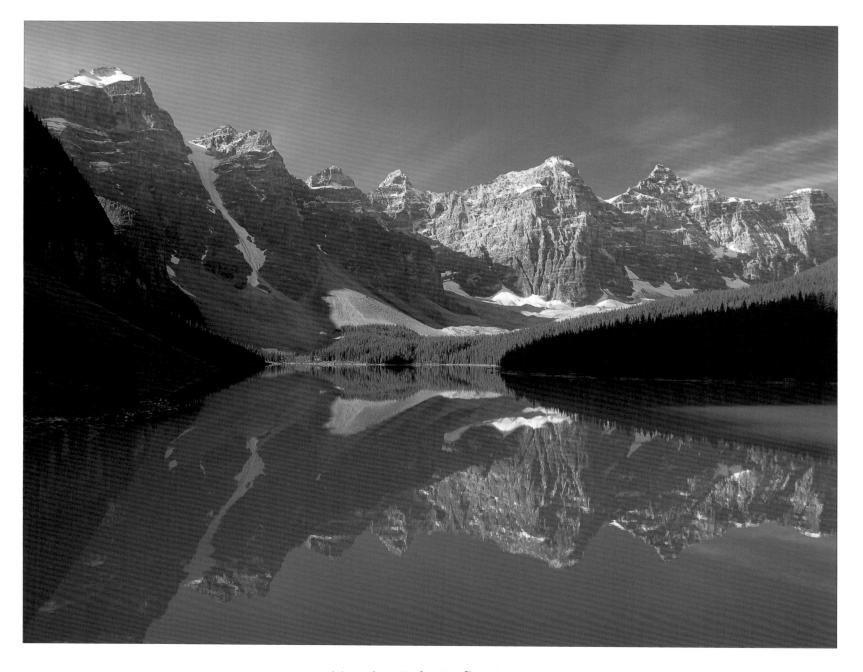

Moraine Lake Reflections

his turquoise blue jewel set against the serrated spine of the Great Divide is part of Canada's most familiar mountain landscape, as portrayed on the back of the twenty dollar bill. The mountains are called the Wenkchemna Peaks, or sometimes the Ten Peaks.

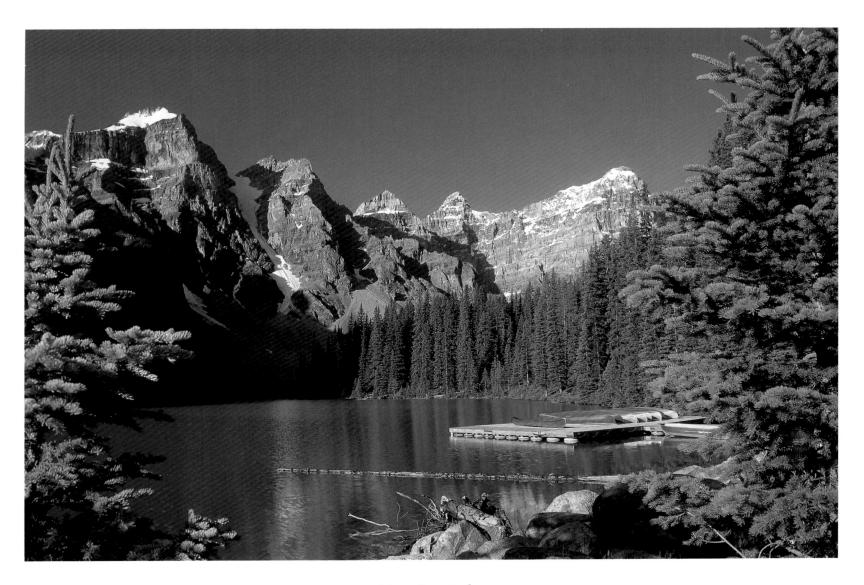

Moraine Lake

Canoes await paddlers below the new Moraine Lake Lodge. Others walk the forested shoreline trail or hike up to Larch Valley, and serious climbers scale the Wenkchemna Peaks looming above the lake. Most visitors are content to simply sit and stare.

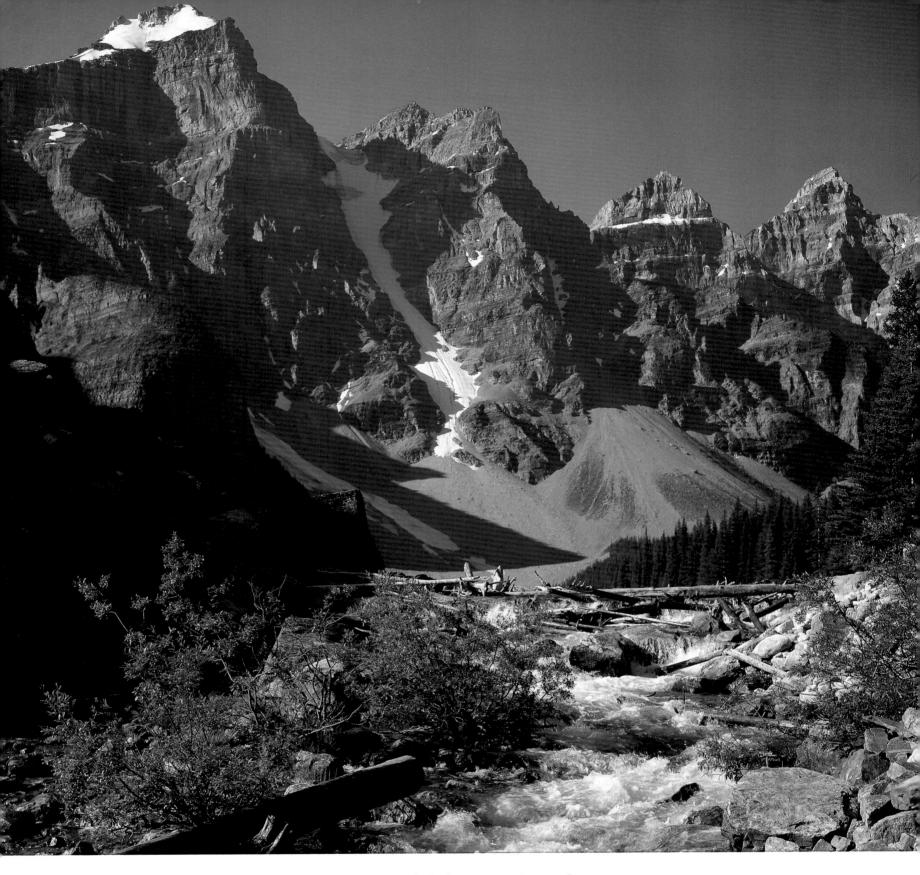

Moraine Creek below Moraine Lake

Levery year water and ice carry off a little more of the Wenkchemna Peaks. Most of the glacial silt settles out in Moraine Lake, leaving this creek crystal clear and full of aquatic insects. Harlequin ducks nest downstream and plump gray dippers are often seen foraging in the riffles here.

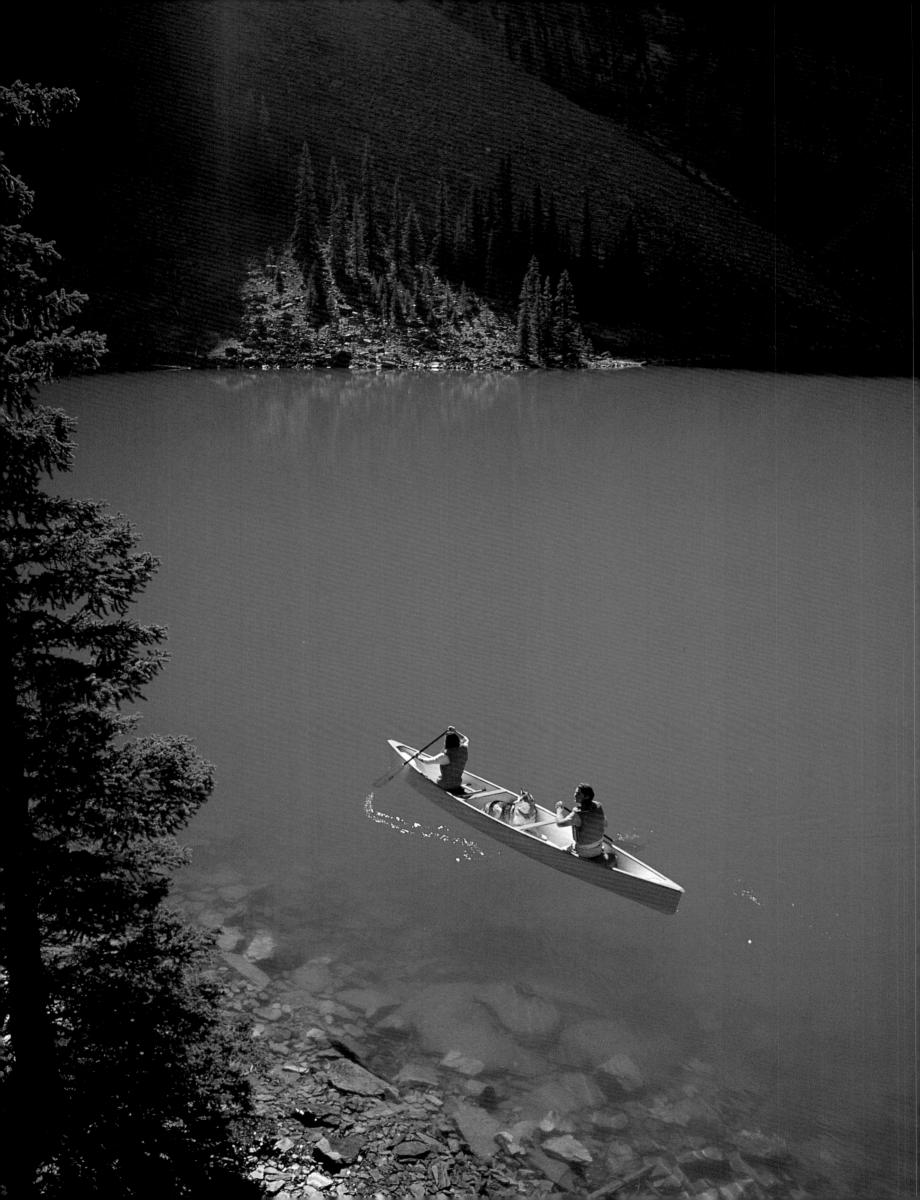

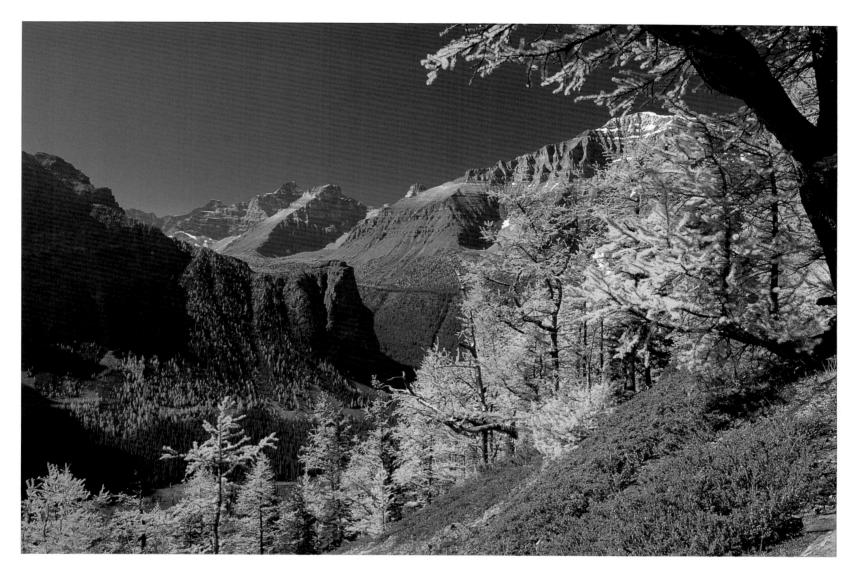

Alpine Larches on Panorama Ridge

his well named ridge above Consolation Valley provides a view north across the Valley of the Ten Peaks to 3542 m/11,618 ft Mt. Temple (right) and 3067 m/10,060 ft Pinnacle Mountain above Larch Valley and Moraine Lake (hidden behind the Tower of Babel ridge). The colourful larch trees attract many late September hikers.

Left: Canoe on Moraine Lake

You almost need to touch this water to believe it's real. Floating, reflective particles of glacial silt give these mountain lakes their unearthly glow.

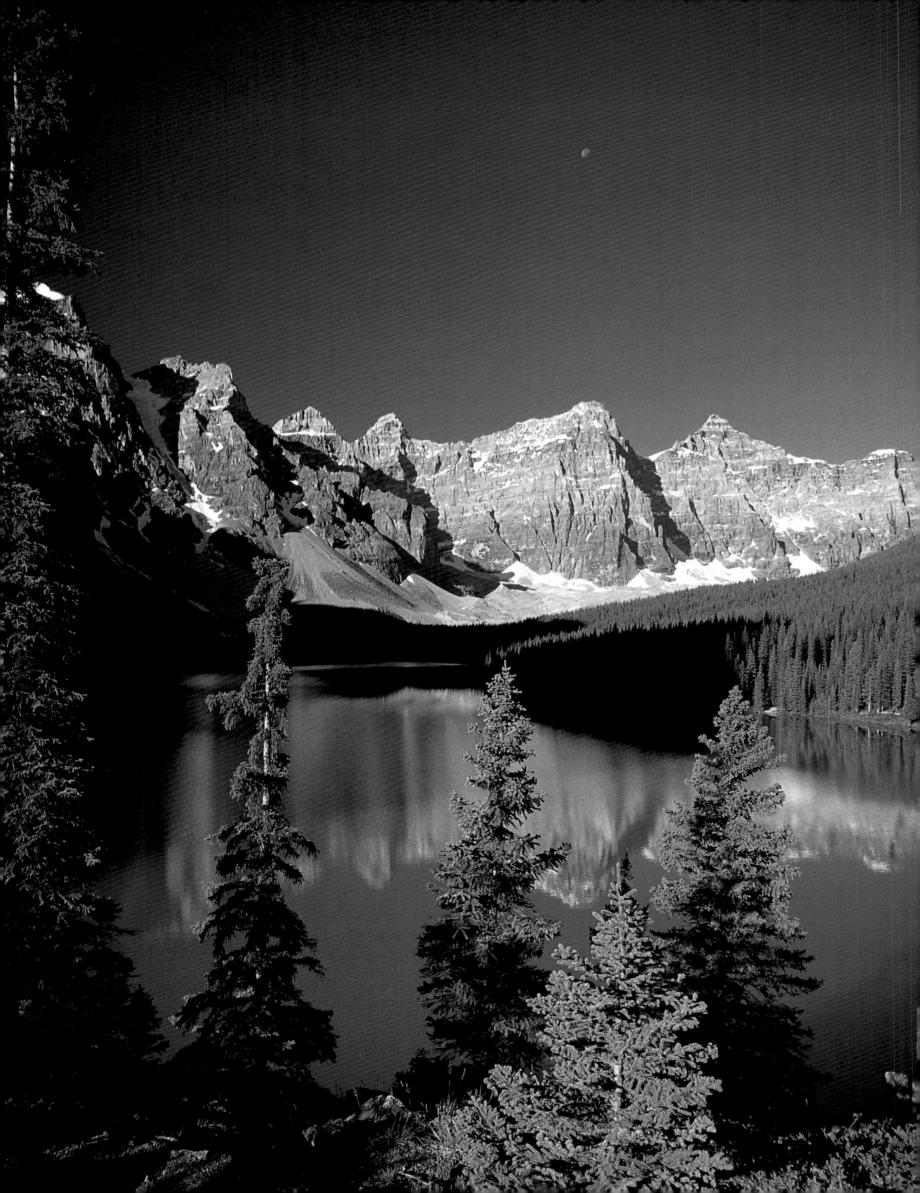

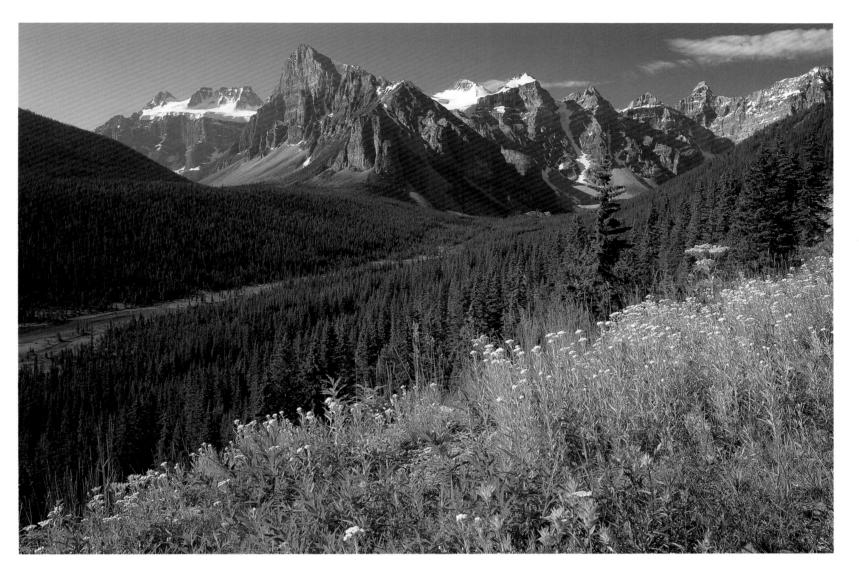

Valley of the Ten Peaks

This is the first panoramic view from the Moraine Lake Road. Moraine Lake lies hidden at the head of the valley, below the Wenkchemna (Stoney Indian for "ten") Peaks. Directly across, glacier-draped 3084 m/10,119 ft Bident Mountain and 3104 m/10,185 ft Mt. Babel tower above the Consolation Lakes Valley.

Left: Moraine Lake

Walter Wilcox, the first European visitor to this lake, named it Moraine on the assumption that its waters are dammed by a moraine deposited by the Wenkchemna Glacier – a manner in which many other lakes in the Rockies have been formed. Now experts believe the Moraine Lake rockpile was actually deposited by a rockslide from the cliffs to the south.

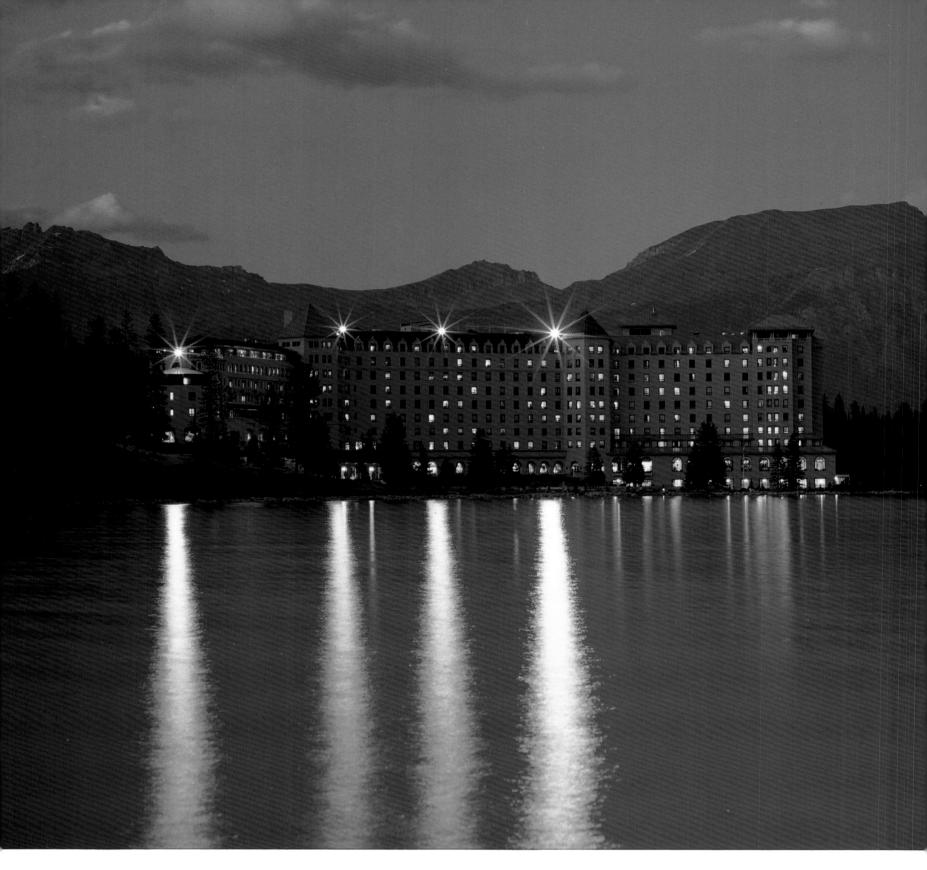

Evening at Chateau Lake Louise

Trowing from a log chalet in 1890 to a grand hotel in the Roaring Twenties, the Chateau celebrated its centennial with a major renovation and the completion of its third wing, built to the original plans. The Slate Range rises across the Bow Valley.

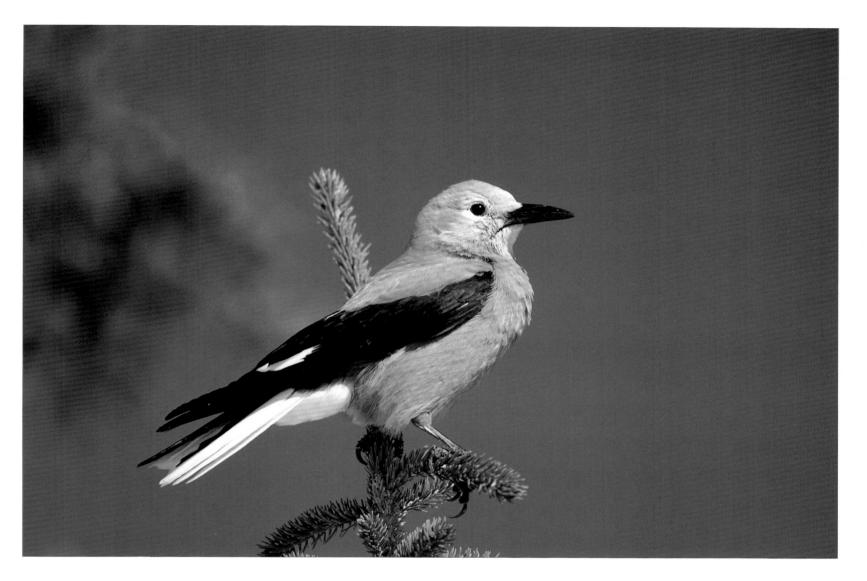

Clark's Nutcracker

This bold, raucous bird uses its sharp beak to pry whitebark pine seeds from their cones and caches them in rocky niches for winter use. Though it has an extraordinary memory, it does miss some seeds – which grow into the trees seen struggling to survive high on barren cliffs. This bird is often mistaken for a "whiskey jack" (Gray Jay), which has a smaller beak and quieter demeanour.

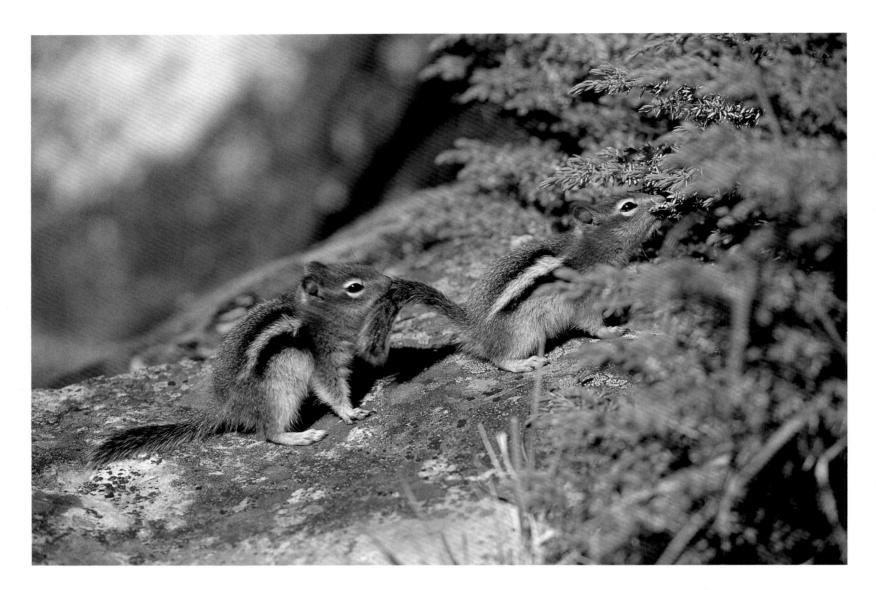

Golden Mantled Ground Squirrels

Often called "giant chipmunks," these ground squirrels lack the white facial stripe that distinguishes that tribe. At home in rocky areas from valley bottoms to alpine summits, particularly tame colonies can be found at the west end of Lake Louise and at Moraine Lake.

Right: Lake Louise

It was a cloudy June day in 1882 when railway guide Tom Wilson first saw this incredible view. He was lured up to this hanging valley by the rumble of icefalls thundering off the Victoria Glacier, and guided there by Stoney Indians who called it "the lake of little fishes."

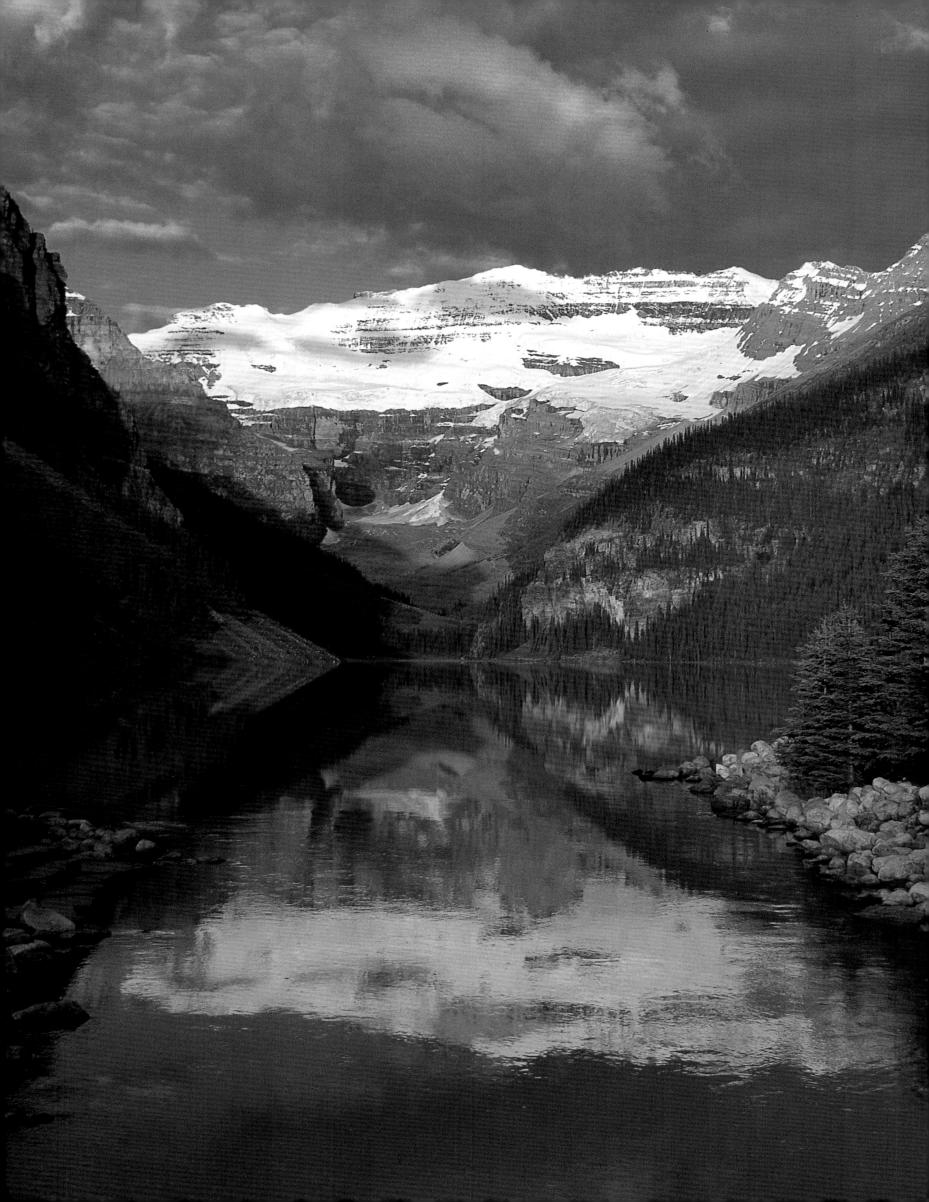

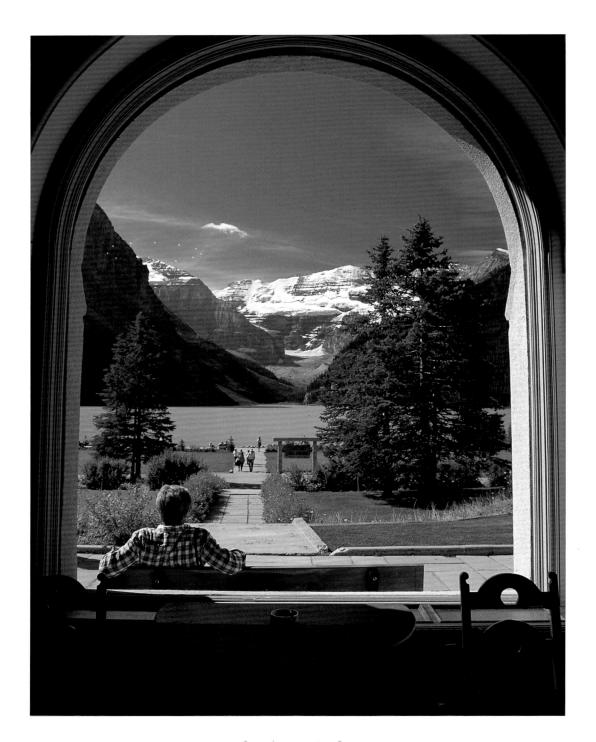

Chateau Window

Guests at the Chateau Lake Louise enjoy accommodation with a world famous view of the lake.

Right: Lake Agnes Teahouse

As the summit of a steep 3.4 km/2.1 m trail above the Chateau Lake Louise, this historic teahouse rewards hikers to the "lake in the clouds" with some of the most famous baking in the Rockies. Mt. Niblock rises behind the tarn and hanging valley.

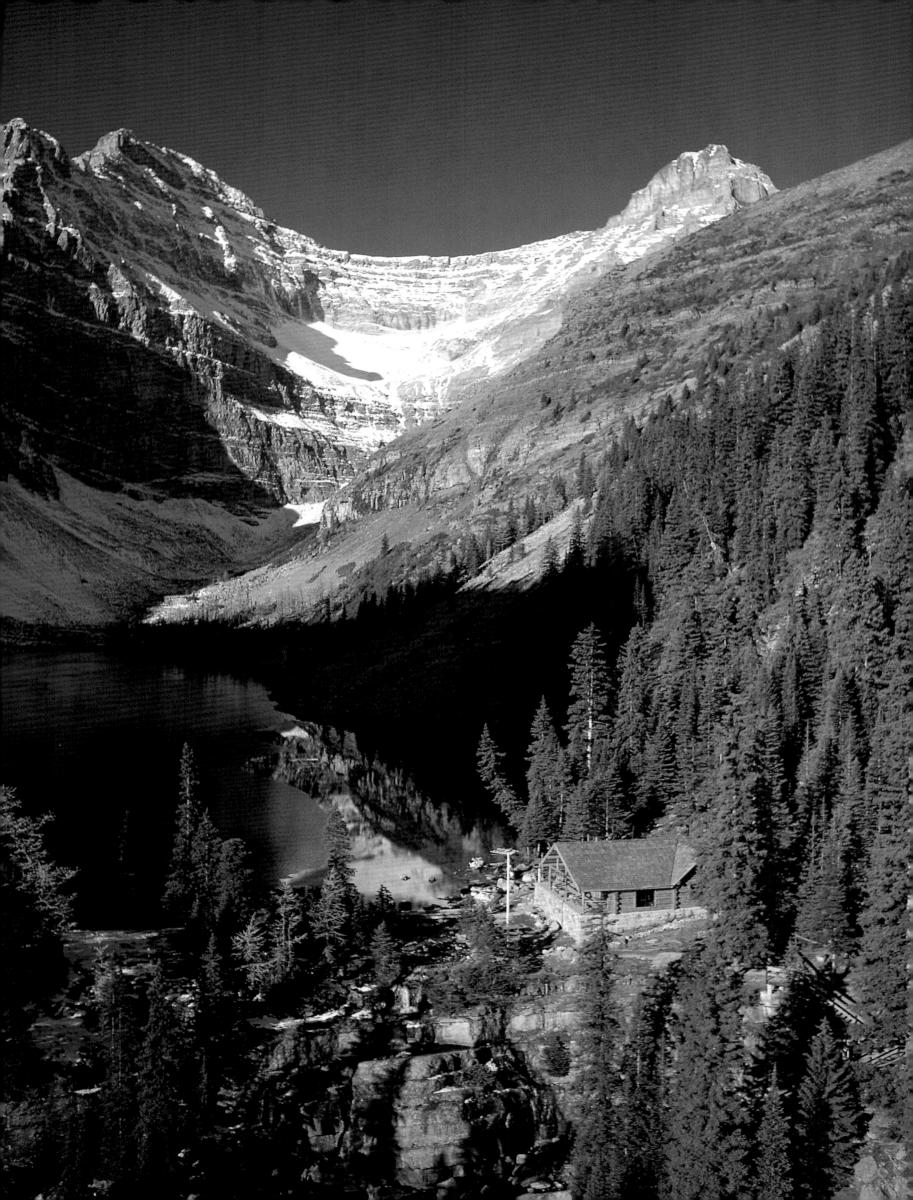

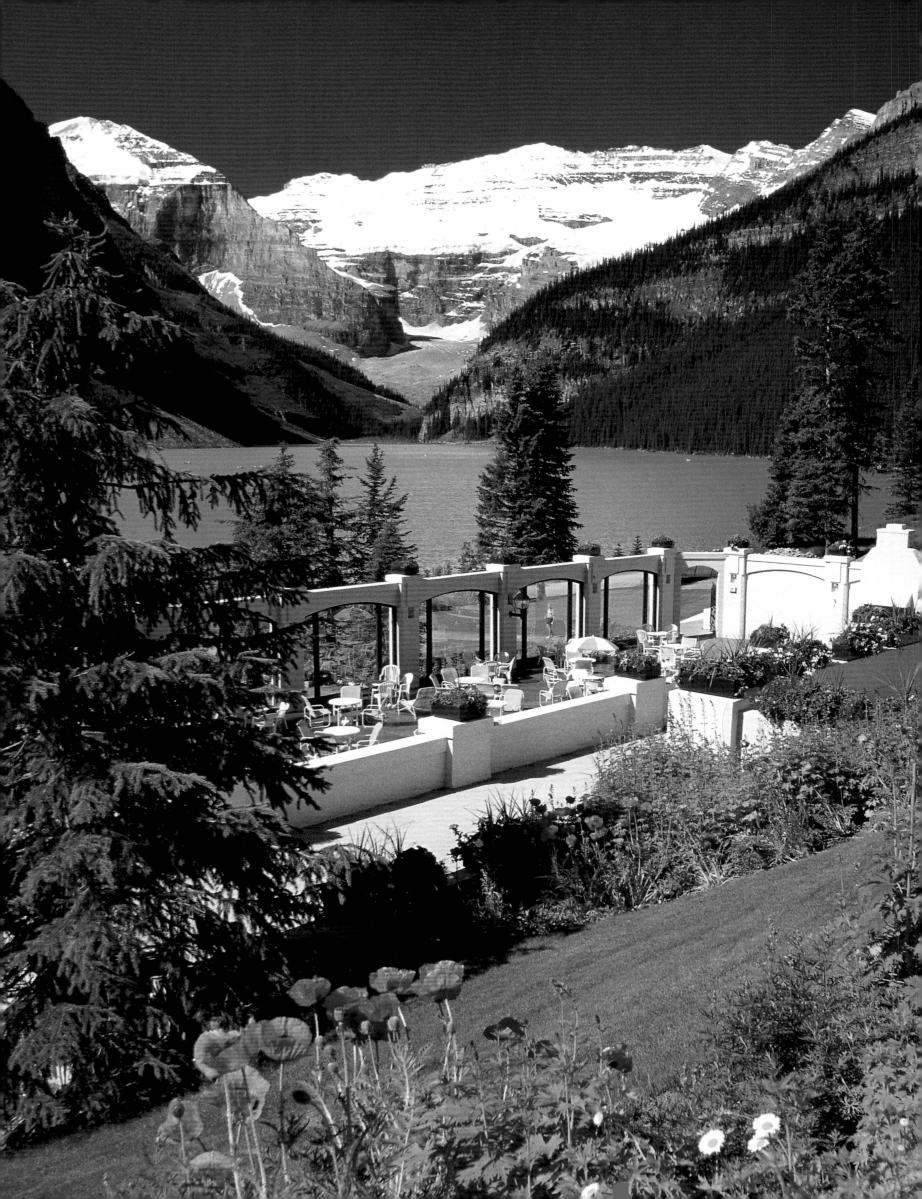

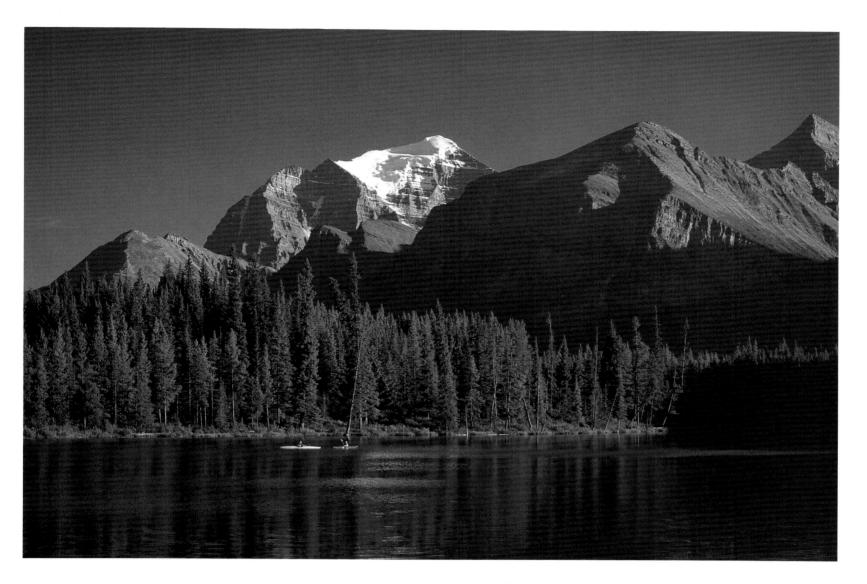

Kayaks on Herbert Lake

For people who like outdoor sports, these mountains are a playground. Here kayakers practice their skills in the calm waters of Herbert Lake before running the glacier-fed whitewater of the Bow River. Across the Bow River valley stands the cluster of peaks that shelter Lake Louise.

Left: At Lake Louise

Lhis sheltered alcove was once an outdoor swimming pool. Visitors lounge here in the sun and fresh air, watching the walkers, hikers, and climbers coming and going on the lakeshore trail.

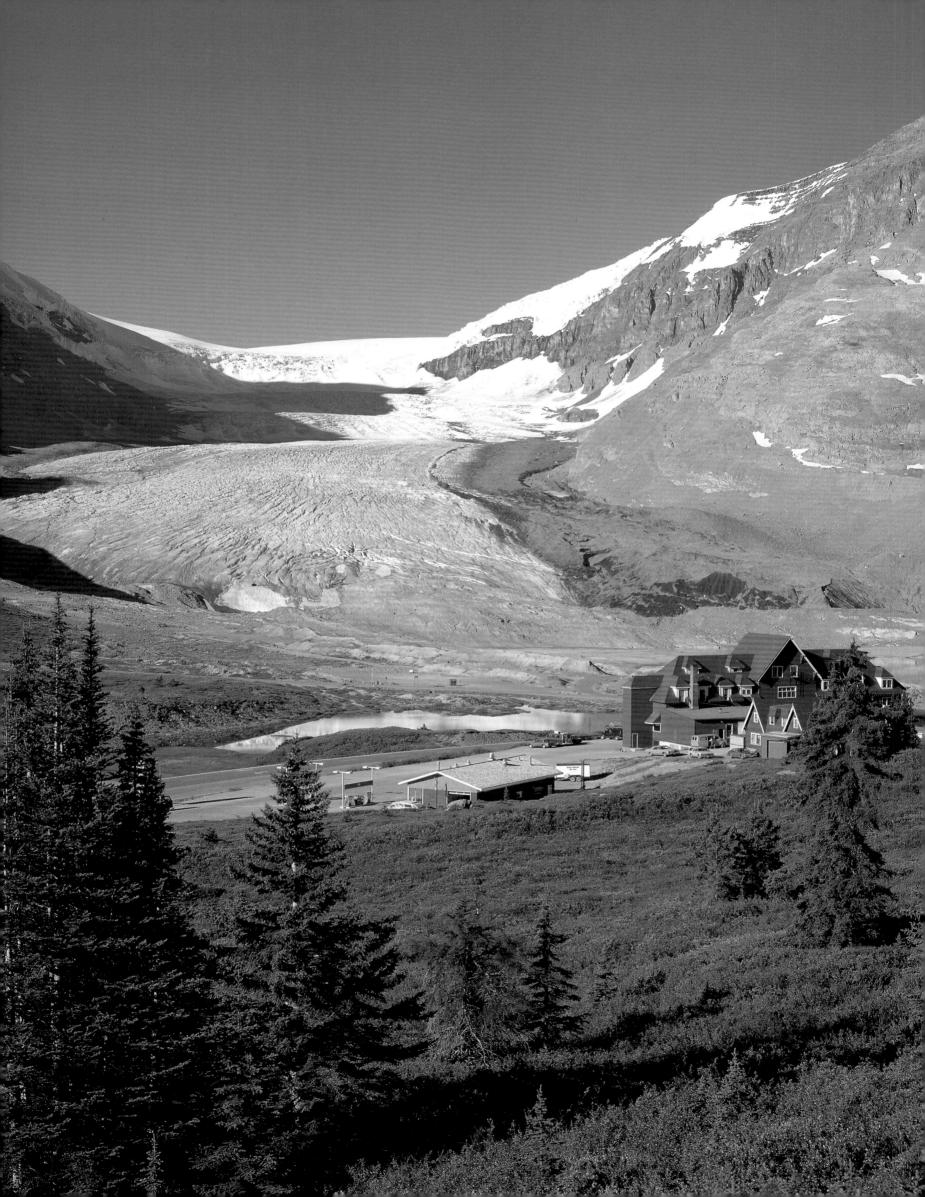

THE ICEFIELDS PARKWAY

"This is arguably the most spectacular highway on the continent."

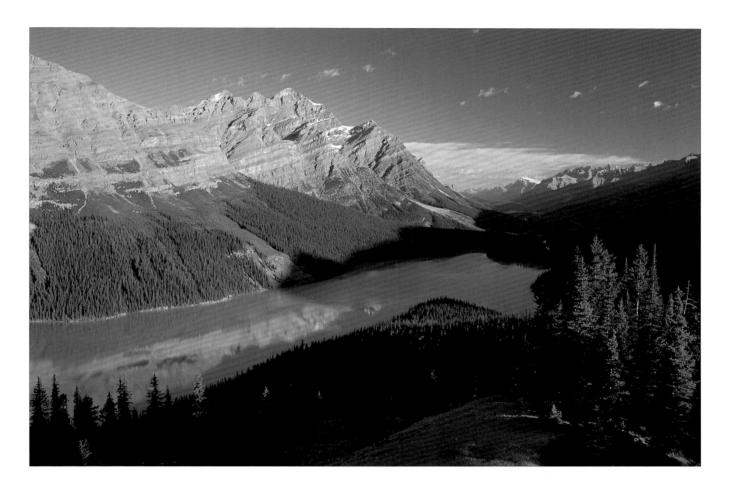

Peyto Lake Overlook

The incredibly blue lake 250 m/820 ft below this famous viewpoint changes colour through the summer, as the spring torrent of glacial silt carried into it from the Peyto Glacier gradually settles out. The distinctive Ushaped Mistaya Valley is in view north of the lake.

Left: Columbia Icefield

Columbia Icefield sprawls on the Great Divide in both Banff and Jasper National Parks. One tongue of ice, the Athabasca Glacier, flows down between 3450 m/11,319 ft Mt. Andromeda and 3520 m/11,546 ft Snow Dome. A century ago the glacier's snout pushed as far as the highway.

The Wonder Trail

he Icefields Parkway between Lake Louise and Jasper is the longest drive in the national parks and arguably the most spectacular highway on the continent. It is a 230 km/143 mi tour of the Continental Divide that travels past a mesmerizing procession of glacier-draped peaks, the Columbia Icefield, rushing rivers, waterfalls, perfect lakes, subalpine meadows, wild forests and wild-life. Completed in 1940, the Parkway was build specifically for sight-seeing. Cyclists stretch it out, stopping at campgrounds and hostels along the way. Others use the Parkway, the only access into this vast wilderness, as a first leg for backcountry adventures.

The Columbia Icefield is the most famous destination on this route. Sprawling along the spine of the Rockies in both Banff and Jasper National Parks, this immense 325 sq km/125 sq mi icecap on "the roof of the continent" feeds rivers that flow into the Atlantic, Pacific and Arctic Oceans. It was discovered on August 18, 1898, after a 19 day pack trip from Lake Louise, by two American climbers who saw it from the 3491 m/11,450 ft summit of Mt. Athabasca.

This frozen ocean can still only be seen by hikers and mountaineers, but just north of 2035 m/6675 ft Sunwapta

Pass in Jasper National Park, there are spectacular roadside views of its margins. The Athabasca Glacier, one of the icefield's eight tongues, pushed into the valley. It's a short walk to the glacier's blue nose or you can take a snowcoach tour or guided hike up onto it for a real taste of the Ice Age.

Hiking above the Icefields Chalet towards Wilcox Pass, there are panoramic vistas of more of the icefield and the giant peaks around it, and visitors often spot bighorn rams and golden eagles. On top of nearby Parker Ridge, you can look at the Saskatchewan Glacier while sitting on an ancient coral reef – and try to imagine the forces that have lifted this sea bed into the clouds.

From Lake Louise the Parkway climbs above the Bow River to its source at Bow Lake, which is fed by the Crowfoot and Bow Glaciers, below 2069 m/6786 ft Bow Pass. With the historic red-roofed Num-Ti-Jah Lodge nestled in its shoreline forests, it is a Canadian Rockies classic. Wildlife photographers sometimes find roadside grizzly bears in the meadows and on the summit, and there's the breathtaking viewpoint above too-blue-to-be-true Peyto Lake.

Right: Cyclists at Bow Lake

The Icefields Parkway has become an internationally renowned cycle tour route, with only two major passes to climb and leg-pumping scenery around every corner. Here some cyclists glide past the headwaters of the Bow River and the distant Bow Glacier.

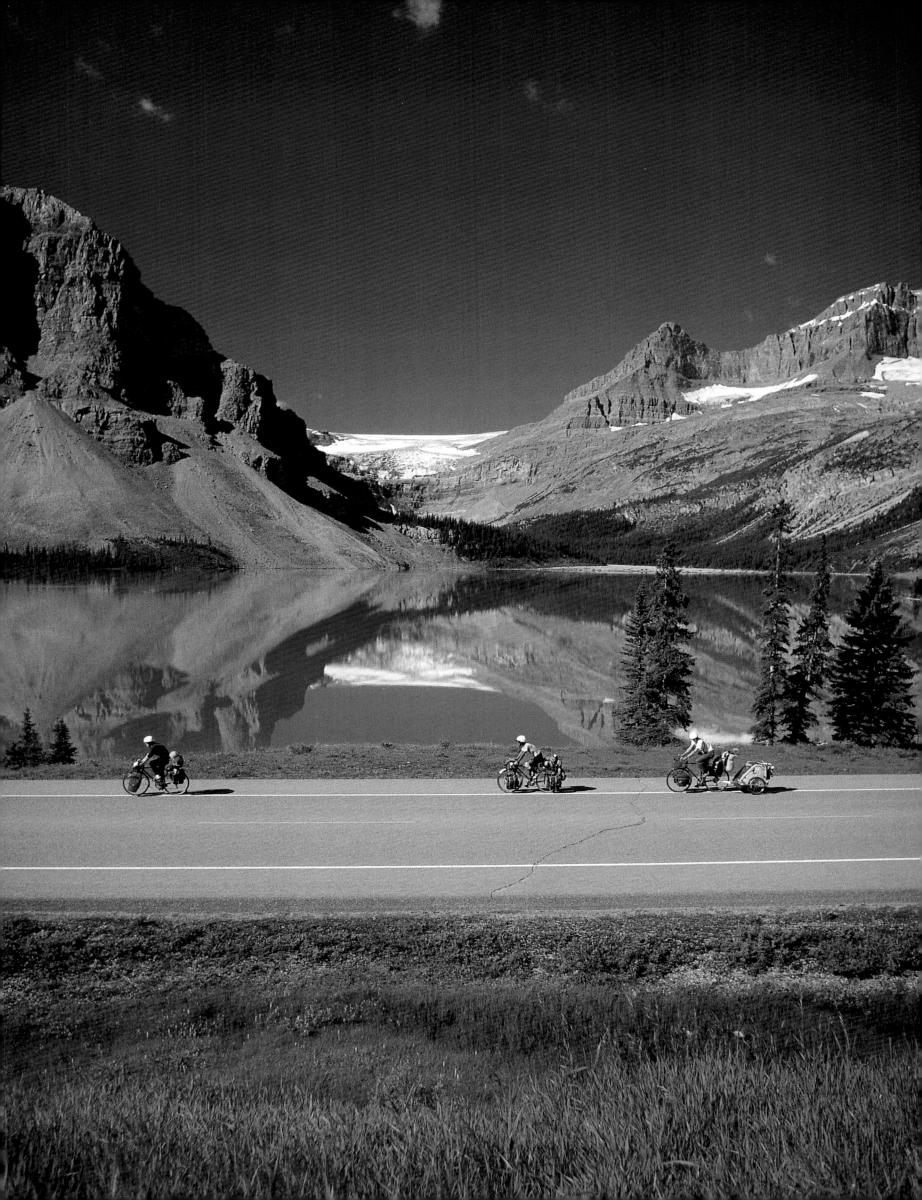

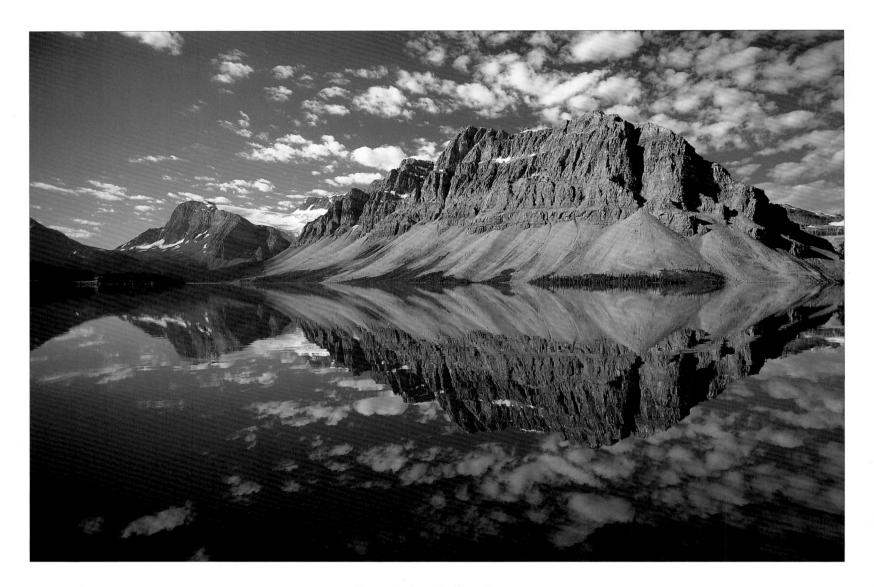

Bow Lake Reflections

Sport fishing for trout is popular at the southern end of Bow Lake, which is one of the larger lakes along the Icefields Parkway. The swampy area at the lake's outlet is a good place to see moose.

Right: Peyto Lake Sunset

From 2069 m/6787 ft Bow Summit, this sweeping view over the glacial blue lake and north down the Mistaya Valley is a popular stop just off the highway. Almost a century ago it was already "too crowded" for Bill Peyto, the eccentric guide for whom the lake is named who camped alone on its shore.

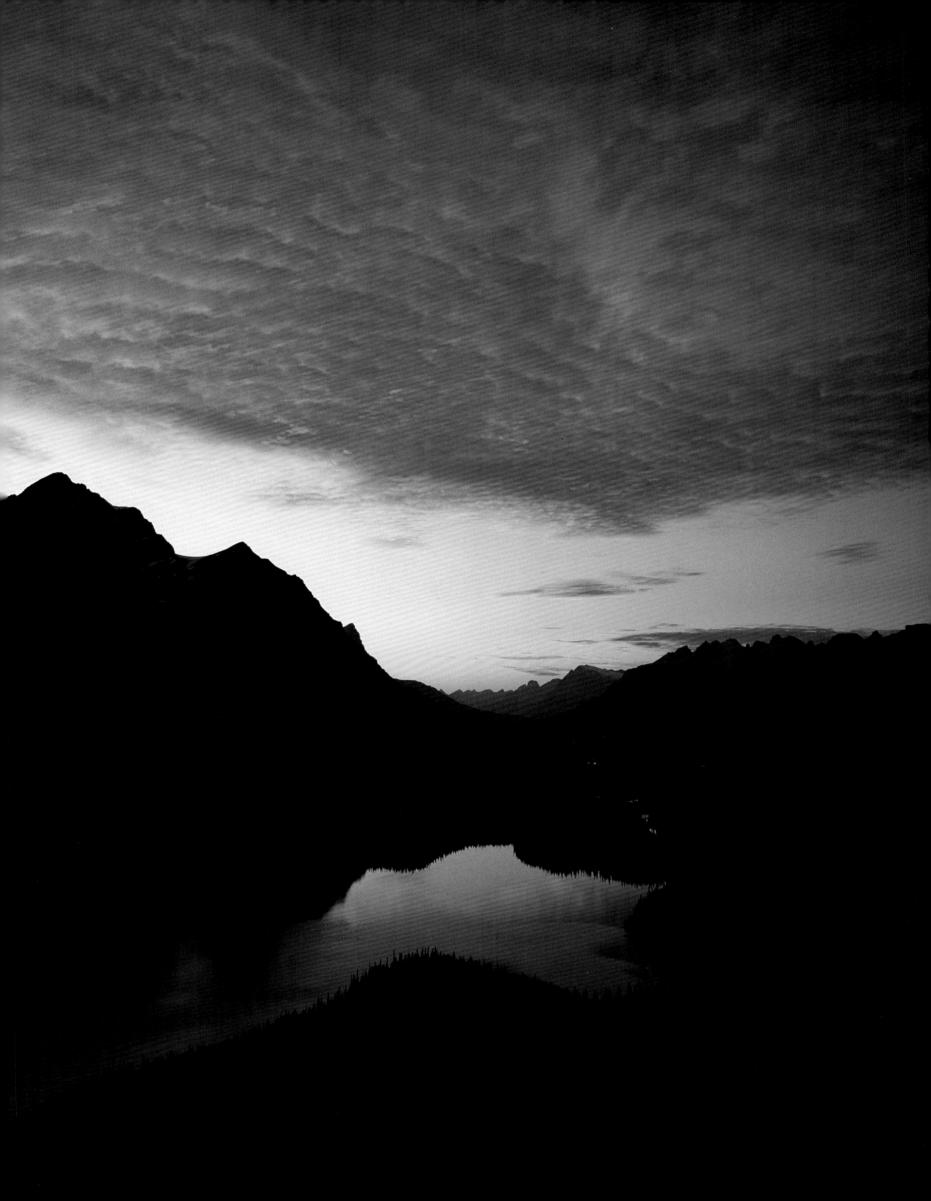

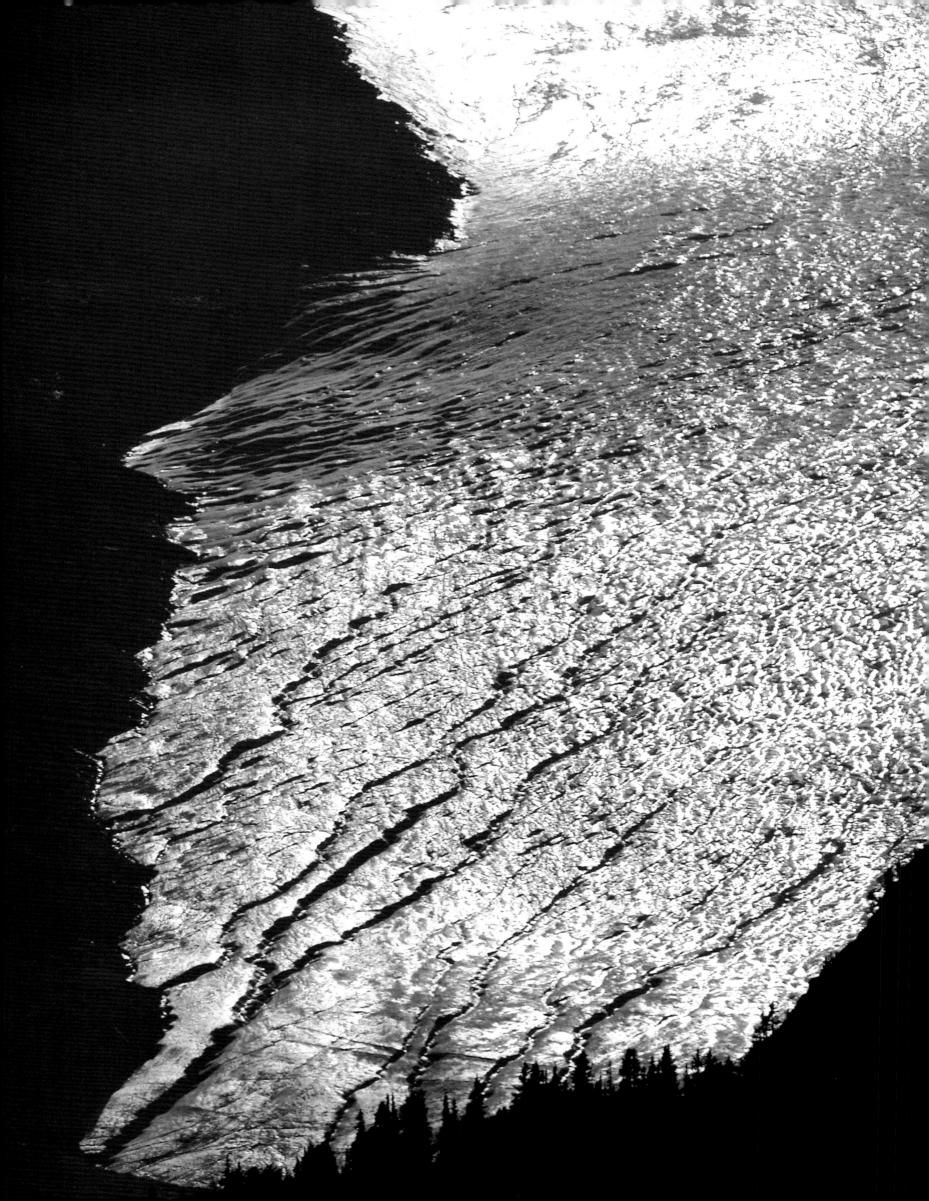

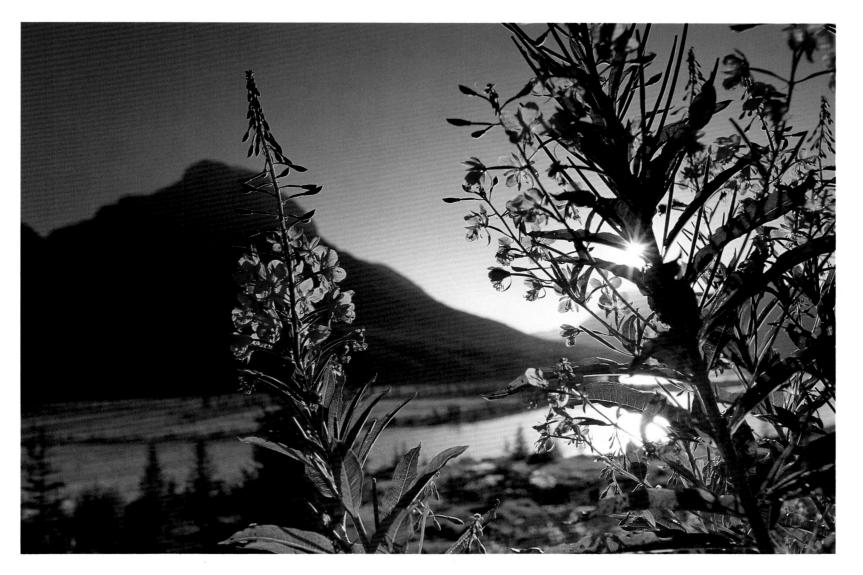

Fireweed along the North Saskatchewan River

Lhese glorious pink flowers are found on disturbed areas like burned forests or the shifting shores of young glacial rivers. A smaller fireweed species with larger blossoms is found on gravel flats at higher elevations.

Left: Toe of Saskatchewan Icefield

One of the eight octopus arms flowing from the Columbia Icefield, this glistening glacier is the source of the North Saskatchewan River.

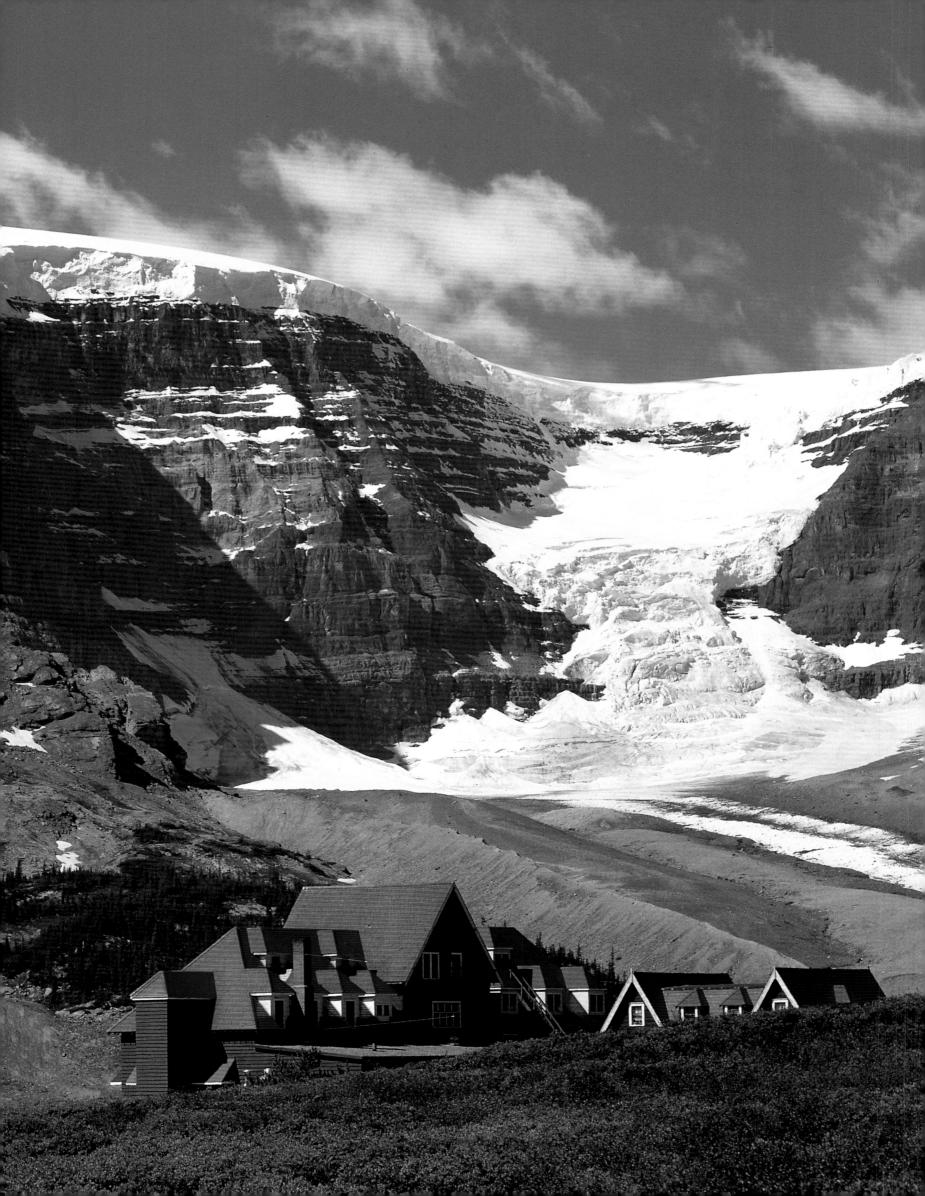

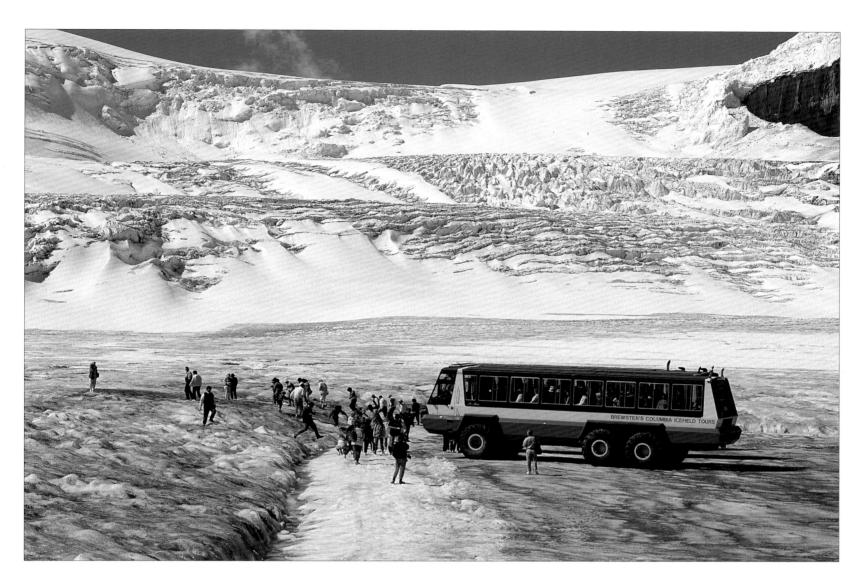

Snowcoach on Columbia Icefield

Every year thousands of visitors take the 5 km/3 mi round trip snowcoach tour up onto the 300 m/1000 ft thick Athabasca Glacier to experience this Ice Age landscape first hand.

Left: The Icefield Chalet and Dome Glacier

Dome Glacier spills off the edge of the Columbia Icefield. The steep roof of the chalet attests to the heavy snowstorms that can blow into this valley off the icebound western summits. Yet above, on the eastern slopes, these same winds sweep the snow off an important winter range for bighorn sheep.

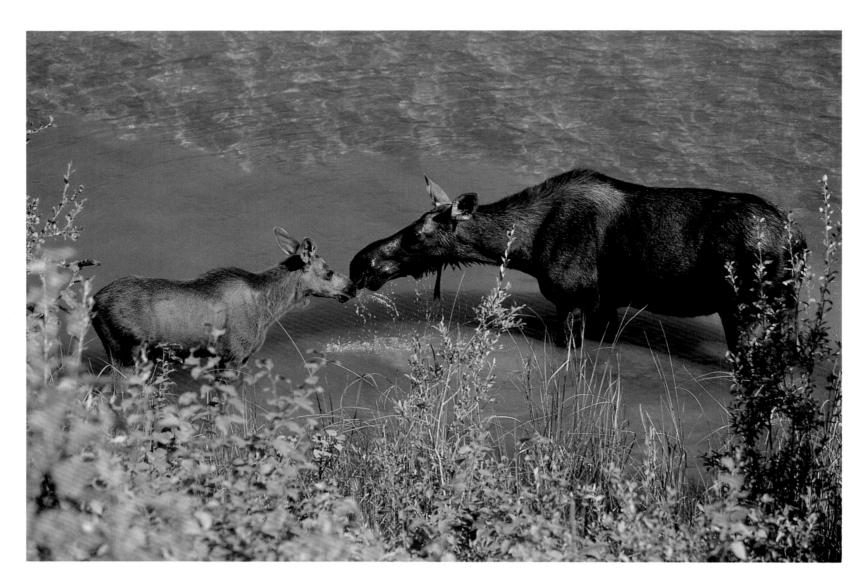

Cow and Calf Moose

Moose are the largest mammals in the Rockies and a cow protecting her calf is a formidable foe to potential predators (and photographers straying too close!). Their long legs carry them through the deep snows of winter and into summer wetlands where their favourite foods grow.

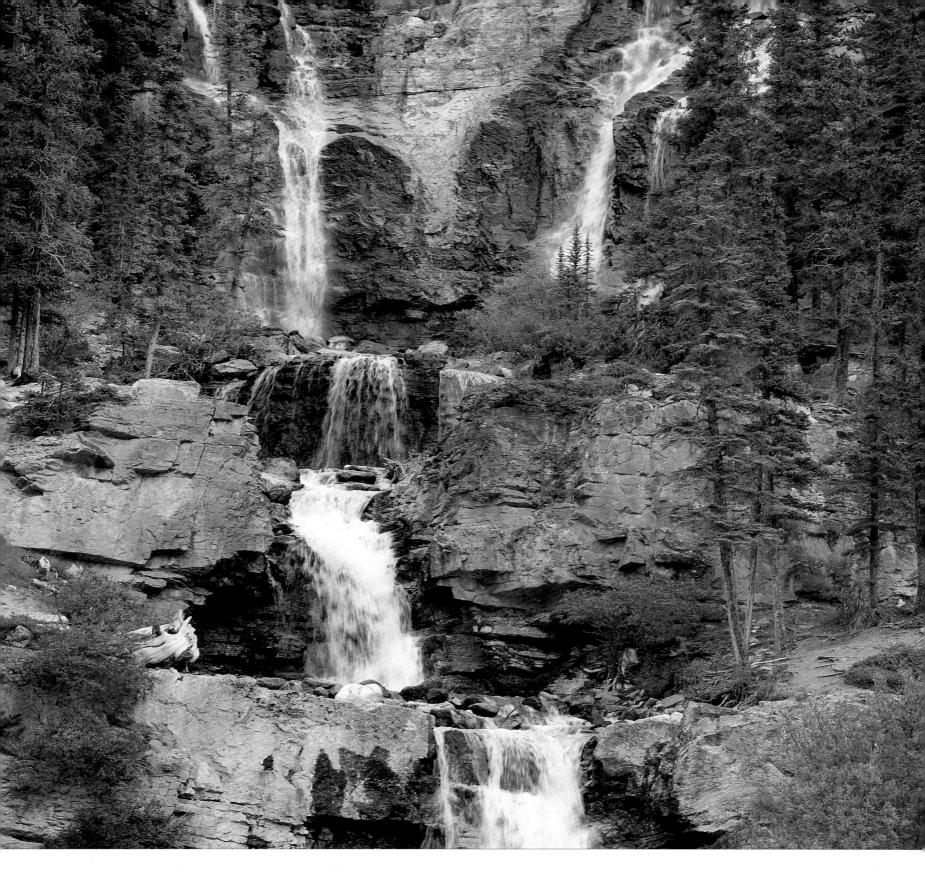

Tangle Falls

Tangle Creek was named by adventurer Mary Schäffer in 1907 when her party had problems bushwhacking down its valley from Wilcox Pass above. A maintained trail now follows her route.

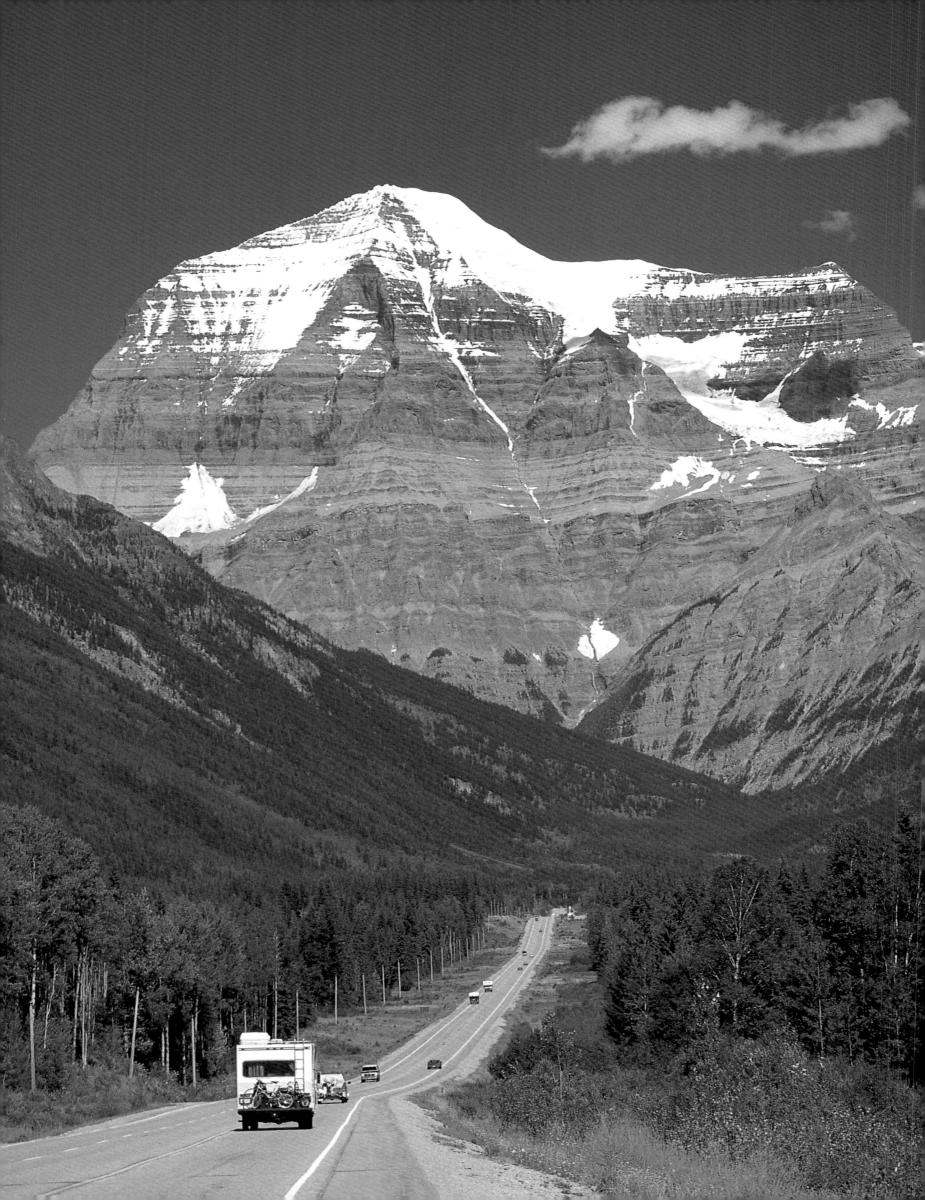

JASPER NATIONAL PARK

"Jasper's tranquility flows from the huge spaces around and within it."

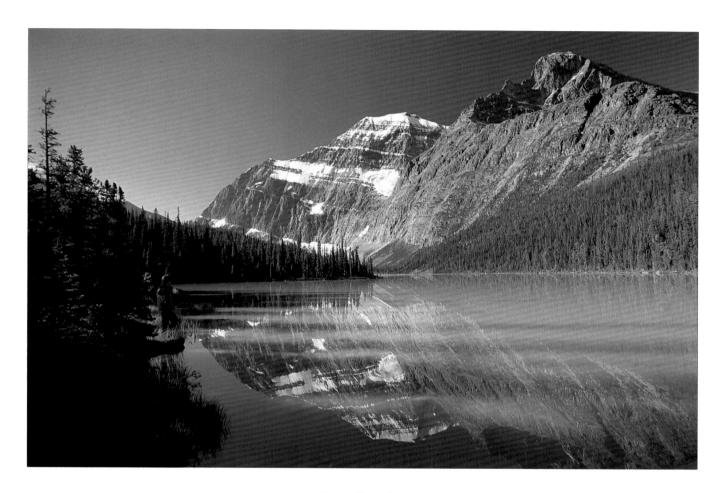

Cavell Lake

In one of the most serenely magnificent settings in the Rockies, 3363 m/11,033 ft Mt. Edith Cavell is mirrored in the calm lake its melting icefields replenish. The pair form a permanent memorial to the heroic World War I nurse for whom they are named.

Left: West Face of Mt. Robson

Its ice-capped 3954 m/12,972 ft summit perennially wrapped in clouds of its own making, this monolith is the highest peak in the Canadian Rockies. From this Fraser River Valley view, it shows almost 3000 m/9800 ft of awesome vertical relief. "The Monarch" was first climbed in 1913 by an Alpine Club of Canada party led by Austrian guide Conrad Kain.

Walking the Wild Side

f you want to catch the attention of Jasper residents, compare their park to Banff. It is a historic rivalry. Banff was a creation of the Canadian Pacific Railway, completed in 1885, and Jasper was on the competing northern line. When it was finished in 1914, Banff's success and Jasper's potential – including the highest peak in the Canadian Rockies, 3954 m/12,969 ft Mt. Robson just over the Yellowhead Pass in British Columbia – were obvious. The Jasper Forest Park had been established in 1907 in anticipation of travellers to come, but the northern railway, still struggling to survive, was slow to start. In 1922 the Canadian National Railway opened the first Jasper Park Lodge, its more peaceful alternative to the Banff Springs.

Jasper's tranquillity flows from the huge spaces around and within it. It is remote from major population centres. Jasper townsite is 362 km from Edmonton, 412 km from Calgary and 805 km from Vancouver. The nearest commercial airport is 76 km east in Hinton; Banff is 287 km south. The town of 4500 is surrounded by 10,878 sq km/4199 sq mi Jasper National Park, the largest park in the Canadian Rockies. To the north is the 4597 sq km/1774 sq mi Willmore Wilderness Park; to the west is 2198 sq km/848 sq mi Mt. Robson Provincial Park; to the south Banff National Park.

You can find real wilderness here, push deep into it or explore its spectacular edges. Trails lead to vast solitudes for days or weeks of backcountry hiking, trail riding, mountain climbing and glacier trekking. Roads lead to Maligne Canyon and Maligne Lake, to the alpine meadows below Mt. Edith Cavell, to Miette Hot Springs, the hottest in the Rockies, and up the Icefields Parkway. There are lakes galore, canoeing, kayaking and whitewater rafting. There's downhill skiing at Marmot Basin and cross-country and ski touring everywhere.

A tramway above Jasper lifts you up onto The Whistlers for a panoramic view and perhaps a face-to-beak encounter with a tame ptarmigan. Wherever you go here, you'll see wildlife. Summer birdwatchers find a symphony of species from the alpine to the rich boreal wetlands of the lower Athabasca River. The whole cast of Rocky Mountain mammals are seen in the park, including the threatened woodland caribou. They migrate between distant seasonal ranges (and across the Maligne Valley Road). In summer they graze on alpine meadows, in winter they find food and security in extensive old growth forests. These forests are disappearing and so are the caribou. Only parklands as vast as Jasper may offer them a last refuge.

Right: Golfing at the Jasper Park Lodge

In this telephoto view, Mt. Edith Cavell looms over the Jasper Park Lodge Golf Course, a deluxe development built in the 1920s. Bing Crosby won the course championship here in 1947. Today golfers share the fresh air and the fairways with grazing elk, Canada geese and the odd black bear.

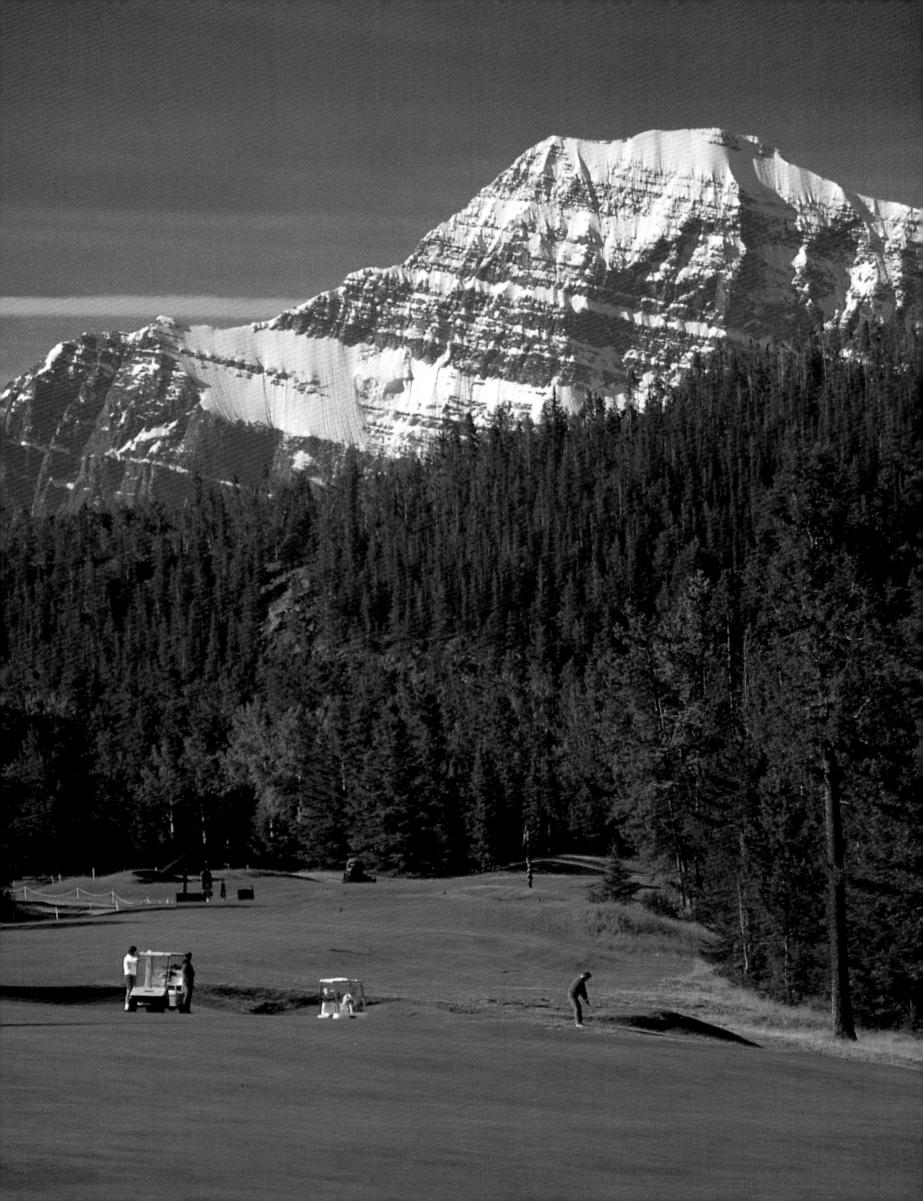

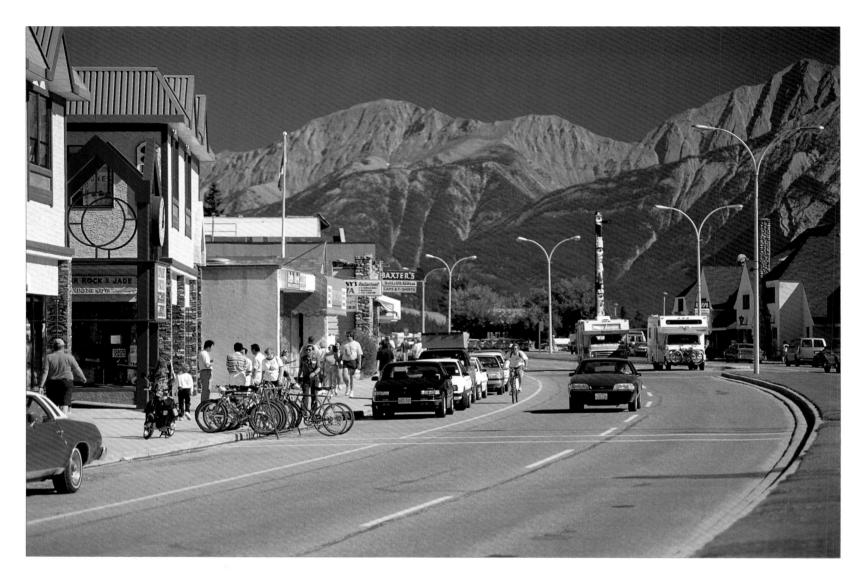

Jasper Townsite

hops, restaurants and the Via Rail station line Connaught Drive, the town's busy main street. The limestone peaks of 2545 m/8350 ft Hawk Mountain and 2697 m/8849 ft Mt. Colin dominate views east.

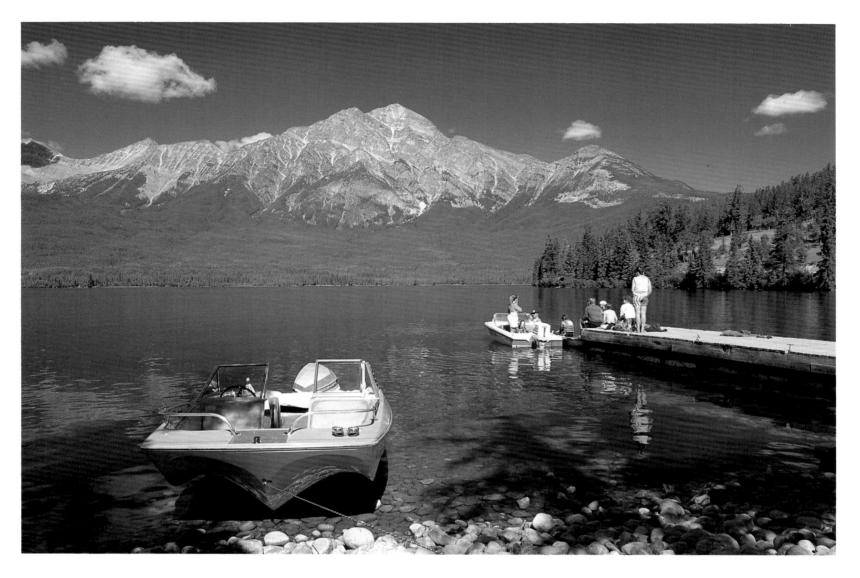

Pyramid Lake

Only 8 km/5 mi west of Jasper, the park's only power boating lake is an emerald summer playground for Jasper residents and visitors alike. The redorange Precambrian sandstone exposed on 2766 m/9076 ft Pyramid Mountain makes the graceful peak a local landmark, and distinguishes it from the pale gray Front Range peaks across the Athabasca Valley.

Overleaf: Maligne Lake with Tour Boat

tour boat heads out from the famous port at Spirit Island, two-thirds of the way up the largest lake in the Canadian Rockies (22 km/14 mi long). Ice-capped peaks, crowned by 3525 m/11,566 ft Mt. Brazeau, rise from the south end of the upper lake.

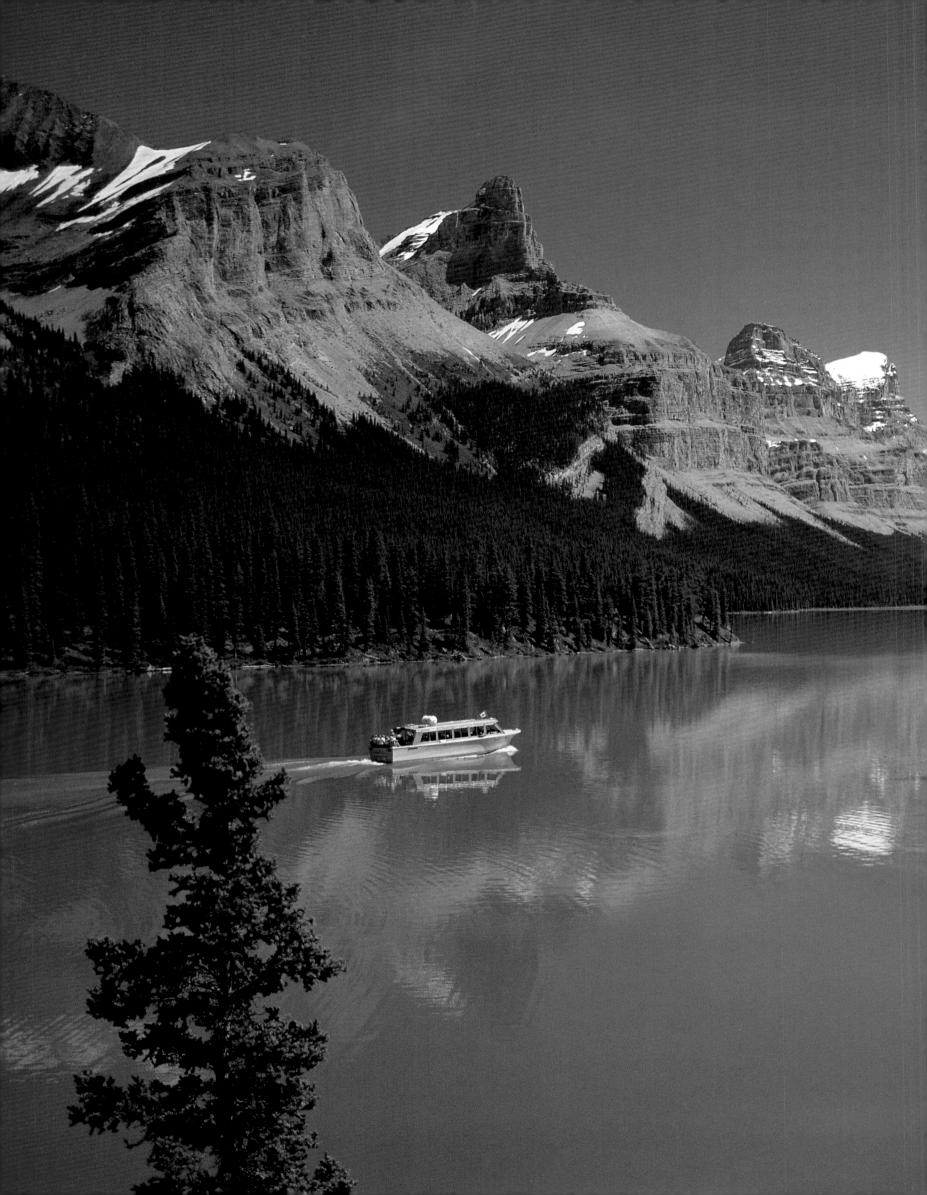

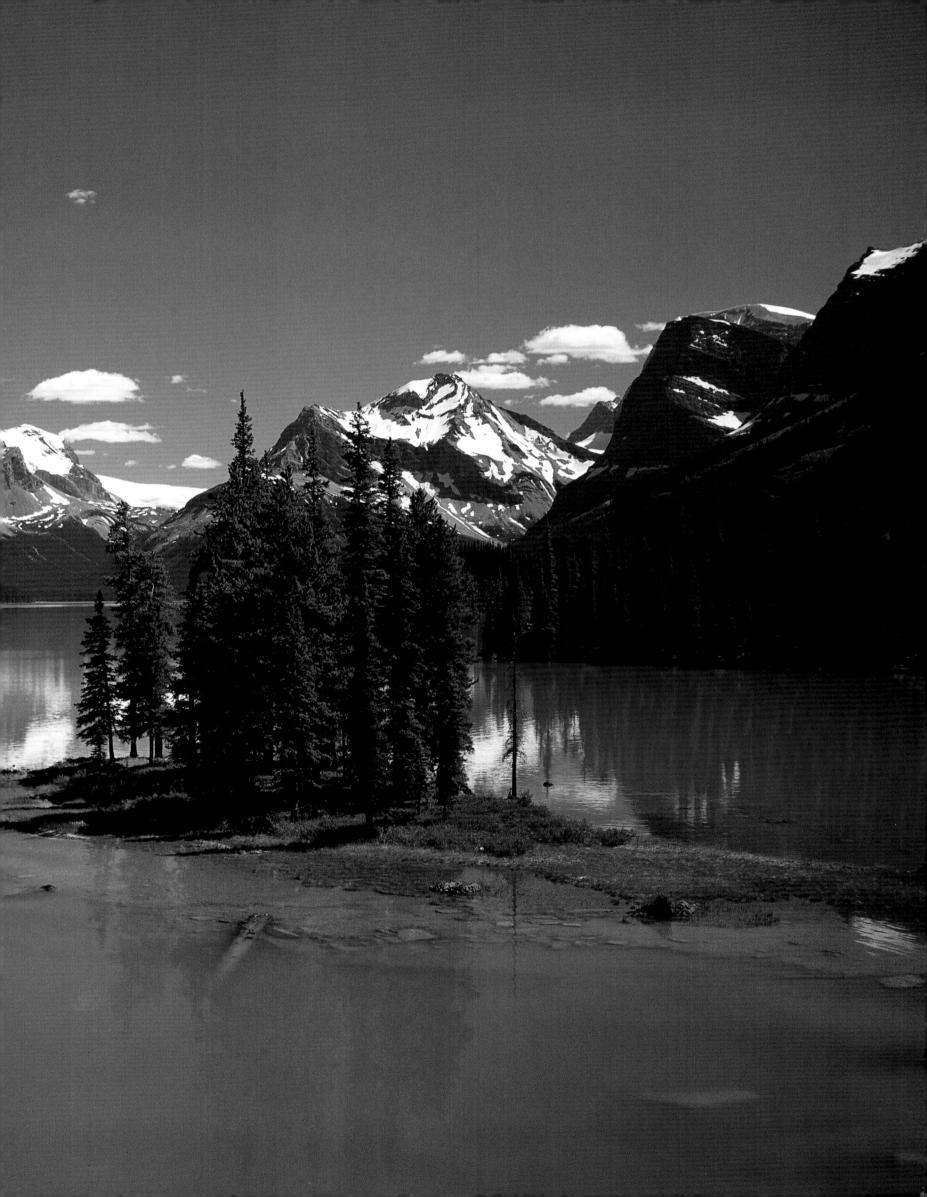

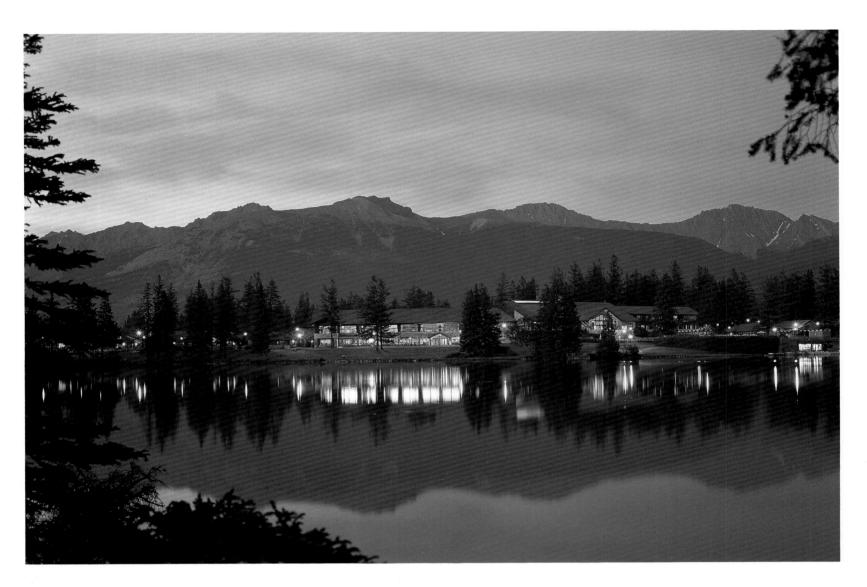

Evening at the Jasper Park Lodge

An oasis of welcoming tranquillity since 1922, the lodge sprawls along the eastern shore of Lac Beauvert, with the "Old Man's" face in 2460 m/8071 ft Roche Bonhomme forever sleeping on the skyline.

Right: The Jasper Park Lodge and Athabasca River Valley

Ihis aerial view reveals why the Canadian National Railway chose this alluring spot to develop their upscale bungalow-style resort to rival the Canadian Pacific Railway's grand hotels at Banff and Lake Louise. The basins of Lac Beauvert and the other "kettle lakes" nearby were formed when huge chunks of ice, buried in the silty wake of retreating glaciers, finally melted.

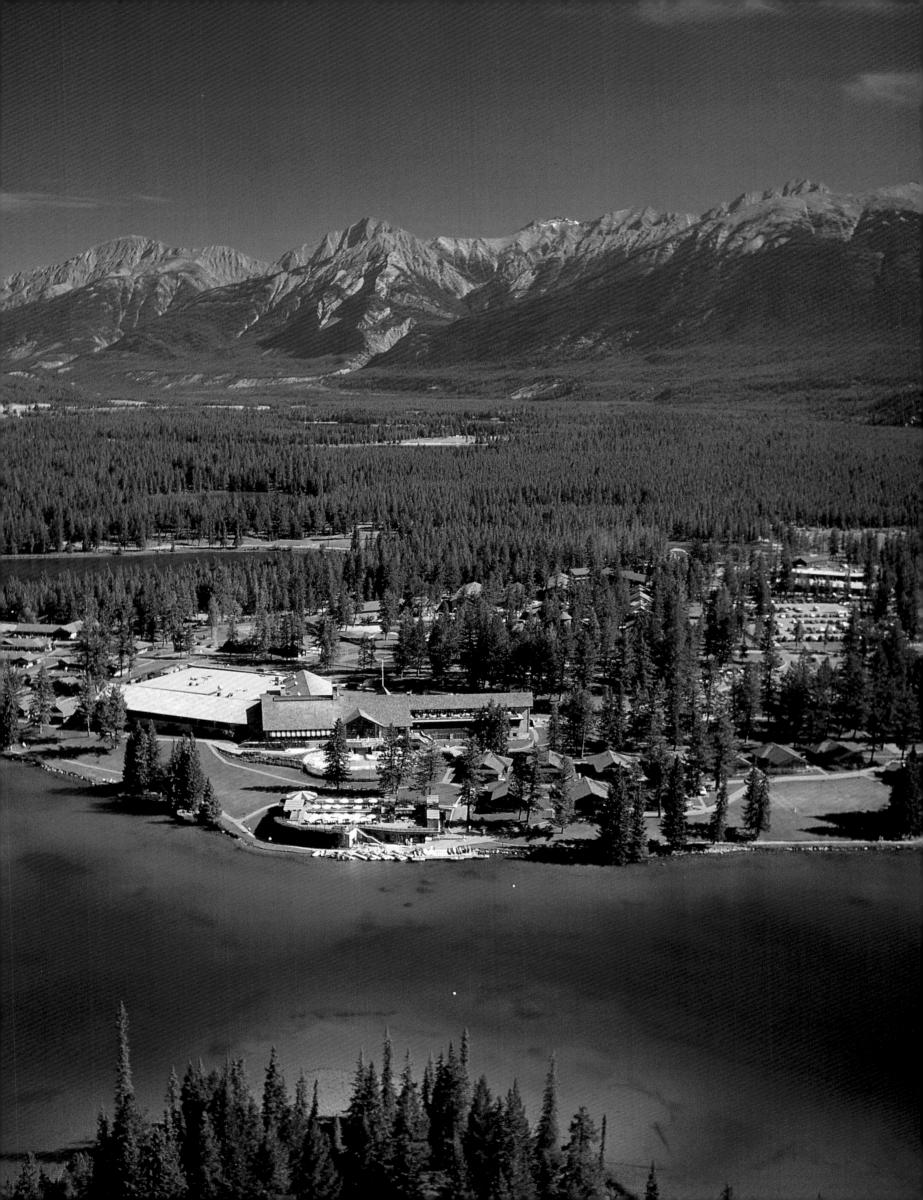

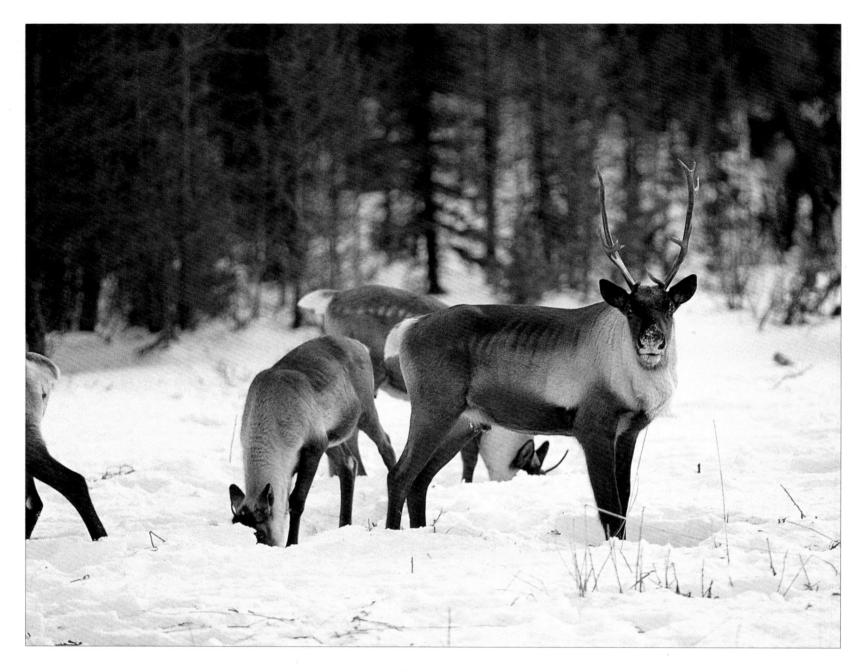

Woodland Cariboo

Caribou can be seen on their forested winter ranges near Maligne Lake and in the Beauty Creek/Jonas Creek area along the Icefields Parkway. Slow growing lichens called reindeer moss are the staple of their winter diet.

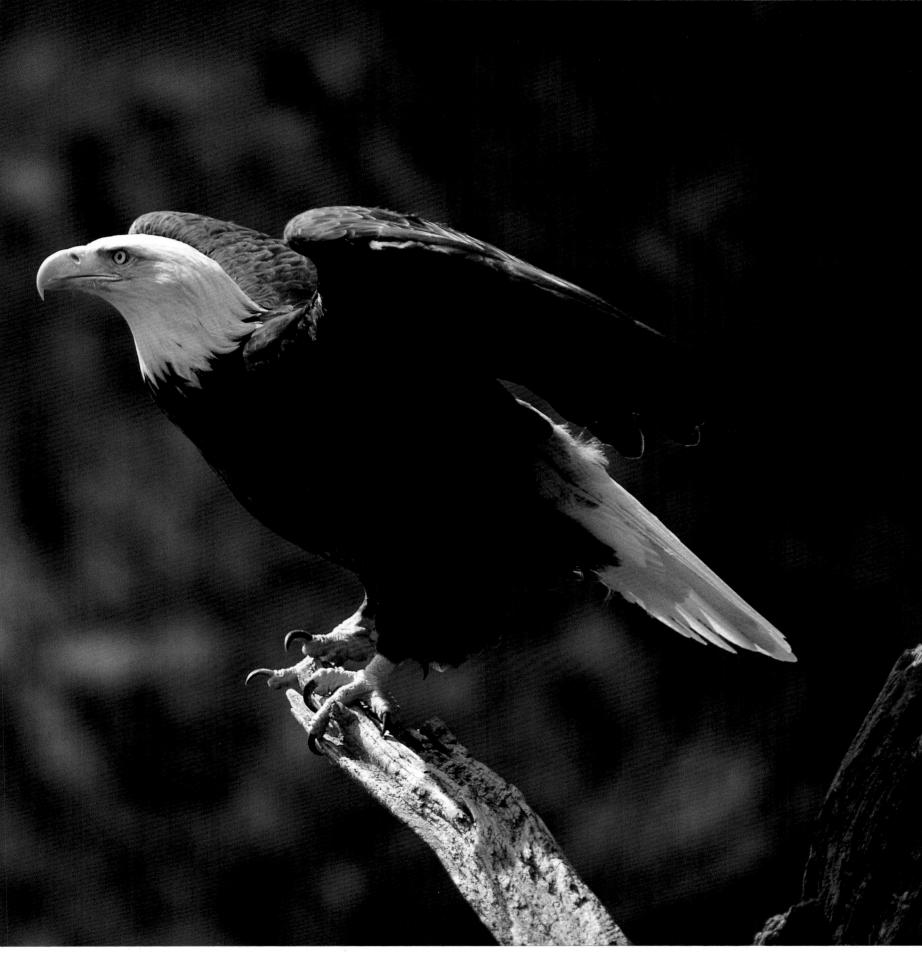

Bald Eagle

As noble as they look, on their spring migrations through the Rockies bald eagles are mostly scavengers who squabble with coyotes or ravens over the carcasses of wolf or winter-killed animals. A few pairs nest near large lakes and wetlands. More common is the golden eagle, who hunts small mammals in alpine areas.

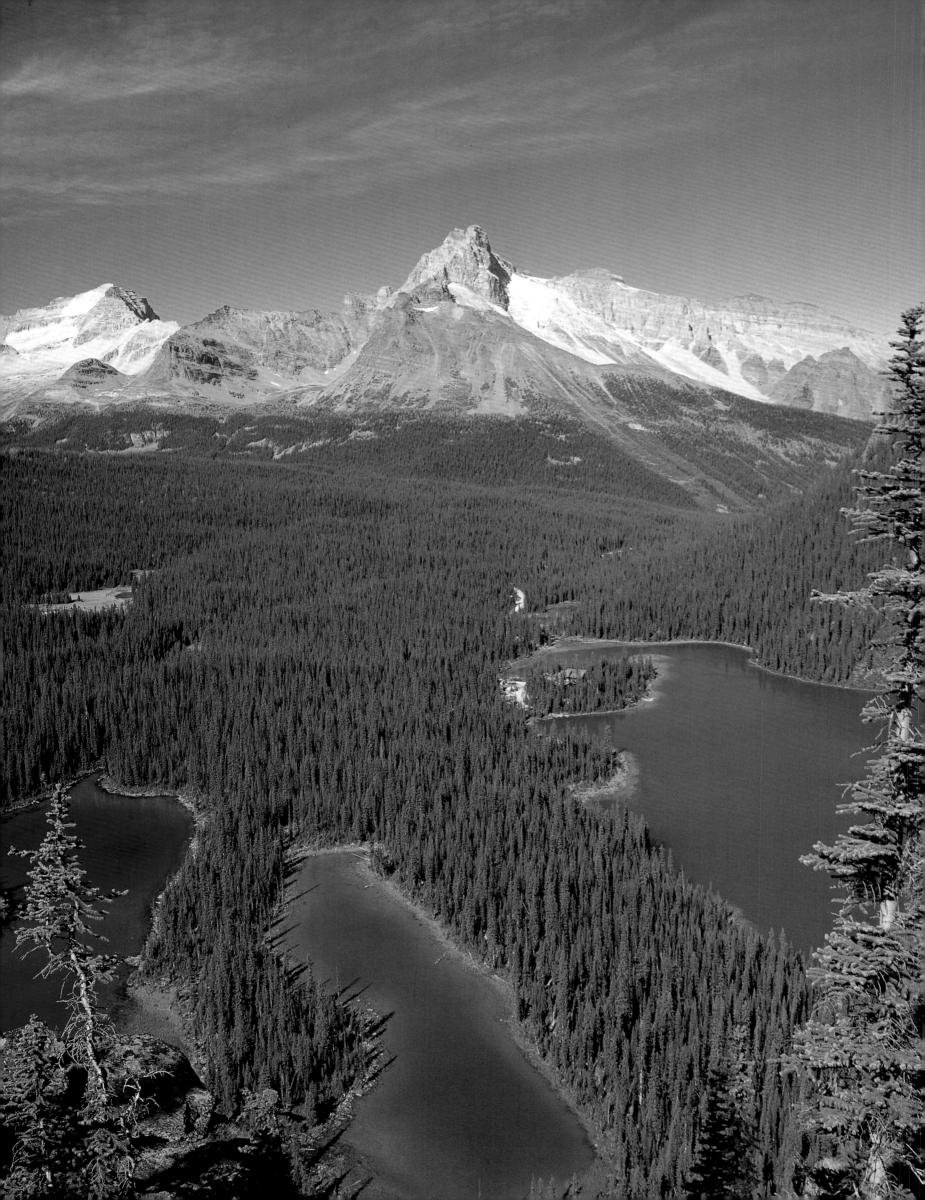

YOHO NATIONAL PARK

"The Cree use the word Yoho to express wonder and astonishment."

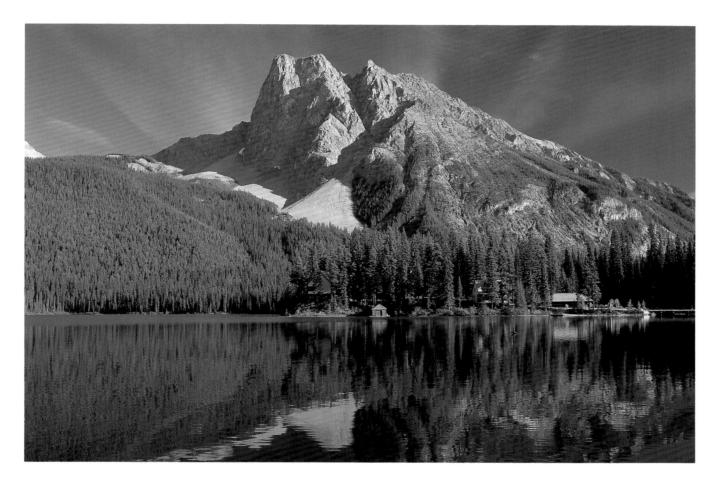

Emerald Lake Lodge

tarted as a summer tent camp by the Canadian Pacific Railway in 1902, the latest lodge was refined and renovated in 1986. This is a very peaceful place. The world famous Burgess Shale fossil beds are up on 2583 m/8473 ft Mt. Burgess, which rises up beyond the lodge.

Left: Lake O'Hara

Viewed from the rim of the Opabin Plateau, this magnificent amphitheatre curls up against the Great Divide across from Lake Louise. It is a hiker's wonderland, with its superb, artfully built 80 km/50 mi trail system. The Lake O'Hara Lodge and campsite are often full of vacationers who return to this mountain Mecca year after year.

Sublime and Unique

oho is the perfect name for this rugged 1313 sq km/507 sq mi park on the west side of the Continental Divide – it is said to be a Cree Indian exclamation of wonder and astonishment.

That's what William Van Horne of the Canadian Pacific Railway may have gasped in 1886 when he named the place. He was astonished both by 378 m/1240 ft high Takakkaw Falls and his luck in having found them just off the new railway line. And in a nearby valley there was Emerald Lake, a glacier-fed jewel wrapped in lush west slope forests. Lofty peaks stood all around, including 3199 m/10,493 ft Mt. Stephen, then thought to be the highest peak along the line. As at Banff, Yoho's eastern sister, he'd found another superb setting for a mountain hotel and its accompanying national park. That year Mt. Stephen House was built and a 16 sq km/6 sq mi reserve was established; Yoho became a National Park in 1911.

But Van Horne's luck was tempered by the practical problems of the Kicking Horse Pass. "The Big Hill" was so steep that runaway trains were a regular terror and pushing them back up took four or more locomotives and the town of Field to service them. It took 24 years

and an engineering marvel to get around this obstacle, with the 1909 completion of the two Spiral Tunnels which loop down, through 1900 m/6232 ft of rock, to the valley floor.

The same summer that train passengers first rode calmly down one side of the Kicking Horse Valley, Charles Walcott of Smithsonian Institute was becoming very excited on the mountains opposite them. In what became known as the Burgess Shale, he was finding some very peculiar 530 million year old fossils – weird creatures found nowhere else, marvellously detailed and intact. Recent studies of these unique fossils have shaken up both scientists and philosophers. Perfectly preserved because they were accidentally buried by a mud slide, these Cambrian scrolls suggest that evolution is much more accidental than we thought.

This would have been no surprise to James Hector, a young geologist with the British Palliser Expedition who came to the park in 1858. Victim of the original kicking horse, Hector was knocked unconscious by a hoof in the chest and taken for dead by his Indian guides. They were preparing to bury him when he awoke. Yoho!

Right: Natural Bridge, Mt. Stephen

This was once a waterfall. Now the Kicking Horse River, bearing its gritty load of glacial silt, has worn a more direct route through a soft layer in the limestone dam barring its course. In time, it will be a canyon.

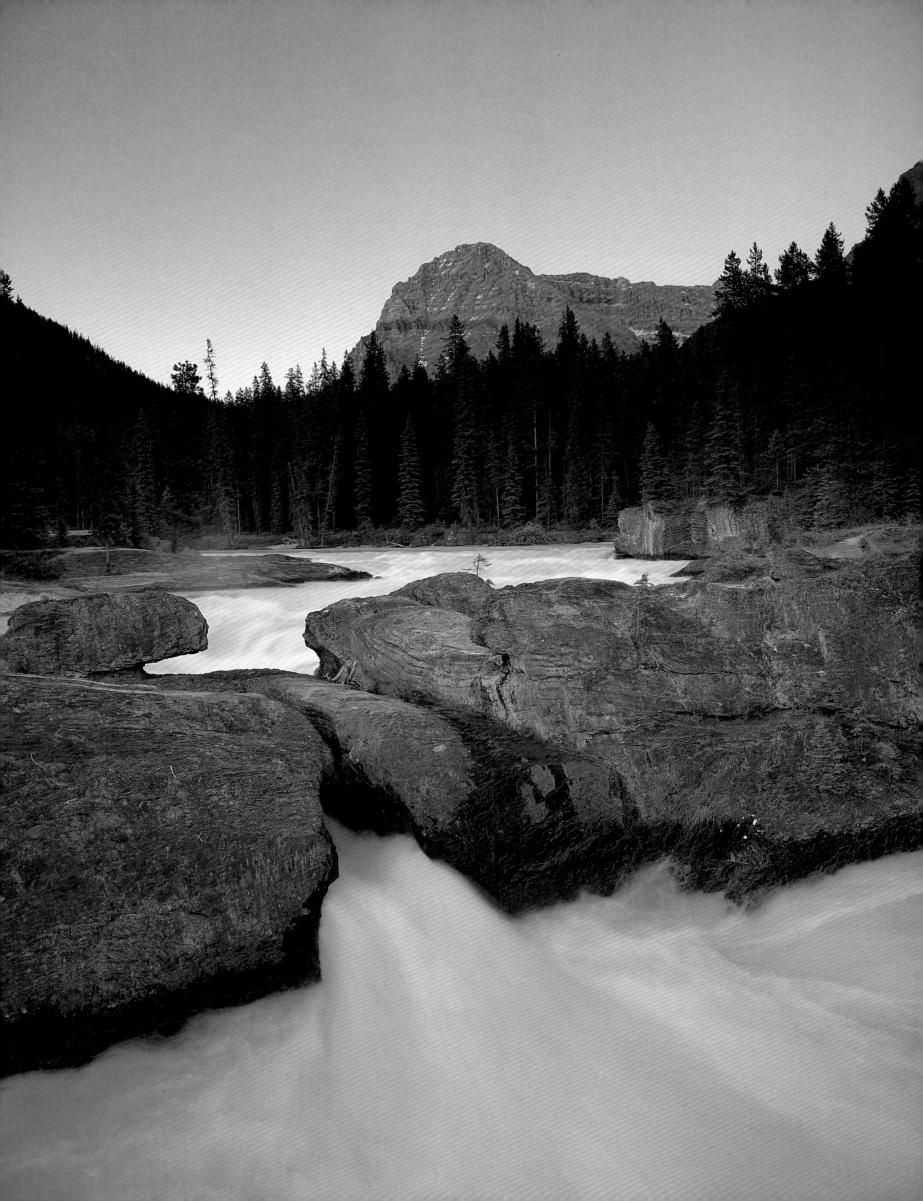

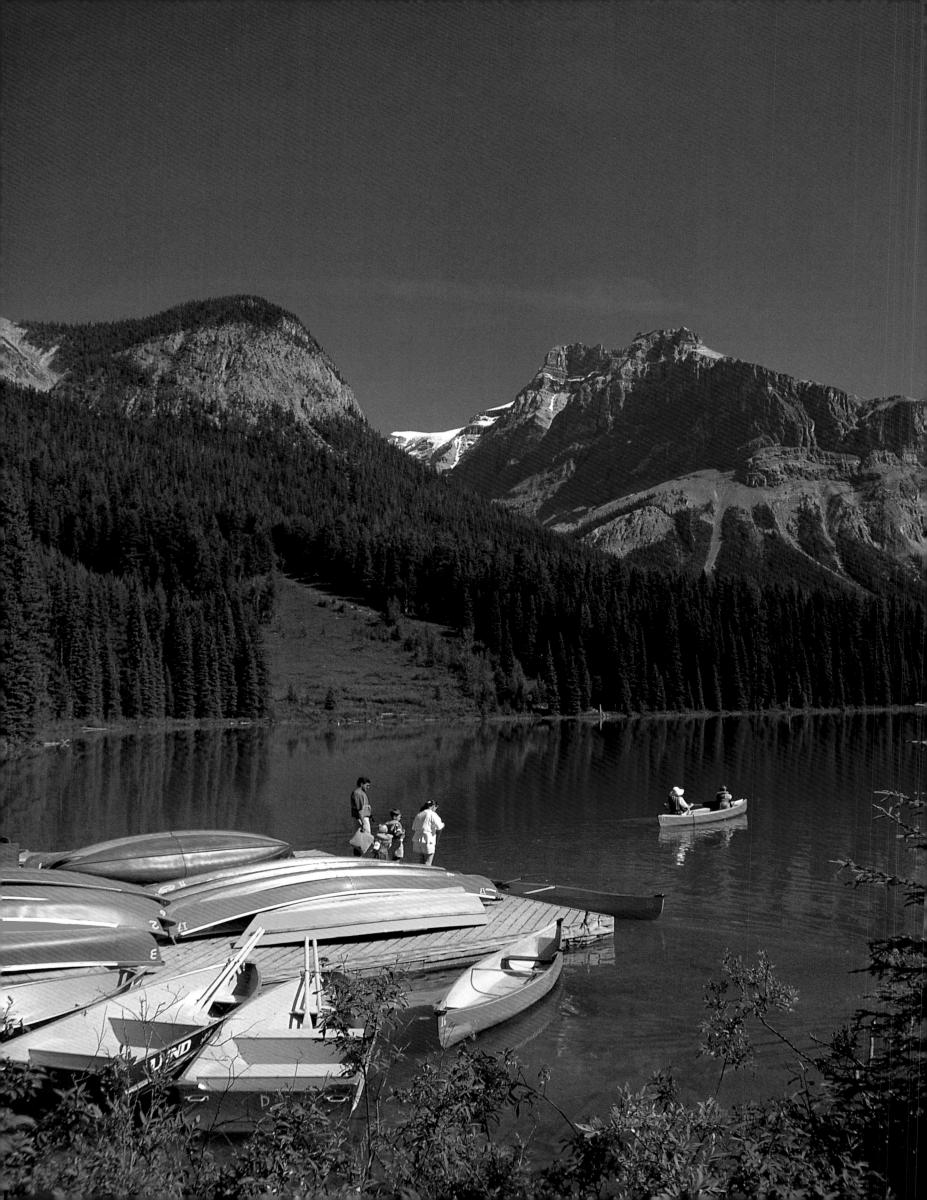

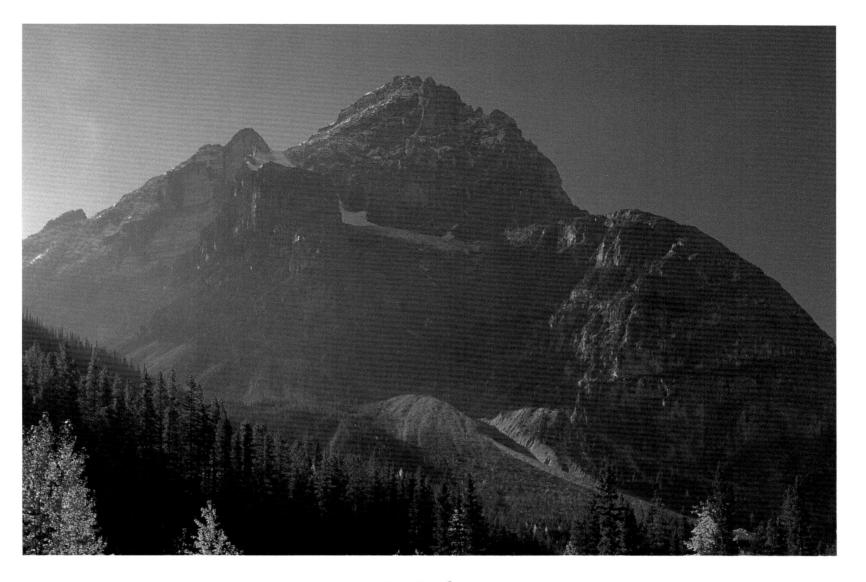

Mt. Stephen

Standing 3199 m/10,495 ft above sea level, more than 1900 m/6400 ft directly above the Kicking Horse River Valley, this massive peak was once at the bottom of an ancient ocean. The discovery of five hundred million year old trilobite fossil beds midway up this mountain in 1877 lead to the discovery of the world famous Burgess Shale fossils across the valley.

Left: At Emerald Lake

In 1882, while searching for some stray horses, railway scout Tom Wilson discovered this secluded beauty below 2696 m/8844 ft Michael Peak and the President Range. It wasn't called Emerald Lake until 1884, because this lucky cowboy had found Lake Louise a few months earlier and christened *that* lake Emerald.

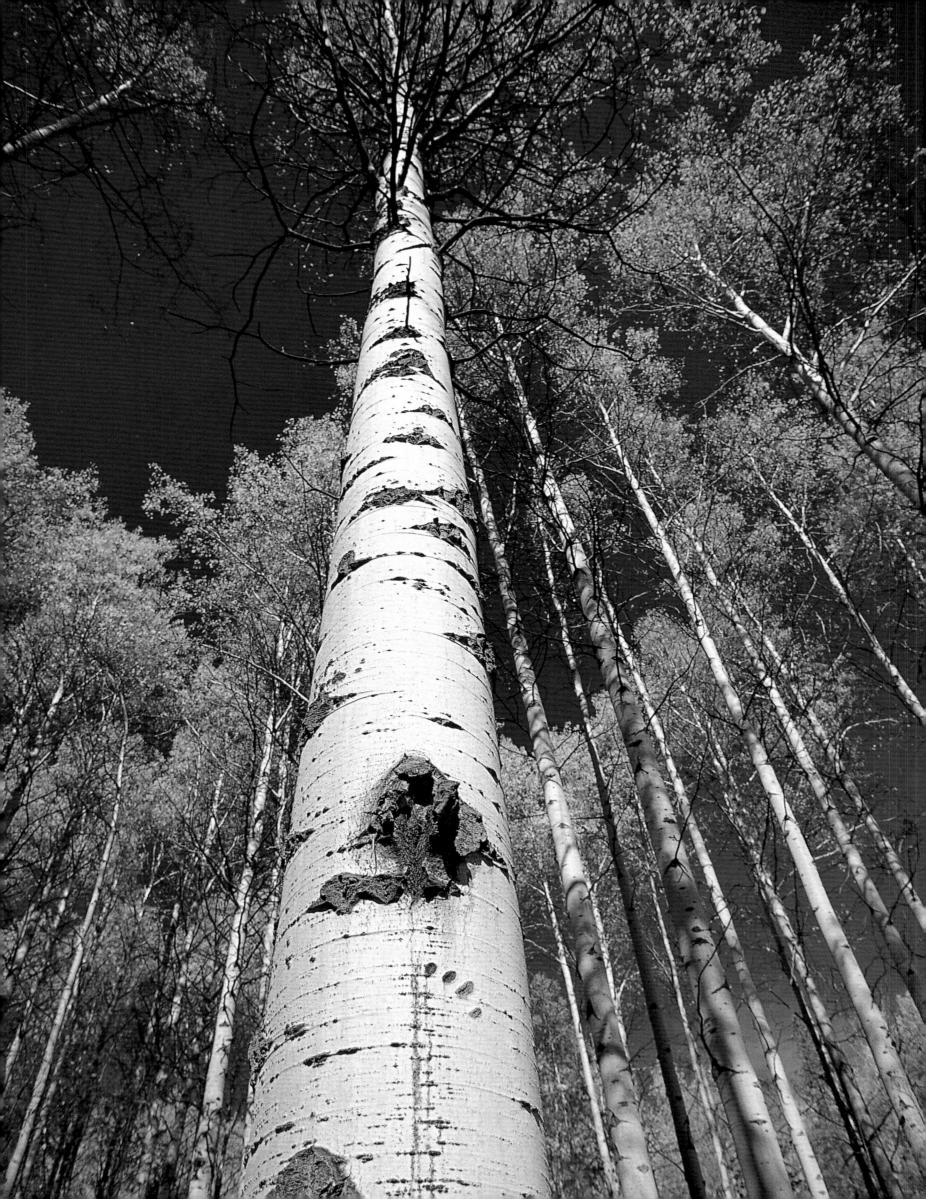

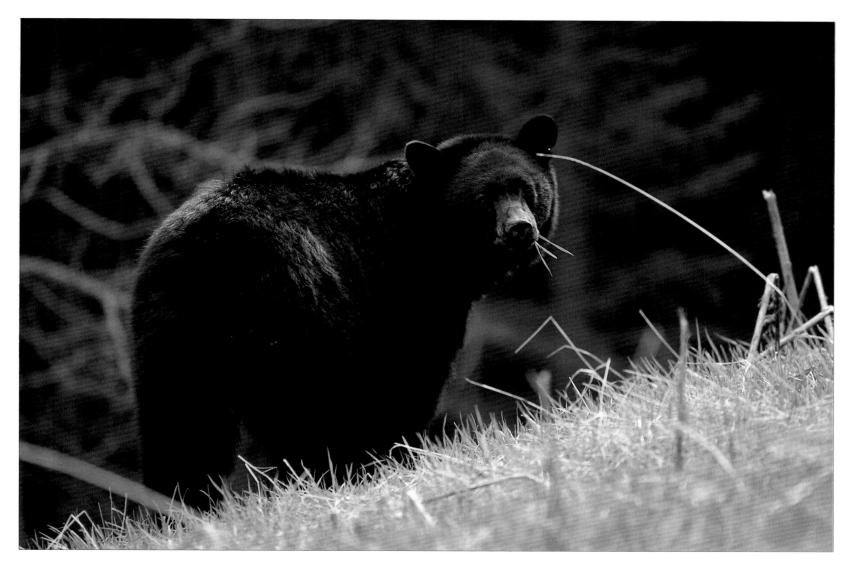

June Black Bear

Lhough bears will eat anything from elk to ants to leftover pizza when the opportunity arises, their diet is 90% vegetable, with berry crops being their most critical staple. They are most often sighted in spring, feeding on fresh greens and flower heads in roadside clearings, meadows and on open avalanche slopes. Grizzly bears can also be seen in these habitats, digging roots with their distinctively long claws.

Left: A Bear-clawed Aspen

Black bears, especially cubs and yearlings, climb aspens to escape danger or disturbance – and perhaps just for the view. They have short, tightly curved claws adapted for climbing, while grizzly bears can only climb trees by using the branches. Lacking the security of the trees, the grizzly takes self-defense more seriously than its forest cousin.

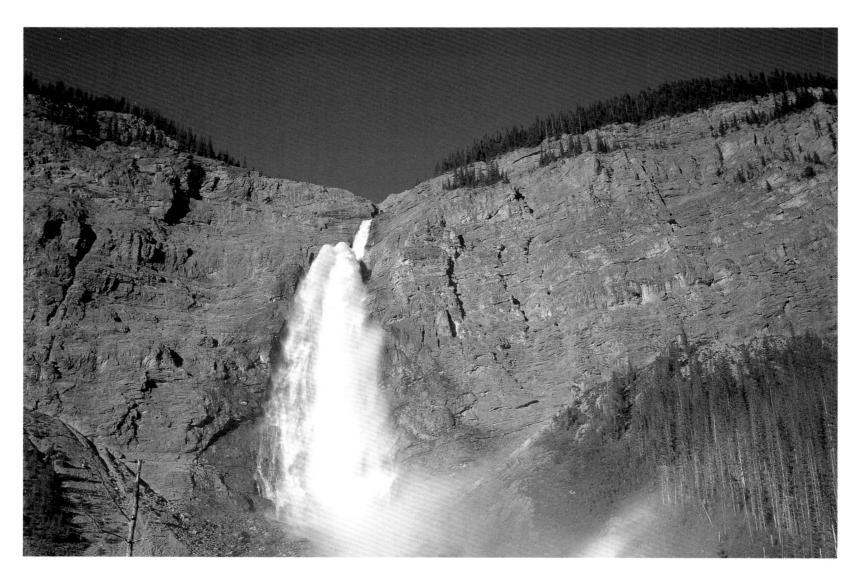

Takakkaw Falls

Takakkaw is a Cree Indian word for "it is wonderful," and these 378 m/1240 ft falls truly are, especially in early summer when the roaring run-off thunders over into spray glowing with rainbows. Some Native peoples believed rainbows had healing powers.

Right: Mountain Goat

Ountain goats can often be seen on cliffs in the Yoho and Kicking Horse valleys. They survive winters on these hostile slopes by eating virtually anything chewable, from twigs to rock lichens. Though safe from predators on the cliffs, they are sometimes killed by avalanches and rock slides.

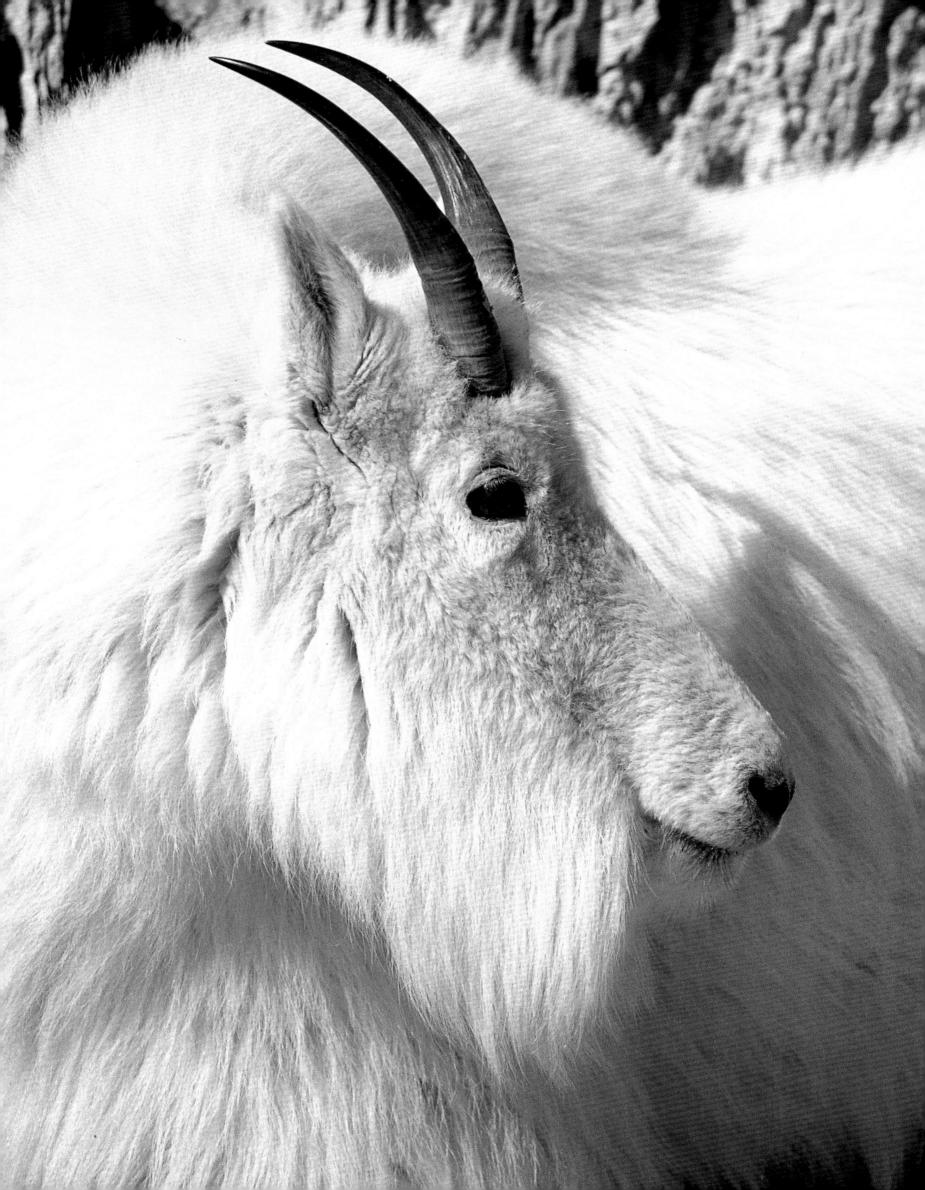

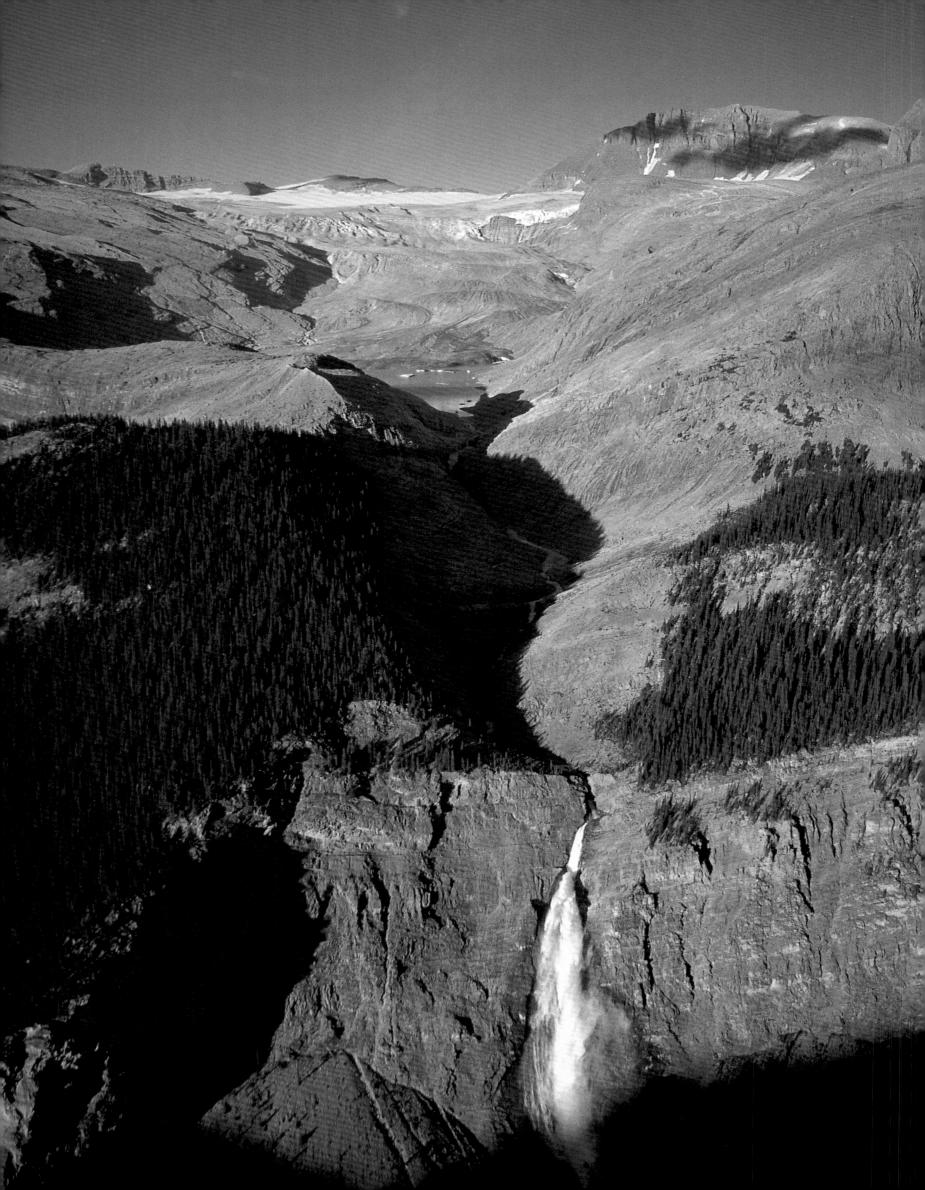

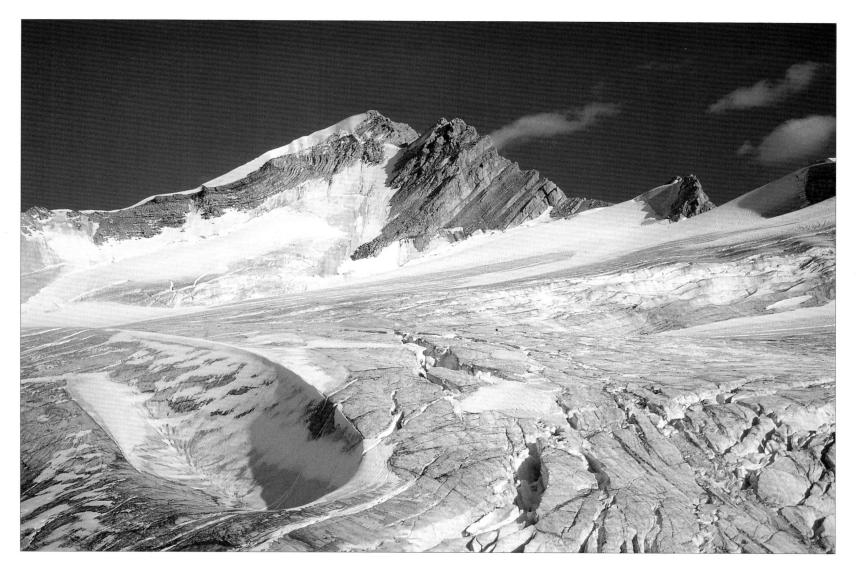

Wapta Icefield

Since we missed the last Ice Age, a mountain icefield is the closest we can come to seeing one this side of the Arctic. Indeed, this is a surviving remnant of the ice sheets that once submerged the Rockies, leaving only the peaks standing like islands in a frozen ocean current. Now the glaciers have retreated up to the last cold and snowy habitats that can sustain them. Global climate change is measured in their retreats and advances.

Left: Source of Takakkaw Falls

Lhis aerial view reveals the Daly Glacier, part of the Waputik Icefield which straddles the Continental Divide between here and Hector Lake in Banff National Park. Ice climbers scale the frozen falls in winter.

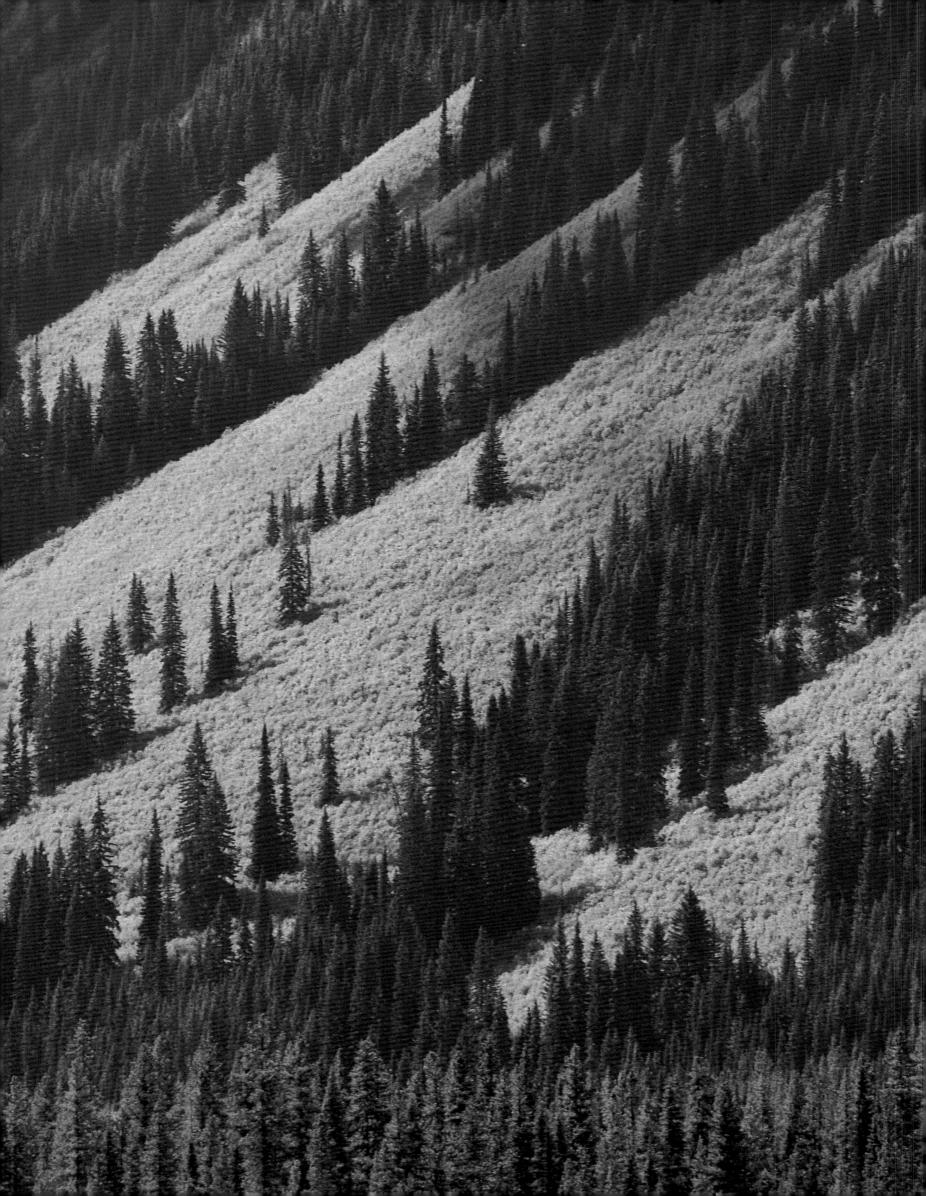

KOOTENAY NATIONAL PARK

"The idea for the park began with bubbling hot springs."

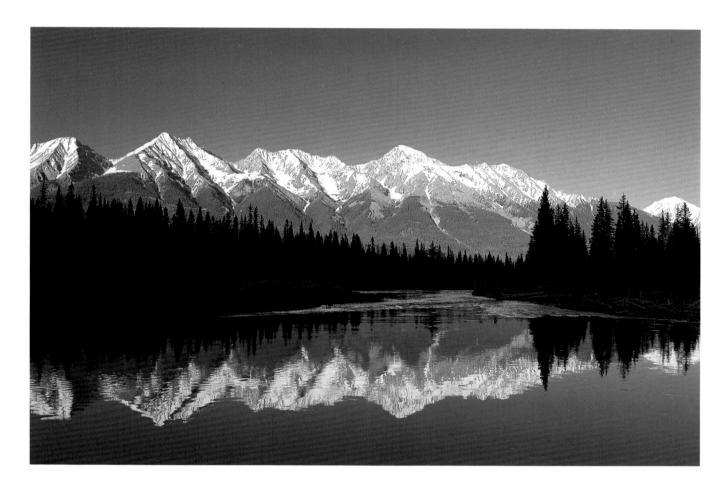

Mitchell Range

Each spring the swelling Kootenay River overflows into myriad reflecting pools and backwaters along its broad meandering bed. There may be elk, white-tailed deer, black bears and wolves along the river on evenings like this.

Left: Spring Avalanche Paths

The avalanches that thunder down these slopes in winter are both destructive and creative. By bulldozing strips of forest, they create ecological diversity: the sunny meadows, shrublands and edges are habitat for many plant and animal species. Black and grizzly bears, elk, moose and humming-birds all forage here in early summer.

Highway to Heaven

ike Banff, the idea for Kootenay National Park began with bubbling hot springs. In the Columbia River Valley, in the far southern corner of the park, the 38°C/ 68°F Radium Hot Springs steams up the red-walled Sinclair Canyon. Today it attracts 350,000 soakers a year; in 1910 it was remote and all but empty. But that year local businessmen began pressuring the British Columbia and Canadian governments to build the Banff-Windermere Highway to their valley. Both governments agreed. By 1916 the federal section of the road, from Banff to Vermilion Pass, was completed, but the provincial end was out of funding. A deal was struck: in return for a 16 km/10 mi wide park along the route, including the hot springs, the Canadian government would finish the road. In 1920 Kootenay National Park was established, and the road opened in 1923.

For many Calgarians bound for weekend homes in the Columbia Valley, 1406 sq km/543 sq mi Kootenay National Park is just a beautiful backdrop on a hurried drive. For many American tourists following Hwy 93 north it is more interesting, but still only on the way to Banff and the more renowned Rockies. The highway follows an easy route over the Continental Divide, through 1651 m/5415 ft Vermilion Pass then south down the Vermilion and Kootenay river valleys. This was the path of the Ice Age glaciers that smoothed out these long, broadening valleys, the route aboriginal peoples had used for unknown generations and the one James Hector

of the Palliser Expedition had followed in 1858. But where the glaciers and Hector had gone south down the Kootenay Valley, the road abruptly climbs west over Sinclair Pass to the canyon hot springs.

Born a highway park, Kootenay has many roadside attractions. In Vermilion Pass, the Fireweed interpretive trail tells the natural history of the huge 1968 fire that created snag forest in the area. Day hikers can climb above timberline to the Stanley Glacier. Further west short trails lead along Marble Canyon, which is really dolomite limestone, and to the Paint Pots, which were just that for the Kootenay Indians who used the red earth for body paint. With two roadside mineral licks and valley bottom grazing it is a prime road for watching wildlife. June is black bear month.

You can see some wonderful landscapes from the road, especially in the Vermilion River Valley. To the southwest the 3618 m/11,867 ft "Matterhorn of the Rockies," Mt. Assiniboine, crowns Mt. Assiniboine Provincial Park between Kootenay and Banff National Parks. Looking up valleys to the east, you catch glimpses of The Rockwall, the park's most monumental feature. This huge limestone cliff is 40 km/25 mi long and up to 900 m/2952 ft high. Along its base is one of the finest hikes in the Rockies, past Floe Lake, Numa Pass and the Tumbling Glacier; then north, if you like, to Helmet Falls and Yoho National Park. There is only one road, but trails lead everywhere.

Right: Marble Canyon

Lokumm Creek flows by, as it has for the past 8000 years, slicing a canyon 36 m/118 ft deep through layers of limestone. It works fastest in spring, roaring and charged with sand-blasting glacial silt. On this September day, the water is slow and clear, the knife dull but relentless.

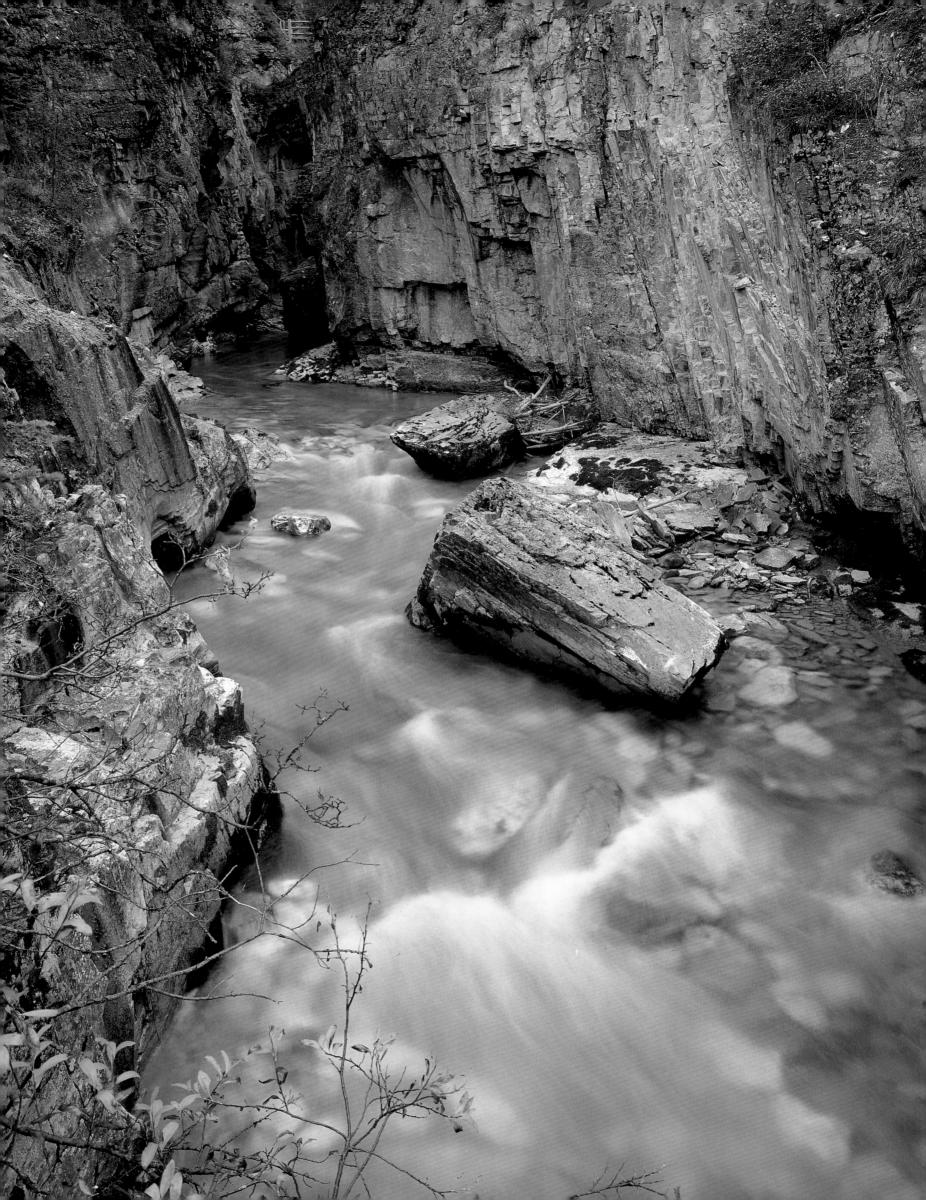

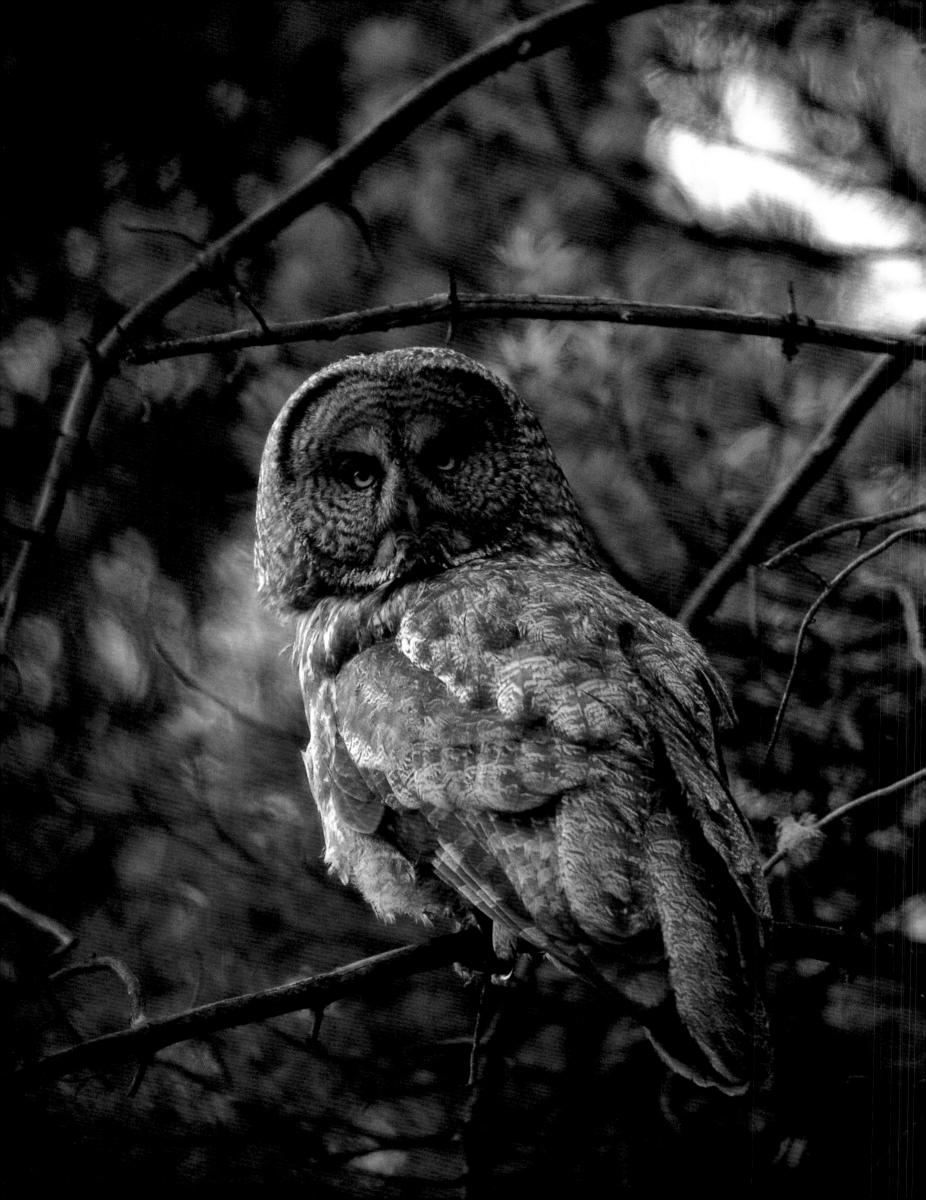

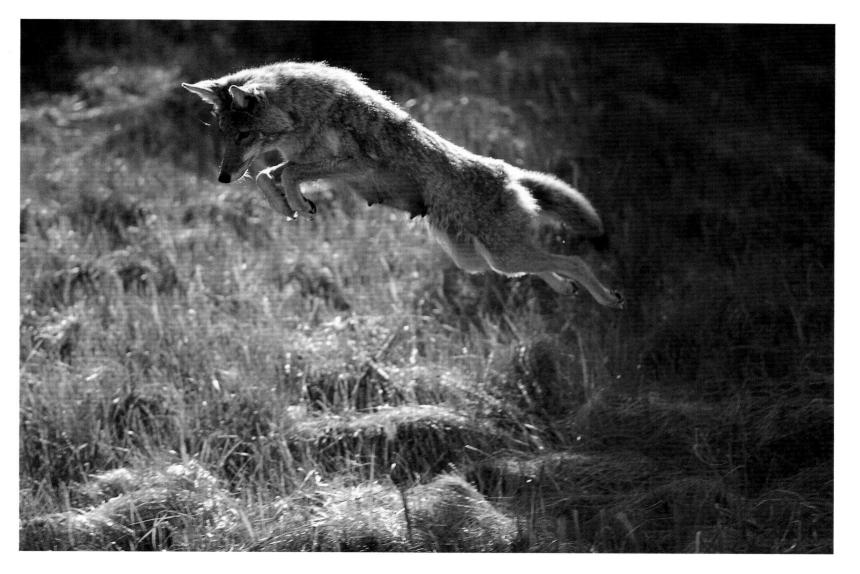

Hunting Coyote

After patiently out-waiting a mouse in the grass, this female coyote pounces on the next lunch for her pups, who are hidden in a nearby den. Coyotes are opportunistic hunters and scavengers, especially in winter, but small rodents are the staple of their diet. Roadside right-of-ways provide prime hunting grounds.

Left: Great Gray Owl

The haunting stare of this reclusive forest owl might never be encountered were it not a wonderfully tame daytime hunter. This huge (up to 83 cm/33 in long) bird is the largest North American owl by volume, but most of its bulk is an incredibly thick feather parka. It shows its strength during the hunt, when it pounces on rodents like a winged cat.

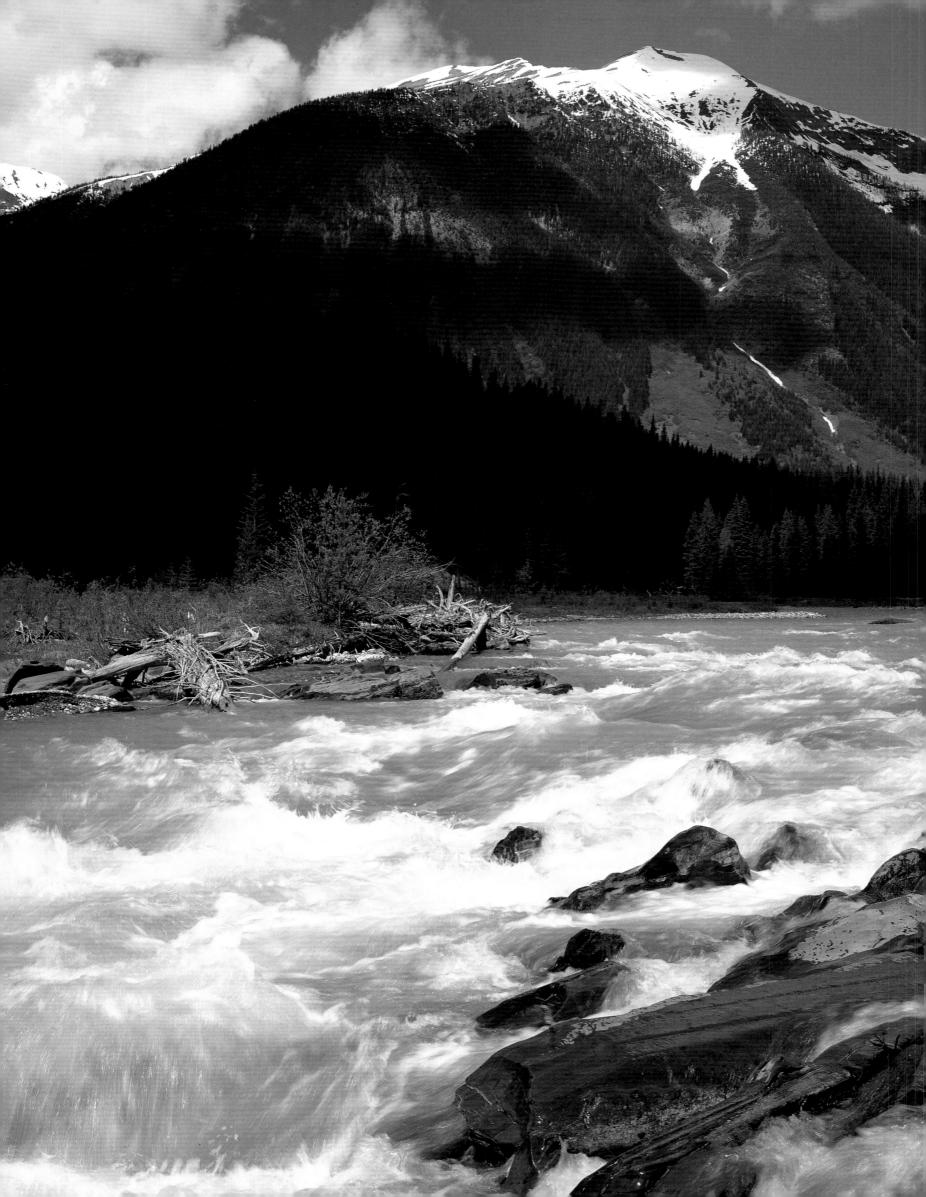

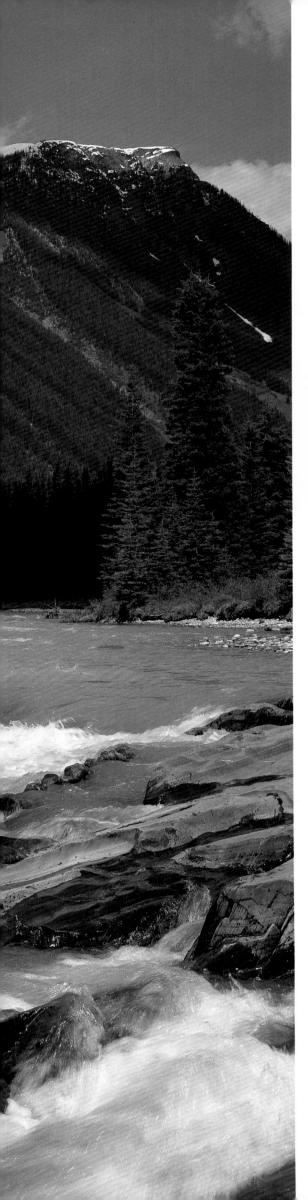

The Redwall, Sinclair Canyon

Usted by a fresh snow, these landmark cliffs are even more striking. This wall marks a major fault at the base of the Rockies and the hellish heat of the friction below has baked the rust into the rocks. Just down the canyon from here, that same deep heat soothes soakers at Radium Hot Springs.

Left: Vermilion River at Numa Creek

Just west of the Great Divide and already the forest is more lush on the Pacific slope. This valley is one of countless mountain headwaters nourishing the Columbia River. What makes it different from most in the Columbia's vast watershed is that these forests will live out their natural lives in a national park.

Western Wood Lilies, Kootenay River Valley

Lound in open valley forests and meadows, the showy Lilium philadelphicum blossoms in June. This flower is often confused with the tiger lily, whose flowers face downwards.

Right: Spike Elk

his yearling bull elk sports his first set of antlers. Next year, if he survives, he'll grow antlers up to twice as long, with (usually) five small points.

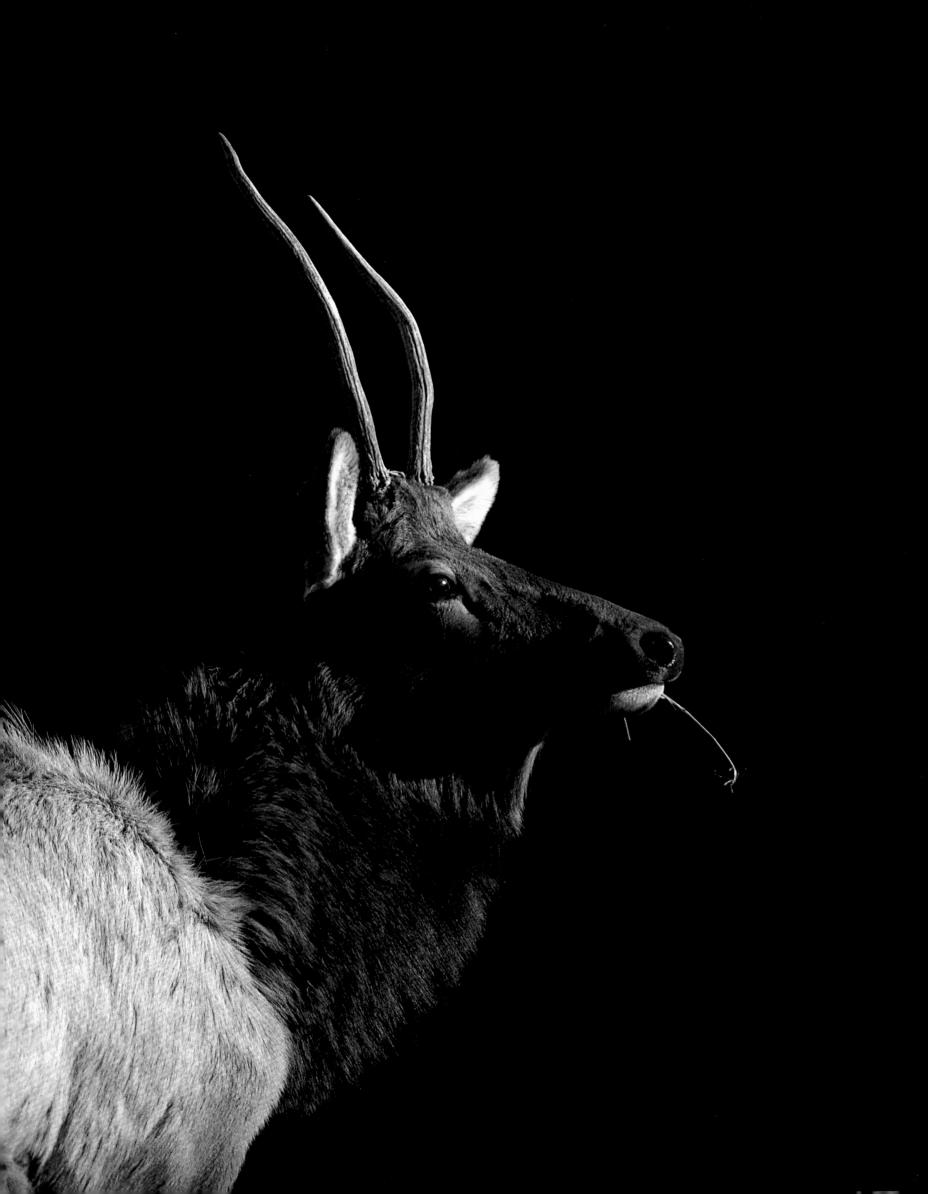

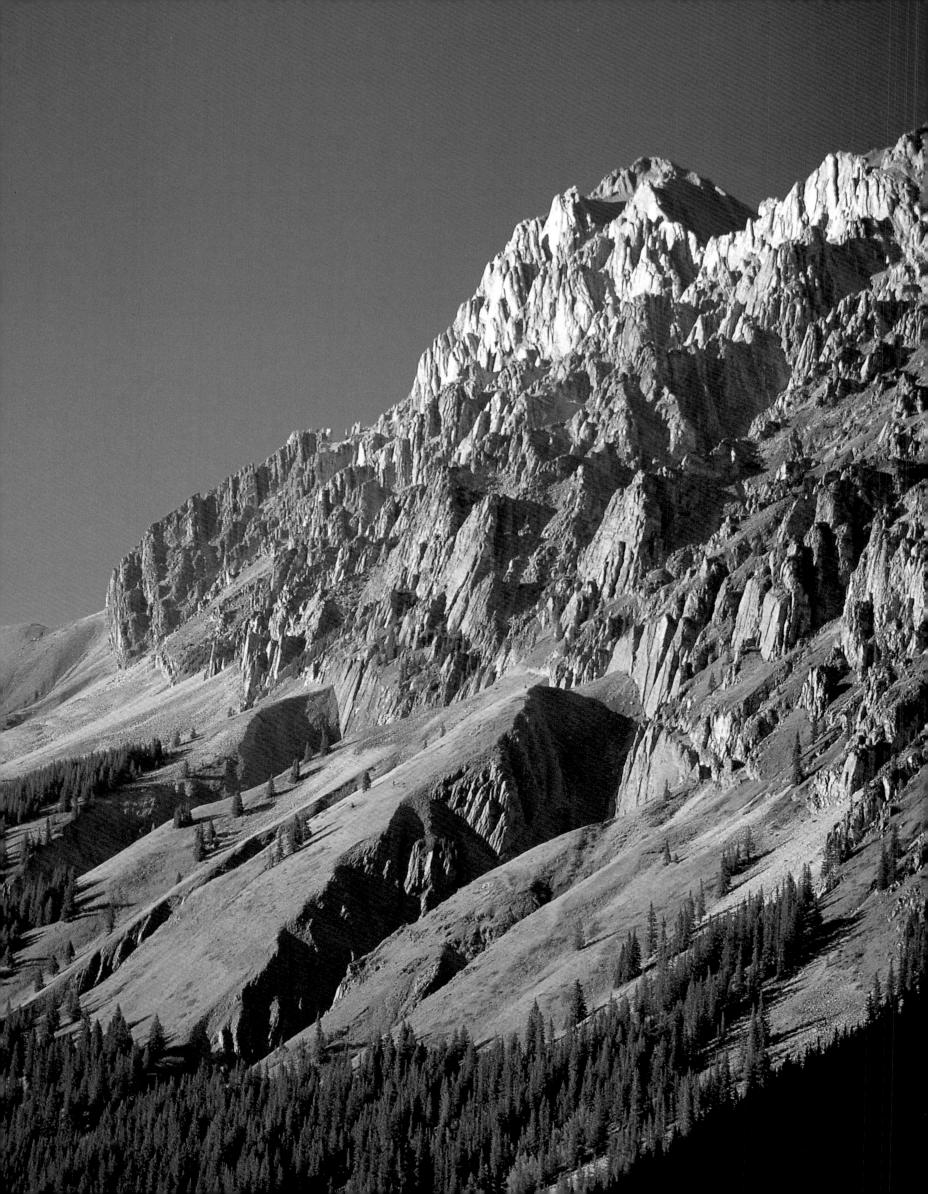

KANANASKIS COUNTRY

"Only in the Rockies could a playground like this be overlooked for so long."

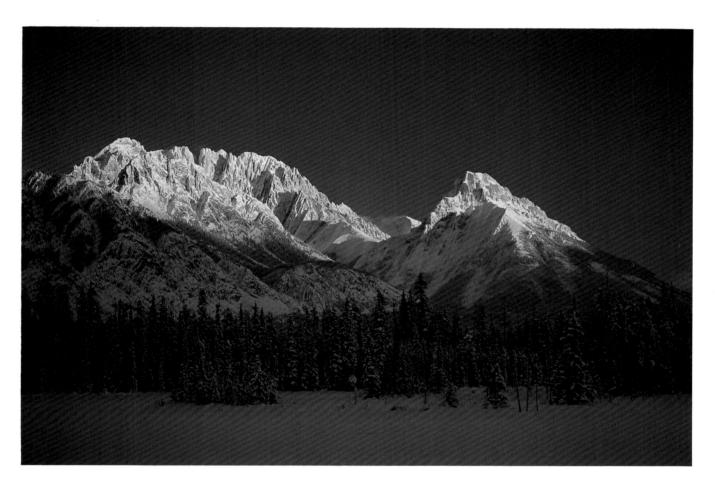

Alpenglow on Opal Range, Peter Lougheed Provincial Park

A frozen calm December evening with ice crystals glowing in the sky. Long cross-country ski trails loop around the valley bottom forests.

Left: Elpoca Mountain, Highwood Pass

This 3029 m/9935 ft wall of limestone standing above the north side of Highwood Pass in Peter Lougheed Provincial Park is a continuation of the pale gray Front Range also seen east of Banff and Jasper townsites. These steep, windblown slopes are prime winter range for bighorn sheep. Elpoca is named for its location between the headwaters of the Elbow River and Pocatera Creek.

A Paradise of Opportunities

nly in an area as rich in beautiful scenery as the Canadian Rockies could a 4000 sq km/1544 sq mi mountain playground like Kananaskis Country have been overlooked for so long. Until 1978, this area was virtually unknown to most Albertans and to the millions of visitors driving right past its gateway on their way from Calgary to Banff. That was the year that, with Alberta's oil boom at its peak and the national parks becoming crowded, the Alberta government began to develop the Kananaskis into an alternative mountain destination. With petro-dollars from the province's Heritage Fund, they built a full spectrum of state-of-the-art facilities (including trails, fishing ponds and a lodge for the disabled) in Kananaskis Country and in the three provincial parks - Bow Valley, Peter Lougheed and Bragg Creek - within it.

A tour of Highway 40 off the Trans-Canada Highway, 83 km/51 mi west of Calgary, is the best introduction to K-Country. It first follows the Kananaskis River up past Barrier Lake to Kananaskis Village, which is home to three hotels, a hostel, a superb golf course, an RV park, biking, hiking, equestrian and cross-country ski trails (some of the more than 1000 km/620 mi of trails in K-Country) and Nakiska, the site of the 1988 Winter Olympics downhill ski events. (The Olympic Nordic Centre is near Canmore, in the northern corner of K-Country.)

Further south is 508 sq km/196 sq mi Peter Lougheed Provincial Park, a camper's, hiker's and boater's paradise. The dark snow-capped Continental Divide, peaked by 3183 m/10,440 ft Mt. Petain, walls the western horizon; to the south is Elk Pass and Elk Lakes Provincial Park in British Columbia; and eastward thrusts the vertical limestone slabs and tombstone peaks of the 3000 m/9840 ft Opal Range. These pale peaks get closer as you ascend 2206 m/7236 ft Highwood Pass, the highest paved road in Canada. A 2 km/1.2 mi boardwalk allows you to explore the subalpine summit meadows without crushing them. The 5 km/3 mi Ptarmigan Cirque trail climbs into the alpine region. (The pass is critical winter range for both sheep and elk and this road is closed from December to mid-June.) Over the pass this tour descends the Highwood River to Longview, through beautiful aspen foothills and some of the oldest ranches in the Alberta foothills.

And that's just one glimpse of the Kananaskis. In the north the glacial high country of Smith-Dorien Pass and the Spray Lakes border Banff National Park above Canmore. The Elbow-Sheep area in the south is more "cowboy country" foothills and forests. K-Country is a huge and diverse recreation area, and surely the best oil boom investment Alberta made.

Right: Spillway Lake, Peter Lougheed Provincial Park

Lishing loons and ospreys ripple the calm waters here. The range was named in 1884 by George Dawson of the Geological Survey of Canada when he found parts of these limestone peaks covered with a thin film of translucent opal.

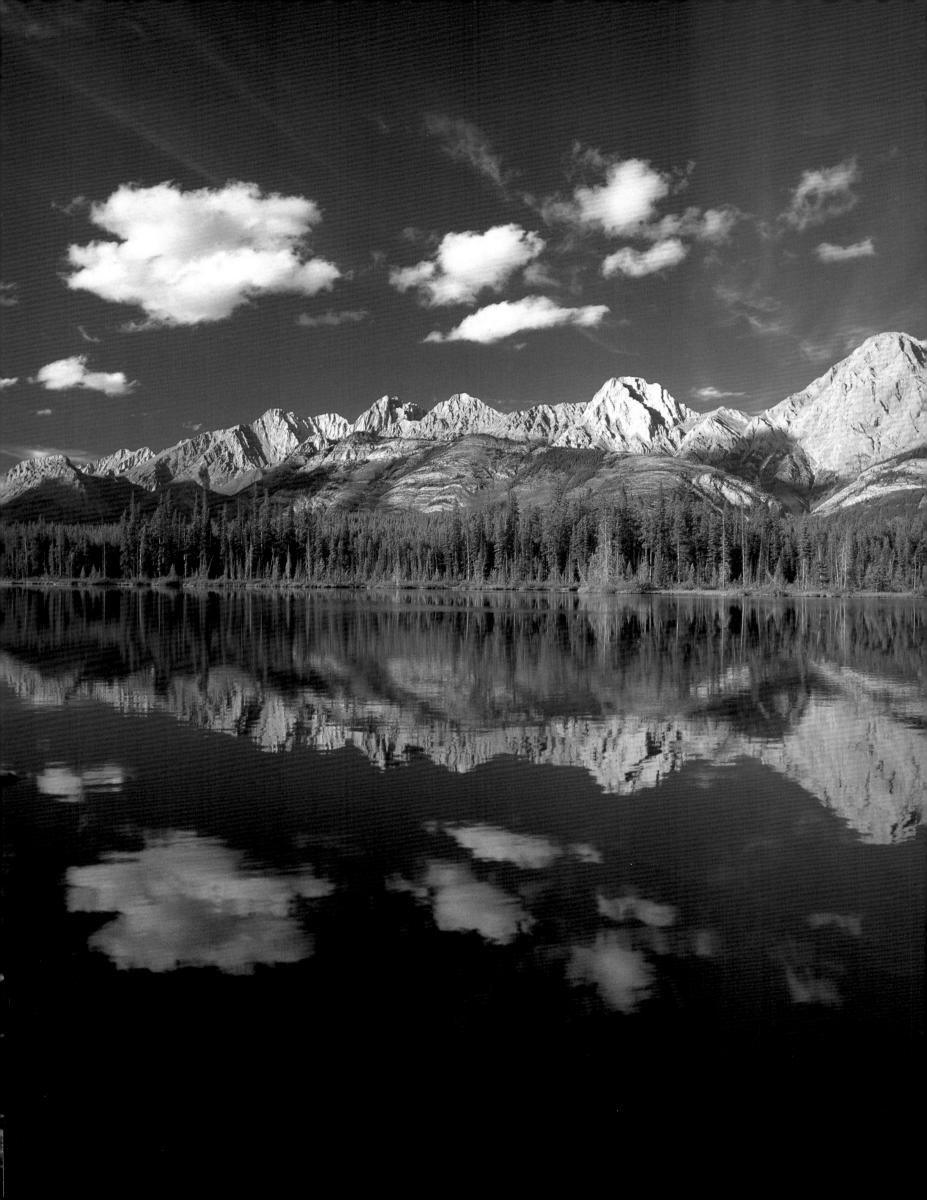

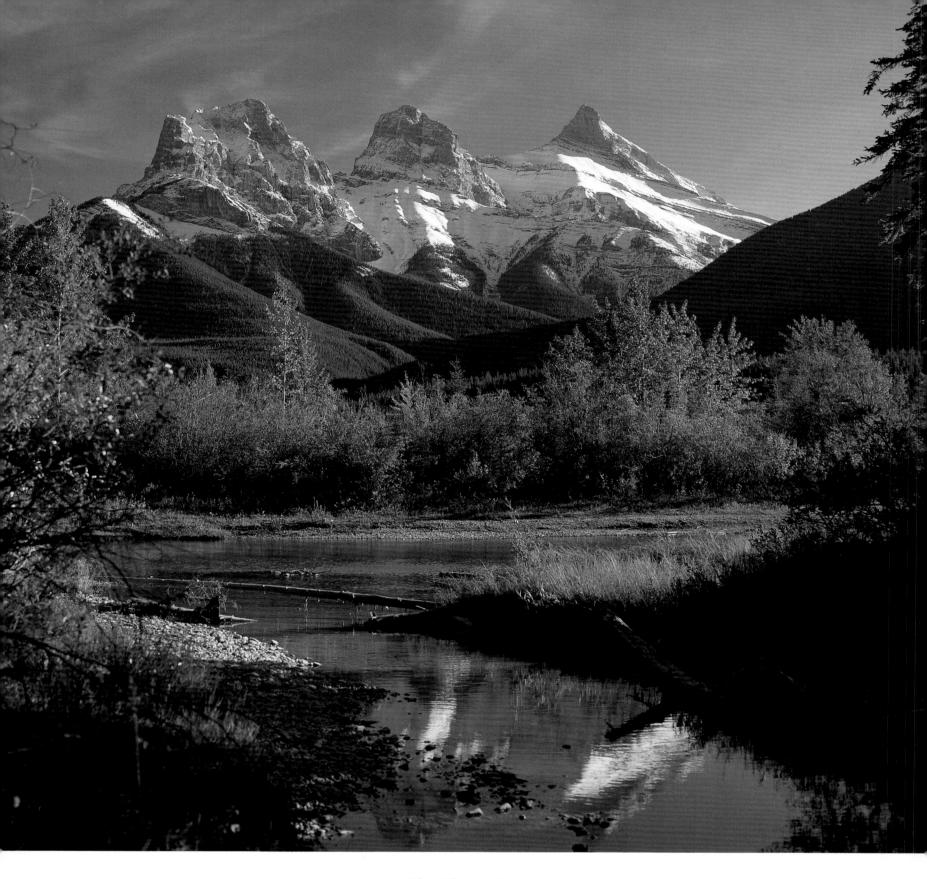

The Three Sisters

Kananaskis Country borders Banff National Park and begins right above Canmore, where this landmark trio stands. The three sisters are close in height, but the one on the right is tallest at 2936 m/9630 ft high. This area was part of Rocky Mountains National Park until 1911.

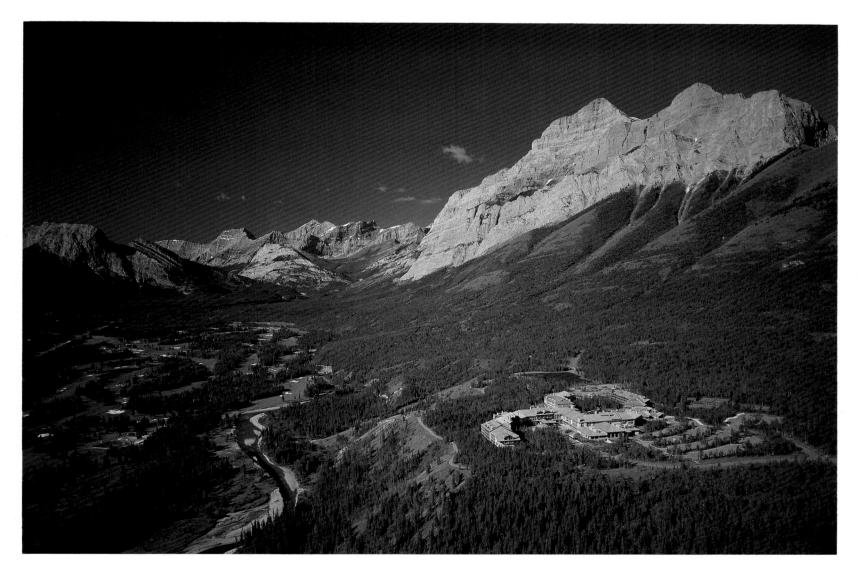

Kananaskis Village, Golf Course and Valley

his aerial view southwest reveals why this new mountain playground is so popular. Between Highway 40 and the Kananaskis River is the 36-hole Kananaskis Country Golf Course, where golfers exaggerate their drives (by about 10% at this 1478 m/4848 ft elevation) past its distinctive white sand traps. Bicycle trails link the Mt. Kidd RV Park in the forests at the south end of the course with Kananaskis Village on the bench below 2958 m/9702 ft Mt. Kidd. On the far skyline 3054 m/10,017 ft Mt. Chester of the Kananaskis Range looms above the Fortress Mountain ski area.

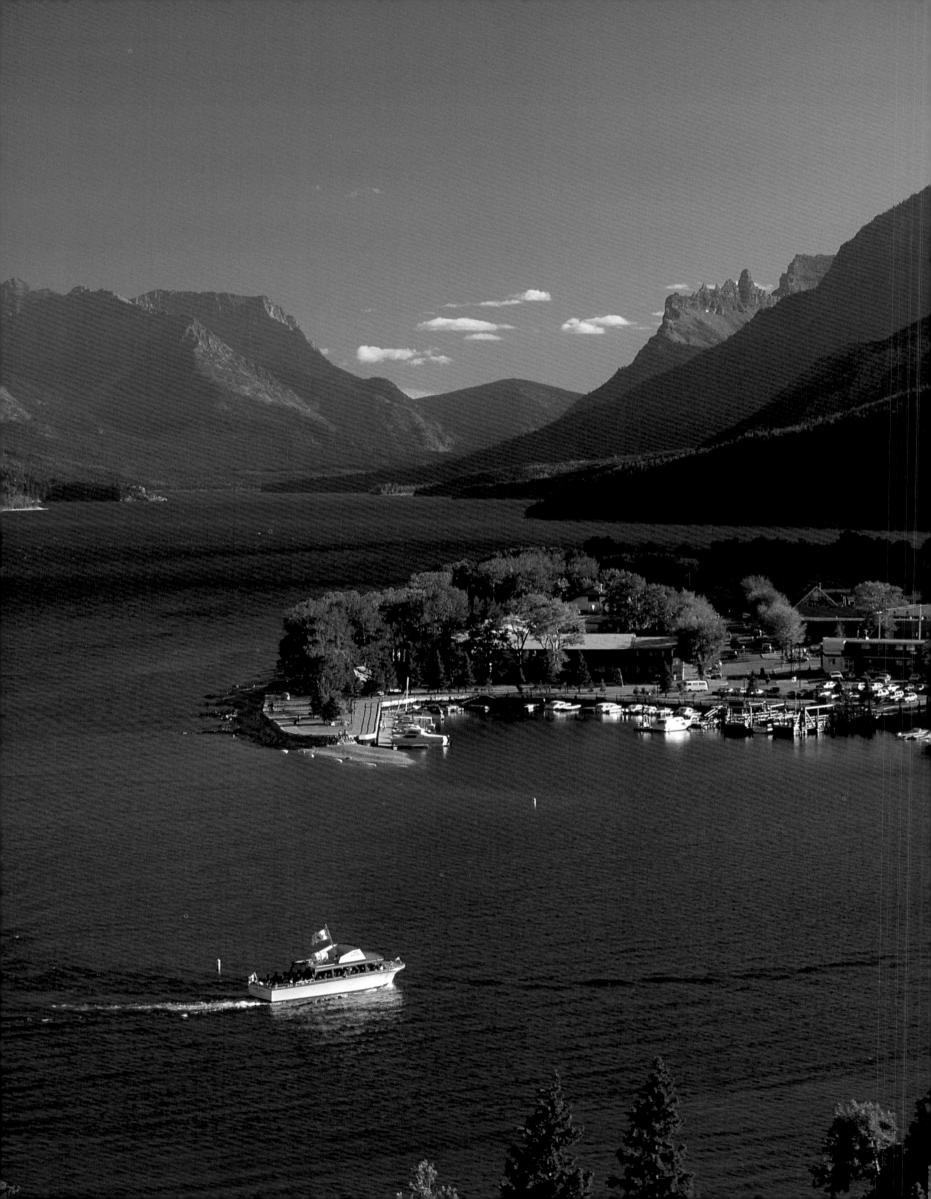

WATERTON NATIONAL PARK

"The smallest Rockies park is also the one with the greatest biological diversity."

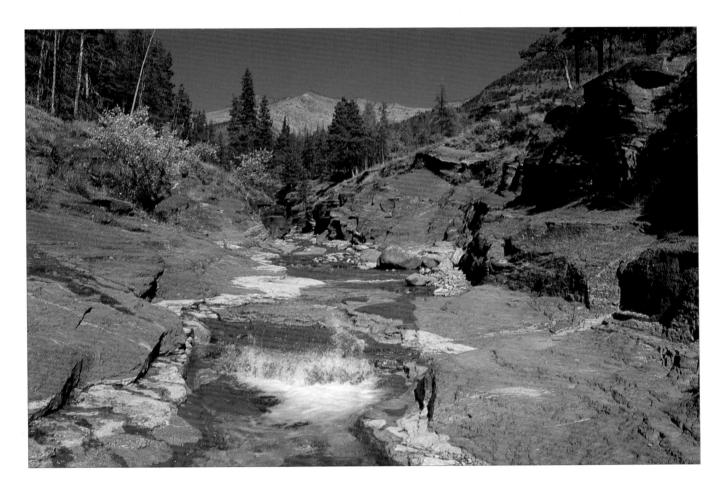

Red Rock Canyon

This canyon in the upper Blakiston Valley cuts through a colourful bed of oxidized argillite, an ancient metamorphosed shale. Fossil reefs of stromatolites, 1.5 billion year old blue-green algae, one of the planet's oldest life forms, are found here. A 20 minute trail loops around the canyon.

Left: International Cruise Boat in Emerald Bay

irst settled in 1911, Waterton townsite sits on the Cameron Creek delta on Upper Waterton Lake. The southern end of this deepest lake in the Canadian Rockies (135 m/443 ft) is in Montana's Glacier National Park.

Mountains Meet Prairies

he smallest national park in the Canadian Rockies takes its name from the Waterton Lakes, which were named for an eccentric English explorer who never saw them. A keen naturalist, Charles Waterton would have loved this park – it holds the greatest concentration of biological diversity in the Rockies. In just 525 sq km/203 sq mi there are 25 different habitat types, over 900 plant species (including 111 of Alberta's rarest and some found nowhere else in Canada), more than 300 terrestrial wildlife species and 25 species of fish. The reason for this wonderful variety is the abrupt ecological edge here: "where prairies meet the mountains" is also where prairie species meet mountain species, where the buffalo meets the bighorn sheep.

In fact, the mountains came to the prairies. During the building of the Rocky Mountains, the collision of tectonic plates to the west buckled the brittle sedimentary crust of the continent and pushed it eastward. The blocks of rock above Banff were moved 250 km/155 mi, rippling tilted slabs of foothills in their path. But at Waterton a huge slab of 1.5 billion year old Precambrian crust – the Lewis Overthrust – slid 40 km/25 mi *over* unbroken 60 million year old crust to the east. The edge of that stone blanket is today's wall of mountains, after 50 million years of erosion and two million years of periodic Ice Age glaciation sculpted their current forms.

This topography creates diversity. Vegetation changes with mountain elevations, on sunny south slopes and

shady north slopes and where water runs away or pools. But at Waterton the prairies not only meet the mountains, they climb them. Despite receiving enough total precipitation to support more forests, Waterton's famous winds steadily blow dry the soil and allow grasslands to dominate much of the park. Summer winds are funneled through the Waterton Lakes basin and warm "Chinook" winds pour over the crest of the Rockies, melting away winter snowfalls. These winds made this area a prized winter bison hunting ground for Native peoples for thousands of years. One campsite 8400 years old has been found at Red Rock Canyon.

Though small, Waterton borders Glacier National Park in Montana. International tour boats began plying the lake in 1927, the year the landmark Prince of Wales Hotel was built. Since 1932 the two parks have together formed the Waterton-Glacier International Peace Park, the first of its kind in the world, providing free trade in grizzly bears long before the two nations established it in commerce. In 1979 the United Nations designated this single ecosystem, including adjacent range and forest lands, to be one of 120 Biosphere Reserves worldwide. Recognizing that no park is an ecological island, the success in the collective management of this "Crown of the Continent" will say much about the future prospects of all of our national parks.

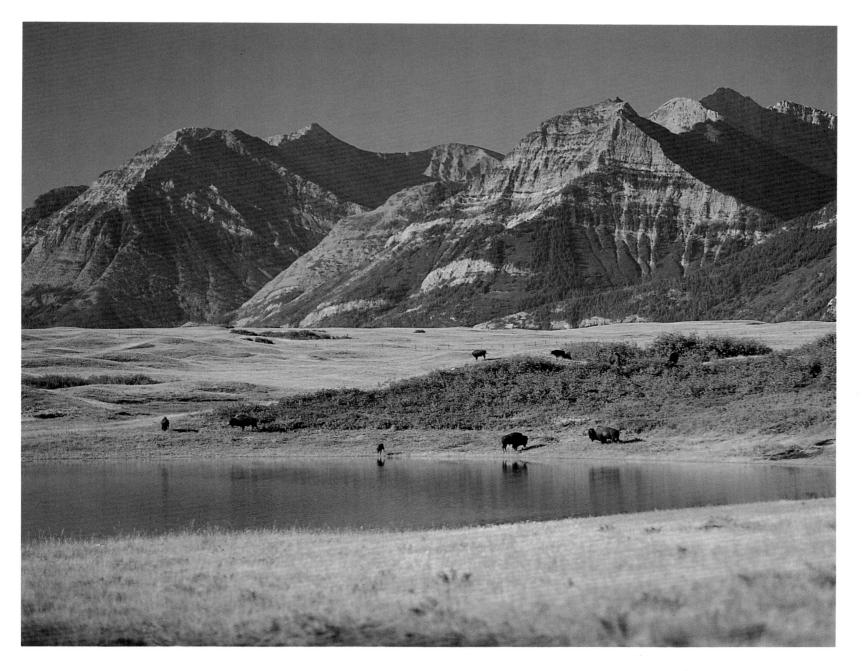

Where Prairies and Mountains Meet

In 1800 there are estimated to have been 60 million buffalo on the Great Plains. By 1890, after the great buffalo hunts, they were all but gone. This is one of the small herds that lives protected in the national parks.

Overleaf: Waterton Lakes

Afternoon sun illuminates the area between Upper and Middle Waterton Lakes. Adventurer "Kootenay" Brown first saw this view in 1865 and he returned to stay in 1879. His love of the area led to the establishment of a 140 sq km/54 sq mi reserve here in 1895 and the Waterton Lakes Dominion Park in 1911. The landmark Prince of Wales Hotel opened in 1927, built by the Great Northern Railway as part of their Glacier National Park tourism package.

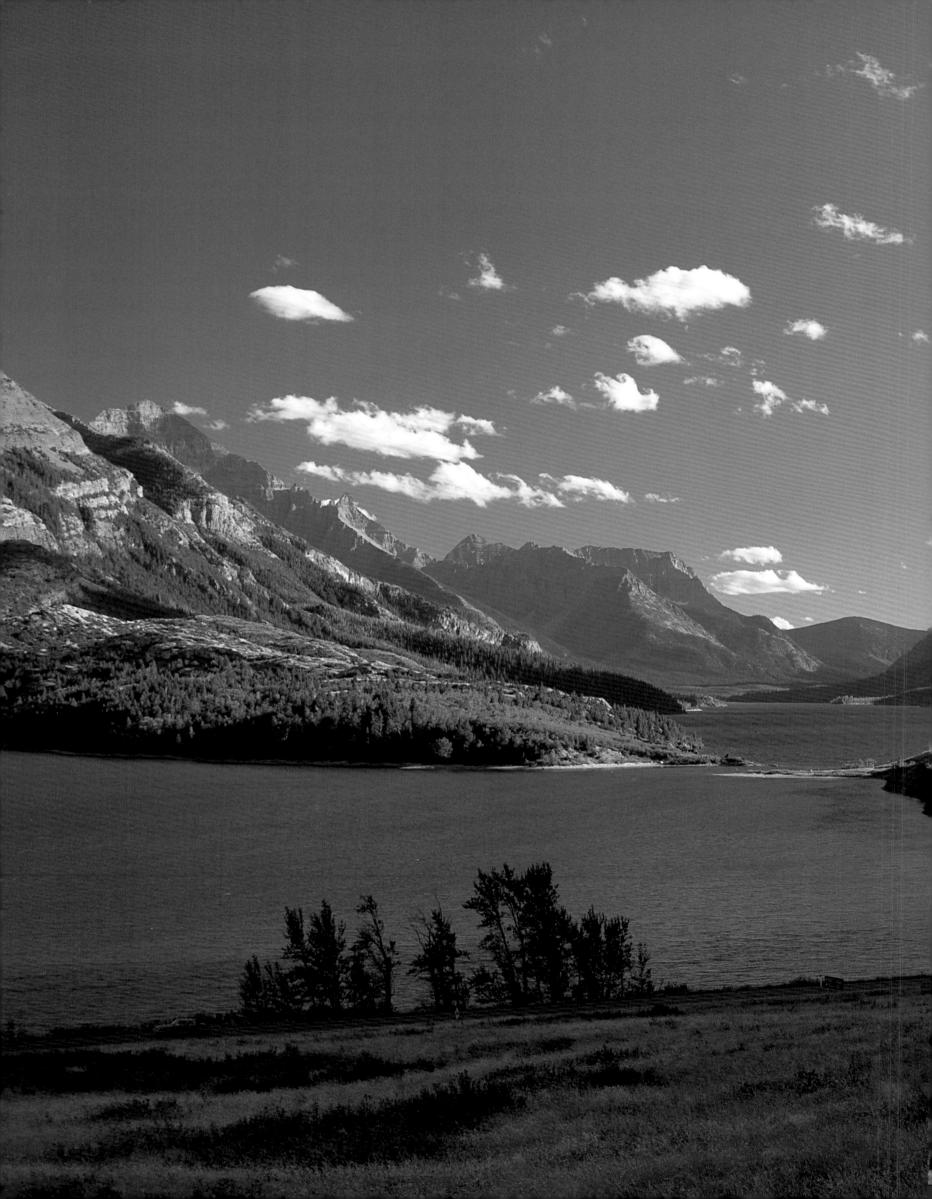

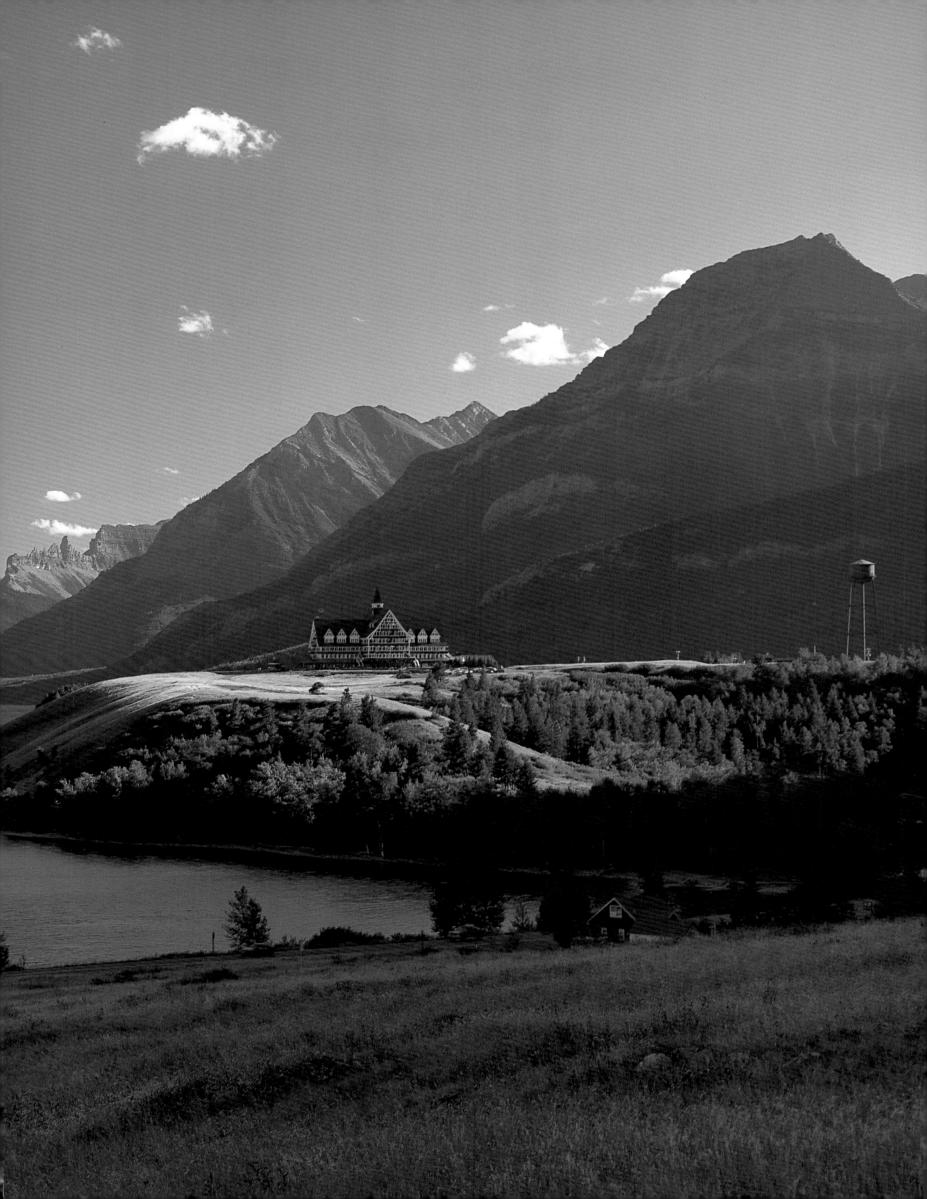

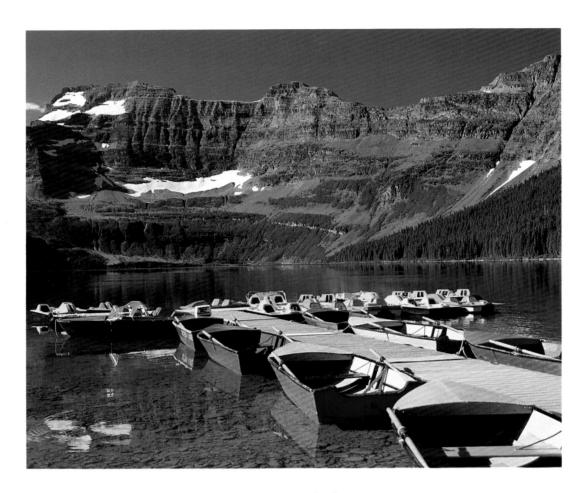

Cameron Lake

From the safety of this international lake, canoeists can watch grizzlies on the avalanche slopes below Mt. Custer (2707 m/8879 ft) in Glacier National Park. The South Kootenay (Akamina) Pass, an ancient Native route, circles around this peak and descends into British Columbia. The Kootenay Indians crossed it on their buffalo hunting trips to the prairies. Lt. Thomas Blakiston of the British Palliser Expedition followed it to discover Waterton Lakes in 1858.